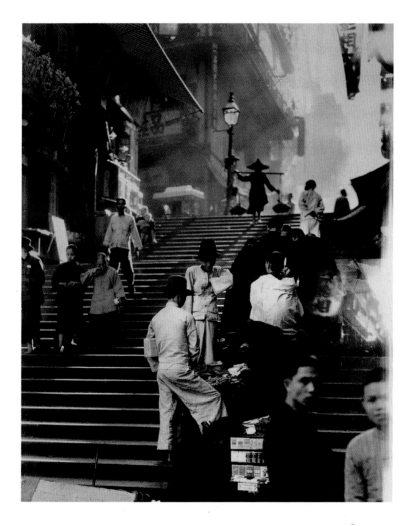

W. ROBERT MOORE | 1932 | HONG KONG *In the Far East*

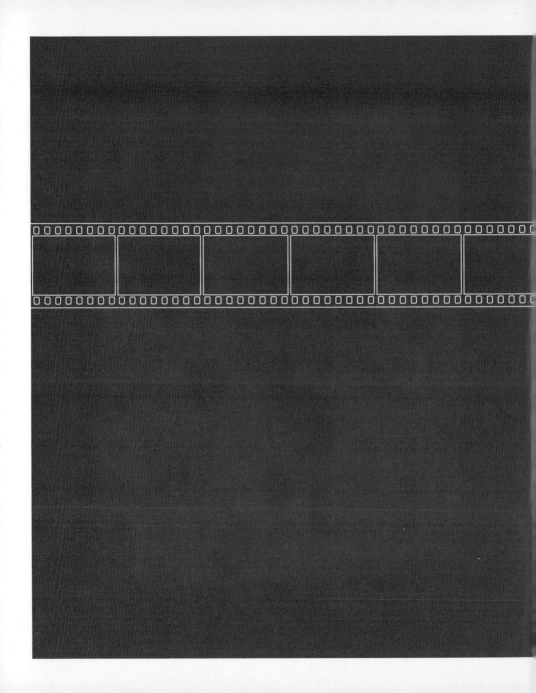

NATIONAL
GEOGRAPHIC
IMAGE
COLLECTION

NATIONAL GEOGRAPHIC

WASHINGTON, D.C.

CONTENTS

CHRIS JOHNS **|** 1988 **|** TANZANIA *In Ngorongoro Crater*

acknowledgments

Fruitful partnerships are behind virtually all major photography books, and this one is no exception. The volume you are now holding is the culmination of a special collaboration among people who love the photography and art housed in National Geographic's Image Collection.

Selecting 450 photographs to stand for some ten million, then explaining the endeavor, has been a daunting though invigorating task to say the least. Image Collection director Maura Mulvihill and her team worked generously and closely alongside our book team with the shared goal of making a book that would be thorough, accurate, and as amazing as we know the Collection to be.

Photography curator Michelle Delaney accepted our invitation to write an essay offering a historical perspective on our Collection. Illustrations editor Adrian Coakley consulted with contributing illustrations editors Bill Bonner and Steve St. John, going through tens of thousands of pictures. Art director Melissa Farris brought visual coherence to our book structure and picture selections. Mark Jenkins contributed captions and commentary throughout, and Becky Lescaze edited the text. All gave their time, insights, and enthusiasm unstintingly.

Choices had to be made and good pictures given up; it wasn't easy. Each person's work was enlarged by everybody else's. We hope you will find the outcome as wonderful as we do.

Leah Bendavid-Val

Herald Island, bearing about W. by S. (magnetic).
From a photograph by Assistant Paymaster J. Q. Lovell, U. S. N.

foreword **by Leah Bendavid-Val**

The book you hold in your hands discloses the full contents of the National Geographic Image Collection for the first time. This sprawling collection of almost 11 million images, with all its diversity, has a unique, unmistakable National Geographic personality. We've singled out our Special Collections and our photographic breakthroughs. We've made room for the whimsical, the quirky, and the unexpected pictures that have, through various paths, made their way into this extraordinary archive. All together the photographs add up to a singular history of the world, concrete and suggestive, from 1890 until today.

The National Geographic Society's founders never planned to build such a large and consequential photography collection. It is safe to say that none of the 33 esteemed gentlemen-explorers who met in Washington, D.C., on a cold, damp January evening in 1888 had photography on his mind when considering the possibility of establishing a society for "the increase and diffusion of geographical knowledge."

They were all science-minded men, albeit with an irrepressible zest for adventure. Their ideas for disseminating yet-to-be-acquired geographical knowledge included lectures and meetings and a journal with a scholarly style that educated laymen could enjoy and respect.

National Geographic magazine was launched nine months after that January meeting, in October 1888, and was an immediate though modest success. The first photograph appeared in July 1890 *(above)*. It was of Herald Island, a small, rocky piece of land isolated in the Arctic's Chukchi Sea.

Alexander Graham Bell, the Society's exuberant, impetuous second president, loved photography, and so did his reserved 23-year-old son-in-law Gilbert Hovey Grosvenor, the magazine's first full-time editor. In a letter dated March 5, 1900, Bell famously urged Grosvenor to publish "more dynamical pictures—pictures of life and action— pictures that tell a story." The young man needed little encouragement. The Society's funds were scanty, and Gros-

venor took advantage of every opportunity to acquire photographs at low or no cost. He loved to travel, uncomfortable as that was in those days, and he took pictures with relish everywhere he went. He published some of his own pictures in the magazine but looked elsewhere for images as well. He obtained inexpensive or free pictures from galleries and from serendipitous encounters when he traveled. Back home, he appealed for photographic donations at every opportunity, from friends he ran into, clubs he belonged to, and from all branches of the U.S. government.

Grosvenor collected broadly in order to have a wide variety of choices on hand to publish when and if the need arose, but many of the pictures he had coaxed out of his contacts never made it into print. He was committed to displaying photography as an objective, potent eyewitness to every kind of human endeavor. In January 1905, the magazine showed readers 11 dramatic photographs of the Tibetan capital, Llasa, taken by two explorers who offered them free of charge. No one had seen such pictures before. Publishing these and other pictures were bold moves at the time. The readership loved it, but board members did not. Two of them resigned. "Wandering off into nature is not geography," they declared, and they were enraged by the idea of reducing their journal to a mere "picture book."

Grosvenor prevailed, and by 1908 photographs appeared on more than half the magazine's pages. National Geographic's strict publishing policy called for documentation unencumbered by the personalities of the photographers. The pictures had to be about geography, defined simply as "the world and all that's in it." The magazine had to stay away from politics, controversy, and subjectivity. This was a policy that excluded important and interesting topics but opened the door for deeper coverage of others.

As a science-minded photography lover, Grosvenor also wanted to break new technical ground. He did this by investing in printing technologies and in the development of films, lighting, and gadgetry as needed. National Geographic's contribution to color publishing stood out, and the archive swelled. Editors commissioned drawings and paintings for magazine stories when they deemed photographs and text insufficient, and an art collection grew quietly and stunningly alongside the photographs.

Over the years a deep and lasting culture of photography developed at National Geographic. A photography staff was put in place, and photography regulars contributed their individual visions and talents. New talent was welcome. Technical support was generous and responsive. Photographers with big dreams hoped for assignments that would allow them to work in exotic places, witness never-before-seen natural and cultural events, and create photographs that would surpass everything done before. Despite long-held principles of neutrality, National Geographic has increasingly made room for diverse styles and topics. Photographers with hugely different interests and approaches have found a home and a niche in the culture. The Geographic has contributed to and benefited from new social realities, yet has remained devoted to its original mission.

This volume presents the facts and also the character and spirit of National Geographic's photography holdings. Michelle Delaney, curator of photography at the Smithsonian's National Museum of American History, offers a view from outside the collection looking in, and Maura Mulvihill, a vice president and director of the collection, gives us her perspective from inside.

Photography has been around long enough now for the world to be awed repeatedly by technical innovations and for us to witness dramatically changing tastes and values. But as these pages show, good pictures somehow stay enigmatic and grow more meaningful with time. It is this and everything yet to be discovered about the ever changing "world and all that's in it" that keeps the photographic work going forward as creatively and passionately as ever.

LUIS MARDEN | 1951 | MAINE *Sardine fleet at dawn*

the national geographic image collection: a historical perspective **by Michelle Delaney**

Washington, D.C., is home to many of the world's foremost photographic history collections. The first to come to mind usually are those collections in the Smithsonian museums, the Library of Congress, the National Archives, or the National Gallery of Art. Each holds millions of images documenting national and international art and history. These collections record the development of photography as a tool of the sciences and the arts. But, often forgotten in the midst of the vast collections on the National Mall is another special photography collection located in cold storage underneath the headquarters of Washington's National Geographic Society. The quality and diversity of the Geographic Image Collection is quite outstanding when compared to the others mentioned. The Society's magazine and ultimately the broader Image Collection document more than a century of our world, a global perspective on change. The Geographic photographers and special collections acquired provide the visual representation of our world—the exploration, wildlife, science, peoples and cultures—and its changing nature.

The strength of the National Geographic Society Image Collection begins with the dedicated staff caring for it throughout more than a hundred years, collecting and commissioning photographers' work to

document our planet. What an indulgence for a history-of-photography curator to be asked to participate in presenting the Geographic collection in historical perspective. Immediately, memories come rushing back to me of lengthy afternoon discussions with my friend and longtime Geographic photographer Volkmar "Kurt" Wentzel. How I wish he were still with us to witness the further study and appreciation of his beloved Geographic Collection. Volkmar and I spent hours discussing his long Geographic career spanning almost 50 years (1937-1985), his assignments, travels, and, of course, his never-ending mission to preserve the images once labeled for discard by Geographic in the 1960s. With his passing in 2006, the historic images he saved from ultimate destruction have been reincorporated into the Geographic Image Collection. Some of the photographs were from his own 1930s "Washington at Night" series, and some dated back almost a century from Gilbert Hovey Grosvenor's early tenure as president and photographer for the Society. Now with almost 11 million photographs of various subjects and formats, the National Geographic Society boasts one of the preeminent image collections in the world, if one lesser known than most American museum collections.

My full introduction to the depth of the Geographic Image Collection came in 1995 when Volkmar Wentzel and I met to discuss my research project and planned exhibition on the beginnings of the Smithsonian's own Photographic History Collection, now a unit within the National Museum of American History. We reviewed together 50 photographs acquired from the 1896 Washington Salon and Art Photographic Exhibition held at the city's prestigious Cosmos Club. This first acquisition of art photography for the Smithsonian was arranged by its first photographer, Thomas Smillie, whose efforts to collect photography for the Smithsonian's United States National Museum dated back a decade to the 1880s. Smillie's professional and personal relationships with Washington's elite men of the sciences and the arts included the gentlemen and explorers who founded the National Geographic Society. Volkmar introduced me to the Geographic side of the story. His lifelong interest in the history of photography, the significance of the Geographic Image Collection, and our common interest in the intersections of all things photographic in our adopted city of Washington, D.C., cemented our ten-year friendship.

The Geographic and Smithsonian photography collections are most closely linked in their late 19th-century beginnings, and the efforts employed in building premier history-of-photography collections. However, while the Smithsonian may be better known for its photography research collections and art holdings, the Geographic Image Collection remained for years a vastly underutilized resource. The two institutions began on parallel paths with several milestone dates in common. In 1888, the same year Smillie began collecting photography and related equipment for the Smithsonian, the National Geographic Society was founded. Soon afterward, the Society began publishing its journal. Less than a decade later, both institutions acknowledged the growing importance of photography in American society by starting historic collections. In 1896, the Smithsonian officially established a Section of Photography within the Graphic Arts Collection of the U.S. National Museum. Smillie was given a second title, honorary custodian of the Section of Photography, and thus initiated what is today the oldest collection of photography in an American museum. Geographic utilized the new halftone printing process to add photography to the magazine beginning in 1896, a pivotal move that changed the nature of the magazine and collecting efforts of the Society forever.

Turn-of-the-century Washington, D.C., was a dynamic place embracing all the possibilities—the science, technology, and art—of photography, a medium just 60 years old at the time, and ever evolving. The Geographic and

Smithsonian each embraced the international nature of the field, collecting the best examples by professionals and amateurs advancing photography. The local D.C. community was thriving with camera clubs and a small circle of wealthy men experimenting in the newest technology and art.

There was one individual instrumental in the beginnings of both the Geographic and Smithsonian collections: explorer John Wesley Powell. Both organizations fostered strong ties with the U.S. Geological Survey photographers under the leadership of Powell. As one of the original founders of the National Geographic Society, Powell understood the powerful potential of photography for government studies, as well as general public interest. Photographs from Powell's earliest Surveys of the American West of the 1870s were added to both collections. Powell was singularly the most important guide in these early efforts toward collecting of photography as visual documentation of our country and its undocumented West. He brought to Washington, D.C., and the attention of the Geographic and Smithsonian administrators and collectors, the best photographers working for him on the U.S. Geological Surveys, including William Henry Jackson. Americans were introduced to these western scenes through publications such as *National Geographic* magazine, as well as to published stereograph images made three-dimensional in special viewers, a very popular family pastime in the late 19th century. Later in his life, Powell led the U.S. Bureau of American Ethnology. There he directed a growing photography collection that eventually transferred important images to the Smithsonian's Department of Anthropology and Section of Photography.

The new medium of photography was enthusiastically collected by many institutions in Washington, and collected earlier for museums and societies here than in most other U.S. cities. The Smithsonian's earliest collecting included Samuel F. B. Morse's 1840s daguerreotype camera and equipment; Eadweard Muybridge's 1888 Animal Locomotion Studies and his patent models; select cameras and apparatuses representing the fast-advancing camera and printing technology, from manufacturers like George Eastman of Rochester, New York, and G. Cramer of St. Louis; as well as the images from the 1896 Washington Salon documenting the new movement in American art photography. Yet, Smillie's Smithsonian unit remained limited in collecting when compared to the Geographic's.

The National Geographic Society launched its image collection so quickly and aggressively as to potentially not even realize the significance of building its own archive. The standard for excellence in selection of photographs and stories to publish determined criteria for the earliest collecting and commissioning of photographs for the Geographic. The images made during Robert E. Peary's North Pole expedition in 1906, Gilbert H. Grosvenor's photographs of early flight experiments in 1907, and technical achievements in early color and underwater photography processes are early acquisitions of note within the first decades of collecting and printing for *National Geographic* magazine. The Geographic Image Collection has always been considered primarily an illustrations collection by most Geographic staff, as well as some outside curators of photography, despite numerous exhibitions and books to counter this notion. As Volkmar Wentzel adamantly voiced throughout his life, the Geographic holds a photography collection of international museum quality, significant to the history, science, and art of photography, from the late 19th century forward. Even a short research visit or tour of the Geographic Image Collection attests to the quality and diversity of the special collections within the archive.

The largest of the special collections in the Geographic's holdings is certainly the Autochrome collection, numbering close to 15,000 images. The Autochrome was introduced to international mass markets by the French brothers Auguste and Louis Lumière in 1907. It provided photographers the first commercially viable process for

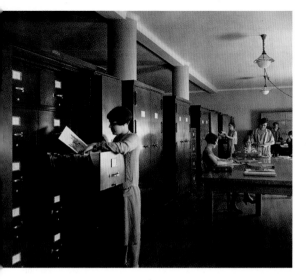

capturing their work in natural color, but with some restrictions. This process was slow and cumbersome; photographers needed to transport heavy wooden cameras, tripods, and trunks of equipment on assignments. The glass color transparencies were fragile and light sensitive, and not very good for exhibition use, as the leading art photographers of the period determined. But the Lumières' use of dyed potato starch grains in the emulsion mixture did elicit subtle colors and beautiful pictures. Many leading art and history museums have collections of Autochromes, but the Geographic Image Collection holds one of the foremost collections of these images dating from their invention to the end of their production in the 1930s.

The Geographic first published an Autochrome in the magazine in 1914, the first natural color image printed in the journal. It was "A Ghent Flower Garden" by Paul G. Guillumette, who began experimenting with the Lumière Bros.' Autochrome process in 1912. He was a pioneer in the use of early color photography. Guillumette's daughter, Doris, meticulously kept most of her father's collection of Autochromes, stereo-autochromes, later Kodachrome slides, and personal notes together until donating them to the Smithsonian's Photographic History Collection in 1995. The notes describe how the U.S. division of the French Lumière Bros. Company was so impressed with his work it hired him to produce samples for world distribution, and later to run its color department. Guillumette was in contact with government agencies, institutions, and professional and amateur photographers. Some of the individual contacts he made through his position at Lumière Bros. included Geographic's Alexander Graham Bell and master photographers Alfred Stieglitz and Arnold Genthe. But, it was another contact at the Geographic, Gilbert H. Grosvenor, who made the most lasting impact on Guillumette's career, with the decision to publish color Autochromes in the Geographic magazine.

The prospect of replacing illustrations in the magazine with natural color photographs interested Grosvenor. In 1913 Guillumette traveled extensively in Europe photographing scenery and the Ghent World's Fair. Subsequently, one image from the trip was selected by National Geographic for the July 1914 issue, a scene of the Horticulture Hall. The accompanying caption concludes, "The picture makes one wonder which the more to admire—the beauty of the flowers or the power of the camera to interpret the luxuriant color so faithfully." For many years Guillumette retained his original fur business but eventually his passion for photography, especially color, led him to pursue his interest full-time. Doris Guillumette understood her father's inspiration to be more than an attempt to conquer the technique of color photography, "as it had the potential of a new art form." Guillumette, like many photographers whose work was selected by the Geographic, chose to explore foreign lands,

especially the European countries of France, Italy, Switzerland, Belgium, and Holland. He was ever curious of the natural scenery. On rare occasions Guillumette included people in his photographs. Several in the Smithsonian's collection are self-portraits. Doris Guillumette recalls fondly, "Father was convinced that technique, artistry, and inspiration were all needed to make a truly great picture." Guillumette's legacy in color photography attests to that. Yet, much as his contemporaries in the art photography movement hoped the Autochrome process would prove lasting as the format to bring color pictures to museum and gallery exhibitions, it did not. These images were too light sensitive and fragile. But there also remain 40 identified Guillumette Autochromes in the Geographic Image Collection. For decades, *National Geographic* magazine remained the premier journal to publish these unique color—and now historic—images. Today, the thousands of unpublished Autochromes collected by Geographic are among the priceless images needing further study by their staff and researchers.

National Geographic's successful magazine and effective use of photographs to engage readers led to the creation of a photography lab and the hiring of staff photographers at the Society in the 1920s and 1930s. The photographers were considered explorers in their own right, populating the magazine with its own style of technical and artistic work. Charles Martin, the first man hired to staff the lab, later became the chief photographer for Geographic. His duties allowed for special assignments, pushing the limits of existing photographic technologies and color photography. In the late 1920s, Martin collaborated with Dr. W. H. Longley of Goucher College to make the first underwater Autochromes of fish species, near Dry Tortugas, Florida. Longley first used his Graflex underwater housing with a 4x5-inch Auto-Graflex camera for marine photography in 1918. For the expedition to the Dry Tortugas, Longley not only planned to use the watertight camera again, but this time, with Martin's assistance, the team discharged a pound of magnesium flash powder floated on three pontoons and used a reflector to light the underwater scene below. Five of their successful photographs illustrate the article, "First Autochromes From the Ocean Bottom," by Longley in *National Geographic* magazine, January 1927. The pair produced a historic series of images now in the Geographic Image Collection. The Graflex camera outfit—underwater housing, camera, and one plate holder—made by the Folmer and Schwing Department of the Eastman Kodak Company, Rochester, New York, was donated to the Smithsonian's Photographic History Collection in 1940 by U.S. National Museum curator Waldo L. Schmidt, a specialist in marine invertebrates. Both the Geographic and Smithsonian greatly increased efforts toward building their photography collections in the 1940s. And, as National Geographic reached its 50th anniversary, additional staff photographers were hired, further establishing the commitment to visual storytelling. Significant time and money were allotted for extended assignments abroad.

In the late 1930s, a young Volkmar Wentzel was encouraged to show his "Washington at Night" series of photographs to staff at National Geographic. The images so impressed a personnel specialist that Wentzel landed a staff position. While Volkmar's first personal project was to photograph his adopted home of Washington, D.C., he thrived on the travel available to him through the position at Geographic. He traveled the world for the next half century. Influenced by such masters of photography as Arnold Genthe, Brassaï, and D.C.'s own Frances Benjamin Johnston, Volkmar used his camera as a tool of exploration and education. His photographs of the United States, Europe, and Asia portray life in the mid-20th century. Beginning his professional career at the height of the Great Depression, Volkmar introduced readers of *National Geographic* magazine to scenes of everyday life in the nation's capital, rural America, and life abroad over the course of the next many

decades. His early photographs establish a visual landscape of the mid-Atlantic region, and a cultural identity of its citizens, eventually becoming what he called his "Vintage Americana" series, dating 1935-1960. However, the biggest assignment of his career came with the overwhelming task to "Do India." He spent two years, 1946-48, traveling throughout India and Nepal documenting many never-before-seen lands and cultures. The experience was life-altering. Volkmar had the advantage of retrofitting a former ambulance into a National Geographic Society van and portable darkroom, using it throughout his long journey. He used smaller format cameras on tripods and handheld cameras to produce eight albums of photographs now residing in the Geographic Image Collection. Hours can be spent turning the pages of history you'll find within these albums. Volkmar befriended a nation, and the results show a nation in transition, and people as curious of the foreign photographer as he was of them.

The second half of the 20th century saw Geographic photographers focused on more stories and documentary photo essays of a photojournalistic nature—including Jodi Cobb's Saudi women; Nick Nichols's elephants and gorillas; Jim Blair's views of Eastern Europe and Africa; David Alan Harvey's photographs from Europe and the Americas; and Brian Skerry's digital work in New Zealand waters. The photographers captured images of countries in modern transition. The Geographic Image Collection holds a visual history of cultures underrepresented in the photography collections of U.S. national art and history museums. The collection illustrates the plight of cultures and individual citizens living day-to-day through apartheid, political upheaval, drug wars, and the realities of daily life, far removed from the comparatively metropolitan lives of most readers of *National Geographic* magazine. This shift to an increased focus on photojournalistic topics and world issues did not preclude the magazine's continuing to commission stories and photographs of more traditional Geographic subjects, such as land and wildlife. Editors just expanded the capacity (and the Geographic Image Collection) to document our world more fully. Longtime Geographic photographers Blair and Harvey are just two examples of the many dedicated staff photographers and freelancers who continue to provide the Geographic with the poignant and harsh realities of the world.

In 1988, the Geographic celebrated its hundredth anniversary, honoring the outstanding accomplishments of the Society, and printing a special issue of the magazine charting its own history over one century. The anniversary issue is rich with the history of photography; many images are republished from core special collections of the National Geographic Society. Starting with Alexander Graham Bell and the Grosvenor men, and continuing with the talented men who headed the illustrations editorial office and the photography lab, the Geographic Image Collection has benefited from the clear and ever-present notion that photography is the best medium to present subjects most often covered by the magazine—exploration, science, wildlife, and cultures. Geographic has encouraged photographers to push the limits of technology, and their own vision for a story, from the first expeditions of the 1890s to the present. The result is most often success. This is evident among the millions of images found in the massive archive housed in the National Geographic Society headquarters in Washington, D.C.—millions of photographs that are rarely if ever seen, but preserved with meticulous care for future research and publication. Whether a glass-plate negative, an early color Autochrome, a Kodachrome transparency, a 35mm negative, a panorama, a small-format print, or a new digital file, the photographers' work found in the Geographic Image Collection represents images exploring international history and art. Previously curators may have had better access to the other long-standing American national photography collections, but this is no longer the case, and none should ignore the hidden treasure of the National Geographic Image Collection.

EXPLORATION

THE EARLY PHOTOGRAPHS 34

DOCUMENTARY REALISM 74 ⌐ ⌐ THE DIGITAL RANGE 86

"THE PHOTOGRAPHY CRAZE IS IN FULL SWING," Robert Falcon Scott scribbled in his journal in August 1911, shortly before departing the cozy hut on the edge of icebound Antarctica for his fateful journey to the South Pole. "Ponting's mastery is ever more impressive, and his pupils improve day by day; nearly all of us have produced good negatives."

Producing good negatives, according to a tenet of those times, was the goal of all good expedition photography, the reason why the brass-bound, hardwood camera and all of its appurtenances—tripods, glass plates, plate holders, processing chemicals—formed as essential a component of one's kit as any compass, barometer, or specimen box. As one devotee advised would-be explorers, good negatives offered the "only trustworthy means of obtaining pictorial records" of a journey.

Good negatives and prints and color transparencies and now digital files—having sponsored exploration for well over a century, the National Geographic Society has amassed a splendid collection, ranging from the days of Scott and Peary to the space program, of such trustworthy images. They are the ones that helped instill a sense of wonder at those enchanted realms above, below, or otherwise beyond the pale of ordinary life: the Poles, the deep sea, the moon. They reflect that hopeful time when men and machines and futuristic domes cropped up in these unlikely places and civilization seemed on the verge of colonizing alien frontiers. And for every depiction of audacity, of people scrambling, scaling, or cresting some obstacle, there is an image of people sampling, weighing, measuring, surveying—informing us that even in these brave new worlds, human endeavor was present in all of its manifestations.

Until it reached its limits, that is. There are places that even the most stalwart hero cannot go, and there the camera has become our ultimate explorer. Space-based telescopes and unmanned probes scattered throughout the solar system now transmit a steady stream of data—modern "negatives"—that, through the alchemy of digital processing, yield sublime images of stupendous marvels at which all of us today can but gaze in wonder.

the early photographs

IT WAS CALLED THE HEROIC AGE OF EXPLORATION, those years before mechanization largely replaced heart and muscle; it might well be called the heroic age of expedition photography as well. For someone had to be the first to hoist those heavy cameras up the pinnacled crags or onto the ice floes and make those images that we find so evocative today.

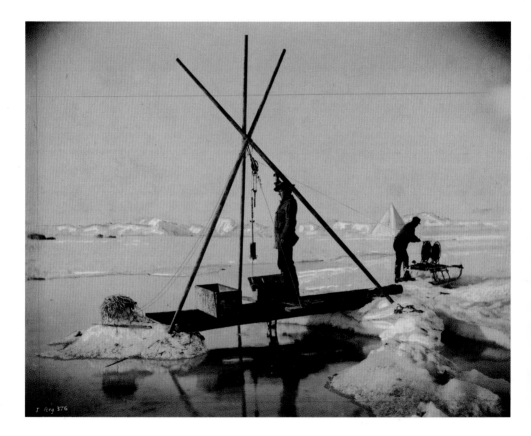

FRIDTJOF NANSEN | 1894 | ARCTIC OCEAN *Scientific sampling in the Arctic*

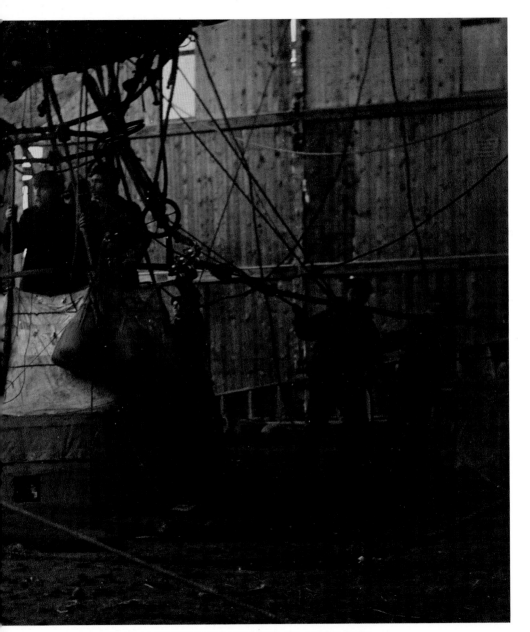

ANDRÉE POLAR EXPEDITION 1897 | SVALBARD *Balloonist S. A. Andrée lifting off on his fatal flight toward the North Pole*

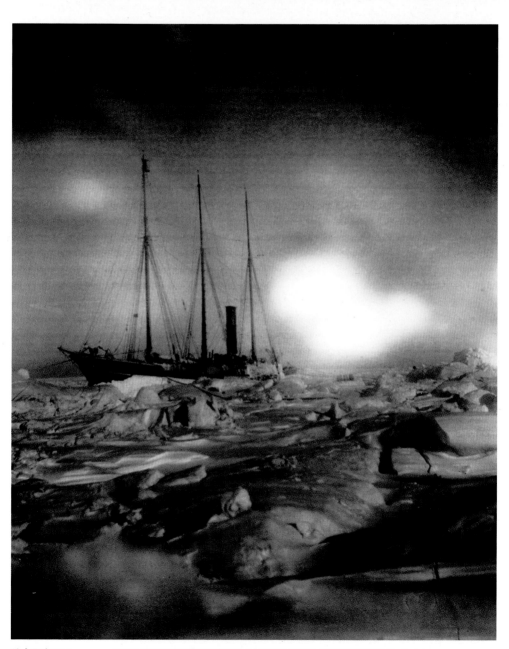

PEARY ARCTIC EXPEDITION | 1905-6 | ARCTIC OCEAN *Icebound beneath the aurora*

PEARY ARCTIC EXPEDITION I 1909 I CANADA *Portrait of an explorer: Robert E. Peary*

HERBERT G. PONTING | 1911 | ANTARCTICA *Dr. Edward Atkinson in his lab*

HERBERT G. PONTING | 1911 | ANTARCTICA *Putting a sledge together*

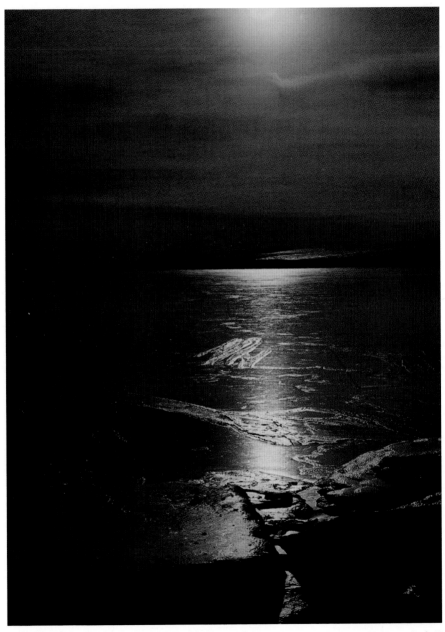

HERBERT G. PONTING | 1911 | ANTARCTICA *Twilight over McMurdo Sound*

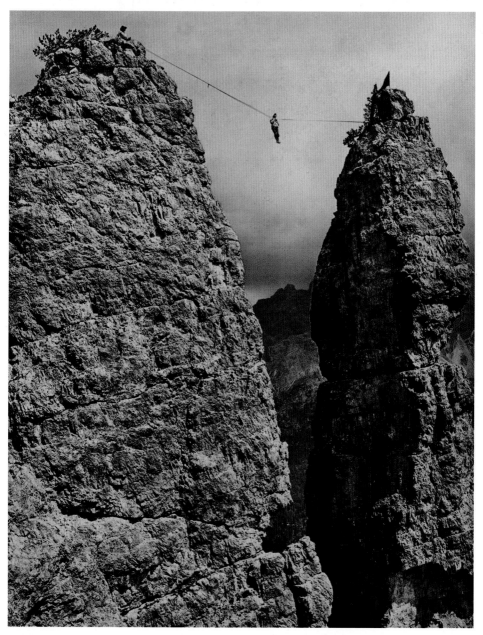

UNKNOWN | EARLY 1900S | ITALY *A daredevil in the Dolomites*

JEAN GABERELL | 1920 | SWITZERLAND *Above the clouds*

"Mountaineering transcends all everyday matters," wrote Italian alpinist Guido Tonelli. "It transcends all natural frontiers. Mountaineers are bands of brothers. They are all one party on one rope."

ALAN VILLIERS | 1933 | AT SEA *Hauling the braces*

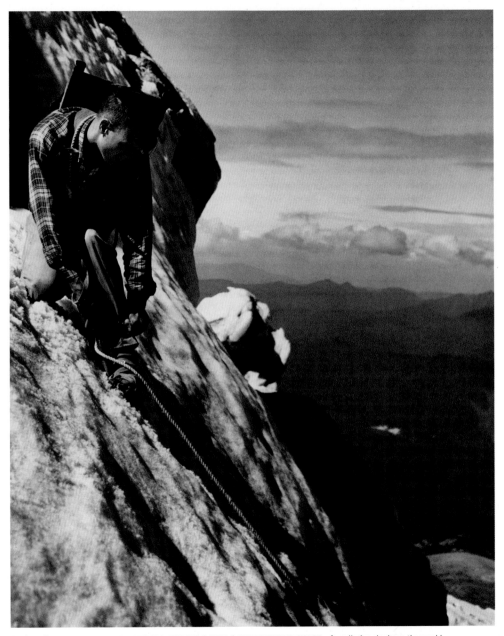

BOB AND IRA SPRING | 1952 | WASHINGTON STATE *A wall of rock above the world*

NORBERT CASTERET | 1953 | SPAIN *A shaft of ice beneath the world*

color & optimism

ONCE THE MACHINES APPEARED, victory seemed assured. After World War II, as explorers pushed deeper and farther into such demanding places as Antarctica, the oceans, and space, they brought their technology with them. Brightly clad men were depicted, in glorious Kodachrome, undertaking the seeming colonization of alien, even extraterrestrial, environments.

DAVID S. BOYER | 1957 | ANTARCTICA *Color in a black-and-white world*

THOMAS J. ABERCROMBIE | 1960 | PUERTO RICO *Jacques-Yves Cousteau and his "diving saucer"*

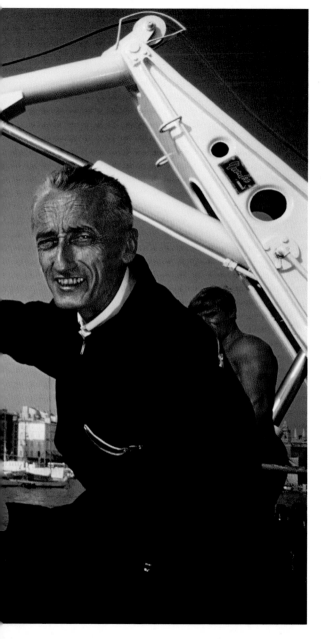

"I address it in French, of course," Jacques Cousteau quipped about Denise the diving saucer. Underwater, however, he saw it as a "natural marine creature . . . poised like some great bivalve or strange crustacean."

CHARLES SWITHINBANK | 1963 | ANTARCTICA *An icebreaker in the Antarctic*

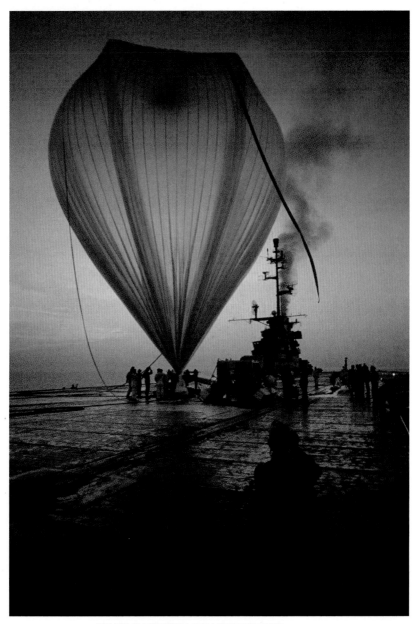

WALTER M. EDWARDS | 1961 | GULF OF MEXICO
Stratolab 5 beginning its record-setting ascent

ROBERT B. GOODMAN | 1963 | RED SEA *Camping beneath the sea*

NASA | 1965 | EARTH ORBIT *Floating above the sky* Color & Optimism | 69

BARRY BISHOP | 1963 | NEPAL *The approach to Mount Everest*

"The possibility of entering the unknown," recalled Sir John Hunt, leader of the 1935 Mount Everest expedition, "the simple fact that it was the highest point on the world's surface—these things goaded us on."

DAVID S. BOYER | 1968 | CANADA
Journey to the center of the Earth: Oilmen inspecting a drill bit

OTIS IMBODEN **|** 1969 **|** FLORIDA *Journey to the moon: Apollo 11 on its launching pad* · Color & Optimism **|** 73

documentary realism

MEN MAY HAVE REACHED THE MOON, but on Earth, as the 20th century drew toward its close, photographers began depicting a different kind of exploration, one more grindingly tedious, more labor-intensive, and still occasionally dangerous, though it was an exploration not without its satisfactions—or even its peak experiences.

JAMES P. BLAIR | 1973 | MARYLAND *Testing a satellite antenna system*

EMORY KRISTOF | 1983 | CANADA *Going down onto a shipwreck in Barrow Strait*

REBECCA WARD | 1987 | ANTARCTICA *Going down after being crushed in the ice*

ROGER MEAR | 1986 | ANTARCTICA
Approaching the South Pole after a 900-mile sledging expedition

Diving among Palau's
jellyfish, biologist
Bill Hamner and
photographer David
Doubilet could
only marvel at "the
exquisiteness, the
profusion, of these living
things that have no need
or knowledge of mankind
but that, strangely, we
feel a need to know."

DAVID DOUBILET | 1982 | PALAU *Diving among jellyfish in a salt lake* Documentary Realism | 81

NASA | ROGER RESSMEYER | 1996 | EARTH ORBIT *Mouth of the Amazon River*

DAVID DOUBILET | 1988 | VANUATU *Troopship sunk in World War II*

the digital range

TODAY'S BROAD ARRAY OF TECHNOLOGIES has given rise to a photography of exploration unequaled in reach, amplitude, and versatility. From caves and chasms and other dark places of the Earth to the stars and nebulae, modern digital imaging is providing a harvest of data for technical and scientific uses while providing us with occasional images of unsurpassed aesthetic impact.

STEPHEN ALVAREZ | 2003 | OMAN *The Majlis al Jinn cave*

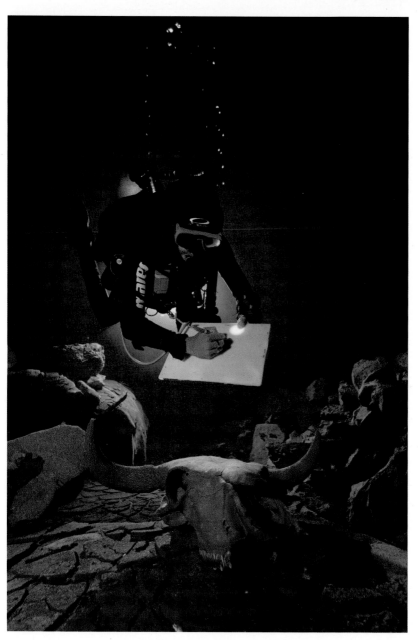

WES C. SKILES | 2003 | MEXICO *An unexpected encounter*

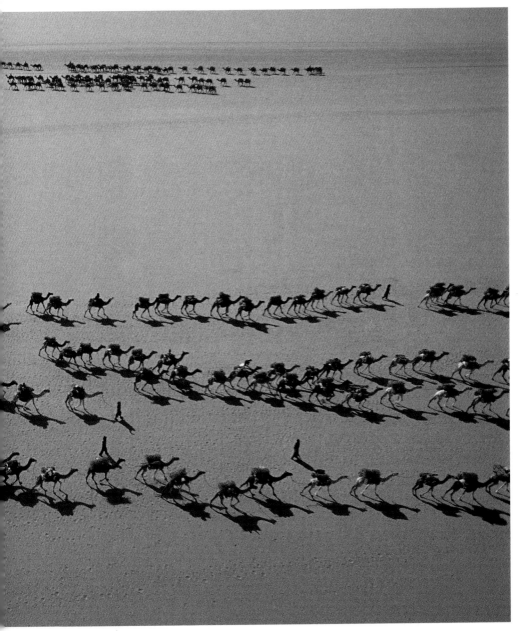

GEORGE STEINMETZ | 1999 | NIGER *Salt caravans crossing the Sahara*

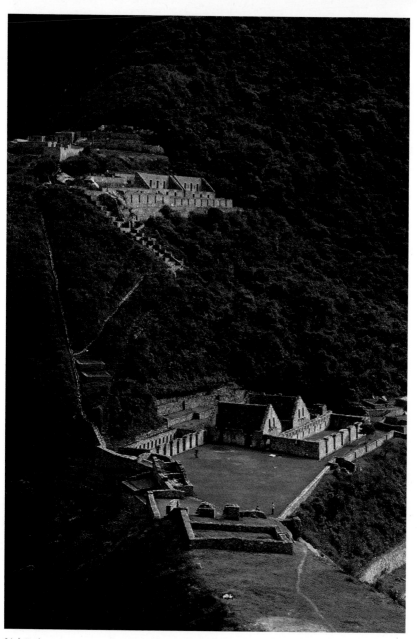

GORDON WILTSIE | 2004 | PERU *An Inca ceremonial center*

GORDON WILTSIE | 2004 | PERU *Crossing the rugged Vilcabamba Range*

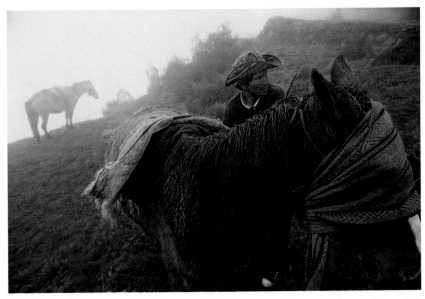

GORDON WILTSIE | 2004 | PERU *Blindfolding a nervous packhorse*

"You think you understand the Earth and its geology," says daredevil photographer Carsten Peter, "but once you look down into a volcanic crater and see what's there, well, you realize we will never understand. It is that powerful."

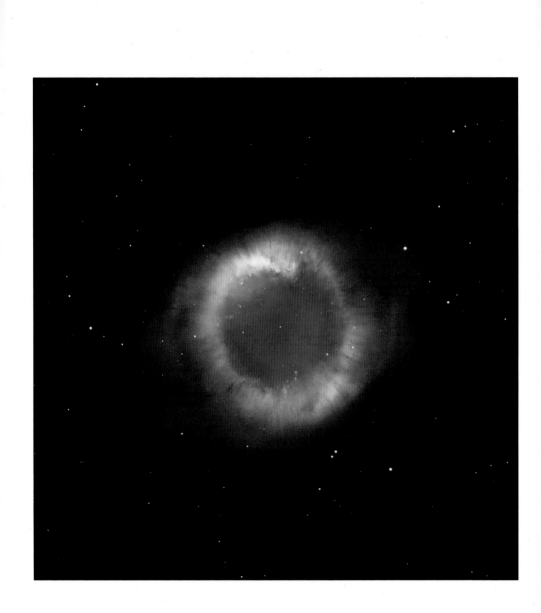

NASA | 2003 | MILKY WAY GALAXY *The Helix Nebula*

NASA | 2008 | MARS *A Martian sunset*

BORGE OUSLAND I 2009 I ARCTIC OCEAN *On thin ice*

MAYNARD OWEN WILLIAMS | 1931 | AFGHANISTAN *In a Herat warehouse*

citroën-haardt expedition

THE GEOGRAPHIC'S MAYNARD OWEN WILLIAMS would always remember them as the "greatest adventure" of his life, those months in 1931-32 when he accompanied the French-sponsored Citroën-Haardt Expedition—via half-track, pony, camel, and yak—from Beirut all the colorful, spectacular, meandering, 7,000-mile way to Beijing.

MAYNARD OWEN WILLIAMS | 1931 | AFGHANISTAN *The Great Buddha at Bamian*

MAYNARD OWEN WILLIAMS | 1931 | IRAN *Schoolgirls of Persia*

MAYNARD OWEN WILLIAMS | 1931 | AFGHANISTAN
In an Afghan bazaar

MAYNARD OWEN WILLIAMS | 1931 | IRAQ *Expeditionary dash and élan*

WILDLIFE

DOCUMENTARY REALISM 164 THE DIGITAL RANGE 188

AT FIRST, IF THEY WERE NOT CARCASSES, they were probably caged. Wild animals, a century and more ago, were exceedingly difficult to photograph in their natural environments. It was easier to set the heavy camera on a tripod and, one plate at a time, record the trophies of the hunt than to undertake a painstaking stalk and, limbs aquiver, try steadily lifting it—only to hear, with a crash of brush or whir of wings, the quarry as it fled. Little wonder that one early practitioner called wildlife photography an "occasion of lost chances."

Yet in few branches of photography have advances in equipment and technique been so mirrored by the increasing artistry of the results. As early as 1906 *National Geographic* magazine printed 74 pictures of nocturnal animals illuminated by flash, and in the years since that pivotal issue the Society has actively promoted one breakthrough in wildlife photography after another. The advantages provided by faster films, portable cameras, or digital technology have all been extended—especially in the making of underwater pictures—by ingenious adaptations devised by the Geographic's photographers and technicians. The result is today's superb collection of images representing creatures at every scale from the tiniest insect to the largest whale.

Over the decades, the striking quality of these images, their increasing realism and drama, has stimulated popular interest in wildlife at a time when concern about its conservation has steadily mounted. These images not only portray the inherent grace and beauty of animals; they also depict behavior and attest to the presence of entire ecosystems. Since many people believe that this is what National Geographic does best, today we work with some of the finest wildlife photographers on the planet. If anything, they work even harder than did their forebears, who overcame so many challenges to make the black-and-white record of what once was and is now gone. They have to work harder, for their mission, every excruciating hour they spend at it, is never to lose another chance of capturing, with consummate artistry, what still remains.

the early photographs

THEY WERE HAMPERED BY clumsy equipment and technique, but if their cameras could not always capture living animals, there were always the slain ones on which photographers might focus. Yet the resulting images still have the power to evoke an era of abundant wildlife, while also recording the beginning of its end.

CARL ETHAN AKELEY **|** 1909 **|** EAST AFRICA *Death in the short grass*

UNDERWOOD AND UNDERWOOD I 1909 I EAST AFRICA *Woman and antelope*

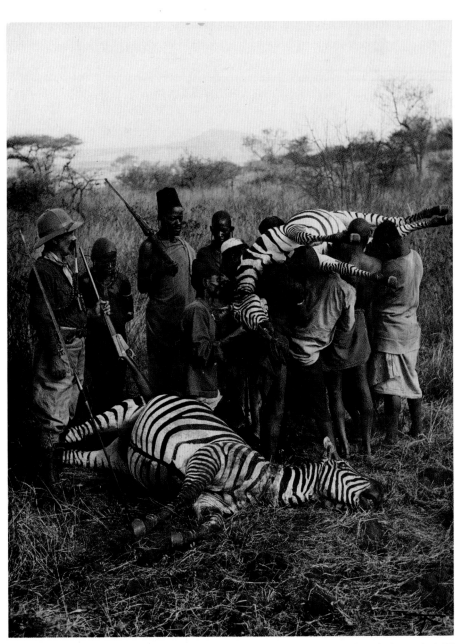

UNDERWOOD AND UNDERWOOD | 1909 | **EAST AFRICA** *Men and zebras*

As early as 1910, Theodore Roosevelt had observed that the ivory of the African elephant was already "of such great value as well nigh to bring about the mighty beast's utter extermination."

N. A. COBB | 1910 | LOCATION UNKNOWN *Face of a fly*

OTHO WEBB | **1930** | **AUSTRALIA** *Riding a sea turtle*

F. E. KLEINSCHMIDT | 1914 | ALASKA *Polar bear and cub*

W. H. LONGLEY AND CHARLES MARTIN **|** 1926 **|** FLORIDA
A hogfish—one of the first undersea color photographs

NIALL RANKIN | 1936 | LOCATION UNKNOWN *Gannet preparing to land* The Early Photographs | 135

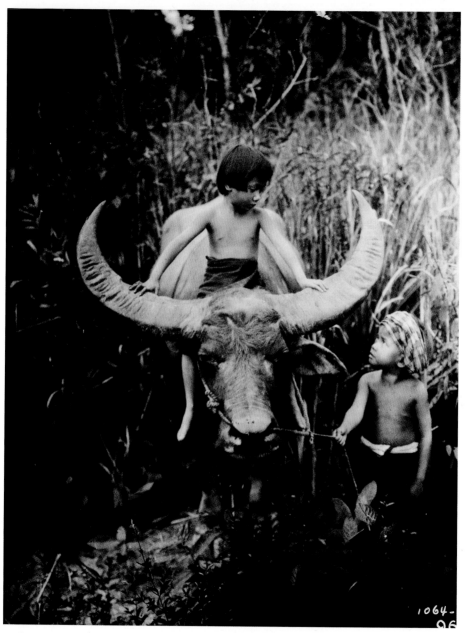

1064-96

ERNEST B. SCHOEDSACK | 1927 | SIAM *Asian water buffalo*

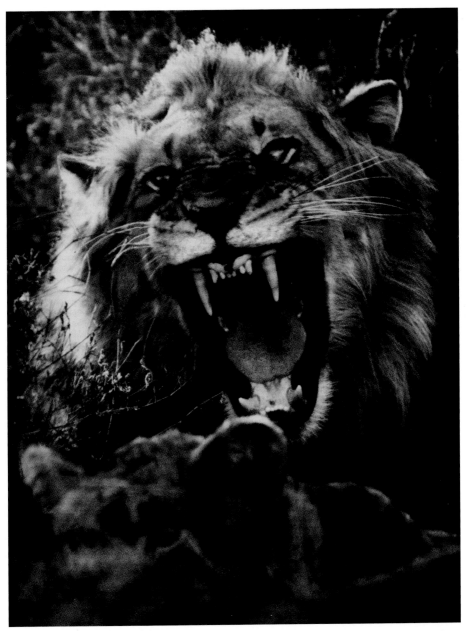

DICK WOLF | 1941 | SOUTH AFRICA *African lion* The Early Photographs

J. BAYLOR ROBERTS | 1939 | SINGAPORE *Tiger and leopard skins on display*

A former Indian maharajah, reported
John and Frank Craighead, "had as
many as thirty cheetahs at one time.
His favorite ones he kept with him in
his palace, just as we keep dogs."

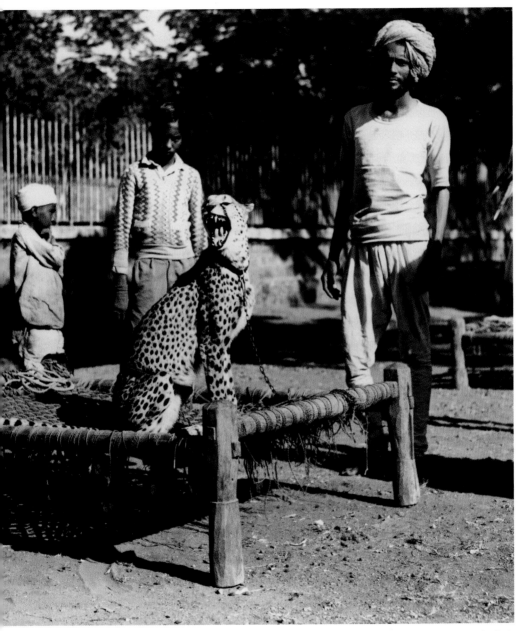

JOHN AND FRANK CRAIGHEAD **|** 1941 **|** INDIA *A maharajah's hunting cheetah*

color & optimism

WITH THE ADVENT OF PORTABLE CAMERAS and fast color film, photographers were freed of former burdens and restrictions. Yet wildlife was depicted as it might be in museum dioramas, with their typical settings and painted backgrounds. Nature was seen as one vast zoo, each species placed comfortably, and colorfully, in its niche.

LUIS MARDEN | 1952 | FLORIDA *Caged man and free-swimming dolphins at Marineland*

B. ANTHONY STEWART | 1953 | CHICAGO *People and bears eyeing each other at the zoo*

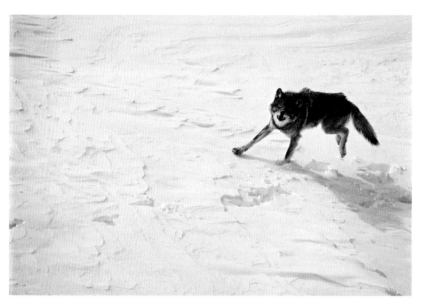

DR. DURWARD L. ALLEN | 1962 | MICHIGAN *Gray wolf on Isle Royale*

STEPHANIE DINKINS | 1963 | SIKKIM *Spotted deer in the Himalaya*

B. ANTHONY STEWART | 1957 | WEST INDIES *Sleeping flamingos*

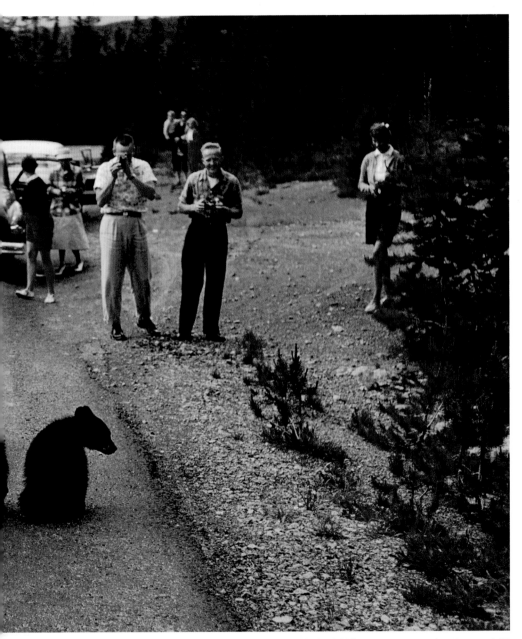

ANDREW H. BROWN | 1950S | WYOMING *People and bears eyeing each other in Yellowstone*

FRANK KAZUKAITIS | 1963 | ANTARCTICA *Youth and age among emperor penguins*

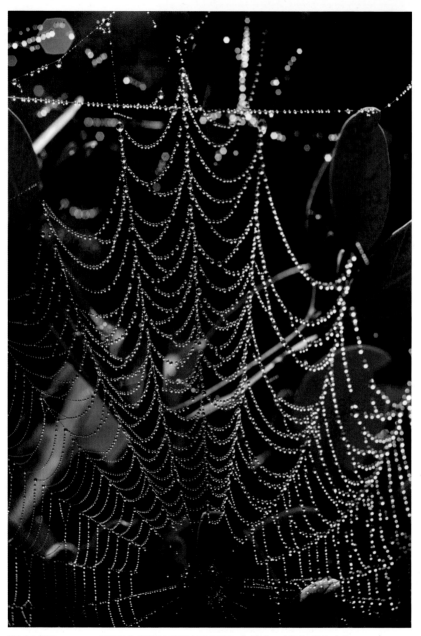

JAMES A. KERN | 1967 | FLORIDA *Spider's web in the Everglades*

TREAT DAVIDSON | 1963 | FLORIDA *Tree snail in the Everglades*

DAVID O. LAVALLEE | 1966 | ANTARCTICA *Weddell seals on a balmy day*

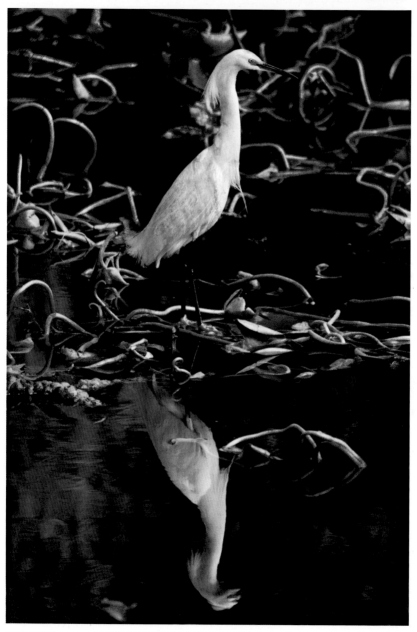

FREDERICK KENT TRUSLOW | 1967 | FLORIDA *Snowy egret in the Everglades*

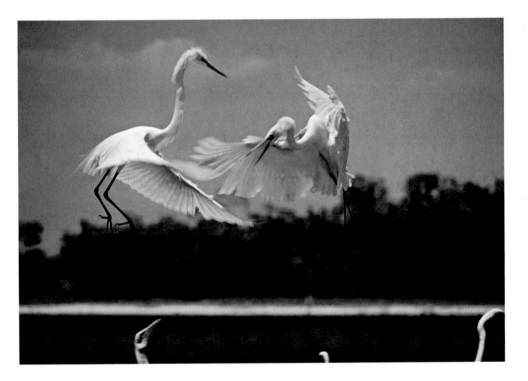

FREDERICK KENT TRUSLOW | 1967 | FLORIDA *American egrets in the Everglades*

"They must have seemed strange creatures indeed to the early explorers," naturalist Cynthia Moss once observed of ungainly looking wildebeests. Yet their vast, migrating herds offer one of the most remarkable sights on the African grasslands.

BRUCE DALE | 1969 | KENYA *Wildebeests thundering across the savanna*

GIANNI TORTOLI | 1969 | ETHIOPIA *Locusts feeding*

GIANNI TORTOLI **|** 1969 **|** ETHIOPIA *Locusts swarming*

documentary realism

BY THE 1970S A MORE ECOLOGICALLY AWARE breed of wildlife photographer had emerged, a subspecies of photojournalist emphasizing nature as it actually appeared, a realm where wonder and repugnance, beauty and danger were often commingled. Gone is the staginess, replaced by creative angles, sharp lenses, and a painstakingly patient approach.

PAUL ZAHL | 1973 | COSTA RICA *Tadpoles' coiled intestines revealed by transparent skin*

ROBERT F. SISSON | 1971 | FLORIDA *Mating octopuses*

BATES LITTLEHALES **|** 1972 **|** PACIFIC OCEAN *Solitary garibaldi*

JAMES L. STANFIELD | 1975 | UNITED STATES *Portrait of a rat*

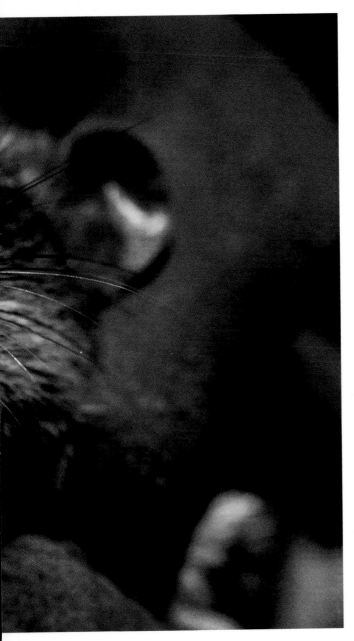

"Gnaw or die," states this picture's original caption. "Fast-growing teeth require perpetual gnashing." Without such incessant grinding, this rat's upper teeth might curl back into the roof of its mouth.

DWIGHT R. KUHN **I** 1984 **I** MAINE *Mantis devouring a grasshopper*

MATTIAS KLUM | 1985 | BORNEO *Green whipsnake*

DARLYNE A. MURAWSKI | 1994 | MEXICO *Sphinx moth caterpillar*

Documentary Realism | 173

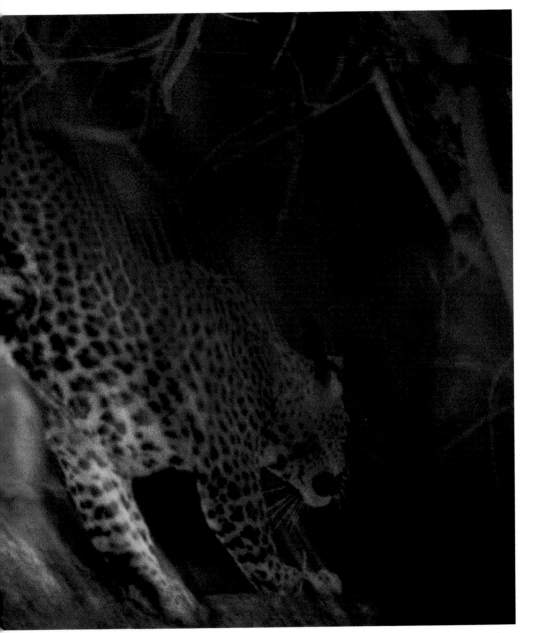

CHRIS JOHNS **|** 1988 **|** TANZANIA *A leopard slipping away*

BIANCA LAVIES | 1982 | FLORIDA *Leaping armadillo*

FRANS LANTING | 1982 | MADAGASCAR *Leaping lemur*

According to Rudyard Kipling, "it is the hardest thing in the world to frighten a mongoose." The Old World snake charmer has become an introduced New World pest, ravaging, for instance, Hawaii's indigenous wildlife.

CHRIS JOHNS | 1993 | HAWAII *An introduced mongoose devouring a nene, Hawaii's state bird* Documentary Realism | 179

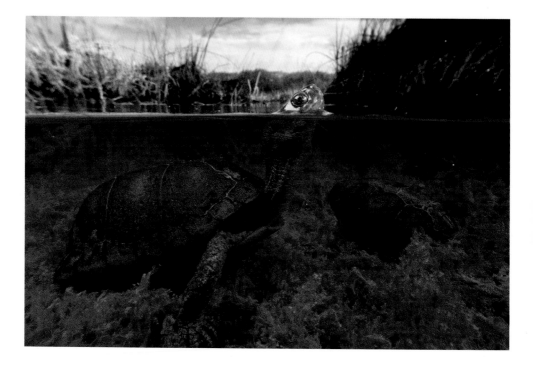

GEORGE GRALL | 1995 | MEXICO *A Coahuilan box turtle taking a peek around*

JOEL SARTORE | 1995 | NEBRASKA *Dusting the sheep diorama in a sporting goods shop*

CHRIS JOHNS | 1995 | SOUTH AFRICA *White rhino in a protective pen*

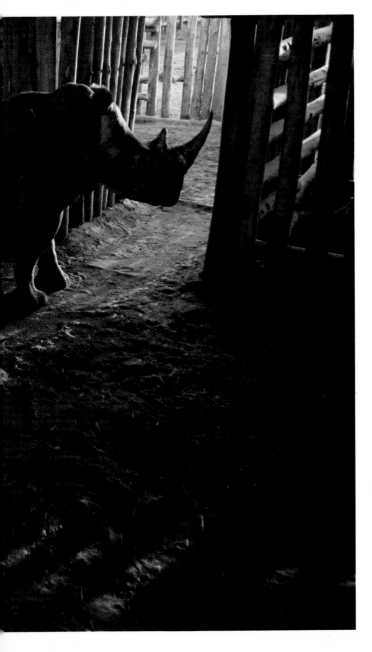

"They are not brethren, they are not underlings," wrote naturalist Henry Beston of animals, "they are other nations, caught with ourselves in the net of life and time, fellow prisoners of the splendor and travail of earth."

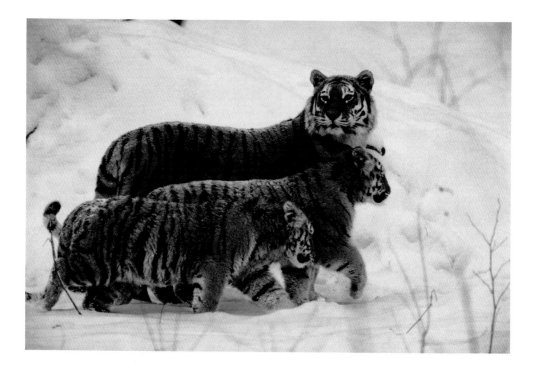

MICHAEL NICHOLS | 1995 | RUSSIA *Siberian tiger and cubs*

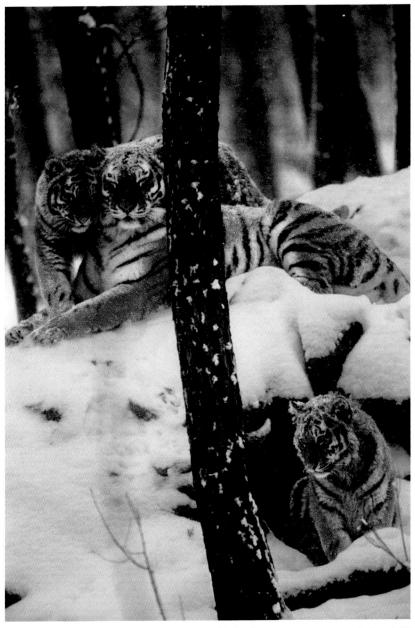

MICHAEL NICHOLS | 1995 | RUSSIA *Endangered Siberian tigers*
Documentary Realism | 185

JOEL SARTORE | 1997 | MINNESOTA *Captive wolf, snapped by a remotely triggered camera*

the digital range

WITH EQUIPMENT TO MATCH THEIR CREATIVE EYE, today's photogra-
phers are better able to record images, even in the most marginal light,
with an unprecedented fidelity and exactitude. As a result, they have
been depicting wildlife ever more dynamically, imaginatively, persis-
tently, and persuasively.

THOMAS T. STRUHSAKER | 1998 | AFRICA *Endangered red colobus monkeys*

BILL CURTSINGER | 2003 | ALASKA *Starfish bathed in a toxic tide*

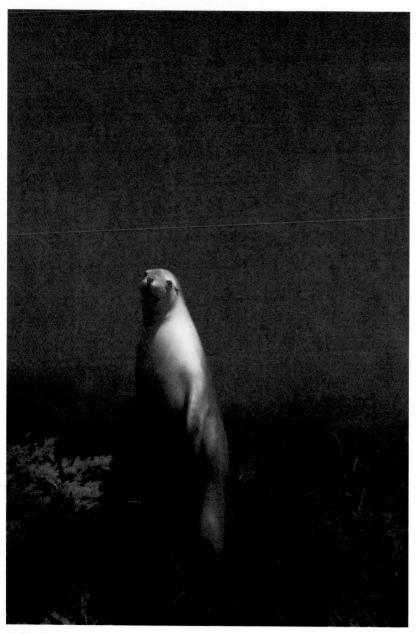

DAVID DOUBILET | 2000 | SOUTH AUSTRALIA *Australian sea lion*

BILL CURTSINGER | 1999 | ANTARCTICA *Emperor penguin*

FLIP NICKLIN | 1998 | CANADA *Polar bear*

MICHAEL NICHOLS | 2001 | REPUBLIC OF THE CONGO *Rehabilitating orphaned gorillas*

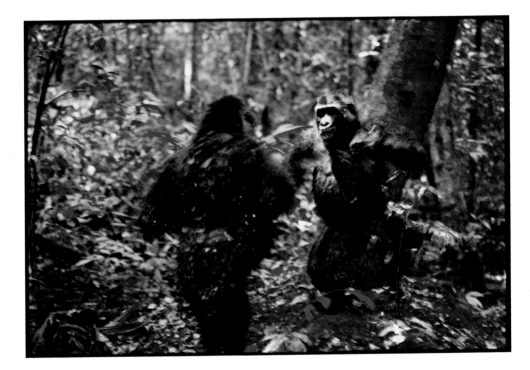

MICHAEL NICHOLS | 2001 | REPUBLIC OF THE CONGO *Young males sparring for dominance*

MATTIAS KLUM | 2003 | PANAMA *Kinkajou with a balsa blossom*

TIM LAMAN | 2002 | BORNEO *Proboscis monkey and her baby*

BRUCE H. ROBISON | 2004 | CALIFORNIA *Fanfin anglerfish*

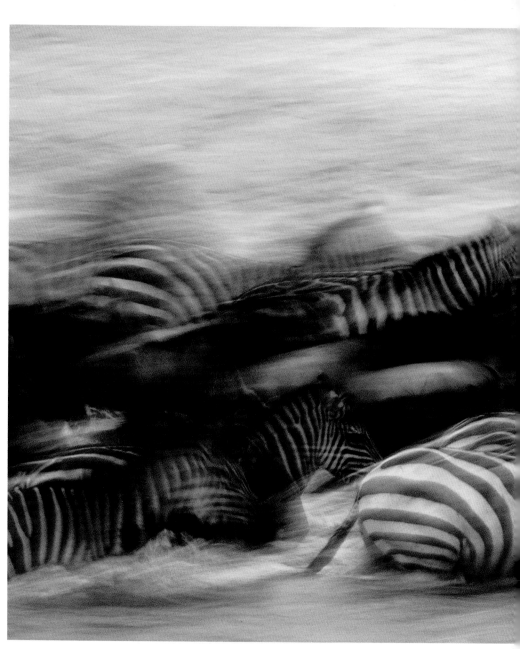

ANUP AND MANOJ SHAH | 2003 | KENYA *Zebras fording a crocodile-filled river*

"With zebras," photographer Anup Shah observes, "you just point the camera at the fantastic view." Fantastic, spectacular—and poignant, as the graceful animals are a favorite prey of some of Africa's most feared carnivores.

RANDY OLSON | 2007 | PAKISTAN *Decoying herons the Indus River way*

FRANS LANTING | 2007 | ZAMBIA *Carmine bee-eaters in breeding plumage*

PAUL NICKLEN | 2006 | CANADA *Walrus*

When dusk fell on the Himalaya, writer Doug Chadwick could easily imagine a snow leopard coming down the slopes: "It flows low to the ground, with huge gold eyes and a coat the color of dappled moonlight on frost."

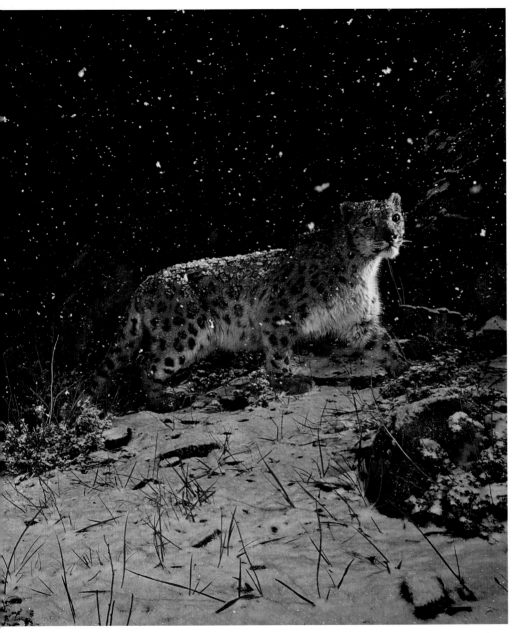

STEVE WINTER | 2008 | INDIA *Snow leopard snapped by a remote camera*

JOEL SARTORE | 2009 | ALASKA *Polar bear in an Arctic twilight*

GILBERT M. GROSVENOR | 1966 | CEYLON *A mahout brushing his elephant's teeth*

elephants up close

ONCE, IF YOU WERE CLOSE ENOUGH to see the yellow of their eyes, you were probably too close, as many a hunter discovered only too late. Today, however, some of our best photographers have been bringing us ever nearer to wild elephants, gradually unmasking one of Earth's most fascinating, as well as formidable, inhabitants.

JOHN BURCHAM | 2006 | NEW YORK *Genuine skin—but a glass eye—on a museum model*

DAVID DOUBILET | 2004 | BOTSWANA *Elephant seen from under water*

PEOPLE &

CULTURE

NESTLED DEEP IN THE SOCIETY'S VAULTS is a small case, the size of a cigar box, its plain red-brown cover embossed with Cyrillic characters. Open it—carefully—and inside are 50 stiff-backed black-and-white photographs of Lhasa, which in 1904, when that case arrived at National Geographic headquarters, gift of the Imperial Russian Geographical Society, ranked among the most mysterious cities in the world. Otherwise unremarkable today, these now-fading pictures of the once legendary capital of Tibet were perhaps the first ever captured on film. So when a selection of them was printed in the January 1905 *National Geographic*, the Society's membership surged as people flocked to join an organization that could provide them with photographs from the far corners of the globe.

Thus began the deliberate pursuit of pictorial exoticism that issued in the long procession of painted and plumed, costumed and turbaned humanity that once paraded through the magazine's pages. Postcard views of faraway cities and portraits of "genuine natives" were assiduously collected from every conceivable source, some purchased in bulk from overseas whereas others were dispatched by an assortment of journalists, diplomats, professors, military men, and wealthy vagabonds who lived, worked, or traveled abroad. Exquisite glass-plate Autochromes arrived by the trunkful from a roaming corps of itinerant professional cameramen.

"Humanized geography," this depiction of the world through its peoples and cultures was called, and on its foundations successive generations of versatile staff and freelance photographers have amassed one of the richest collections in the Society's archives. Though exoticism has long given way to photojournalism, this collection remains a kind of time capsule enshrining the world as it has evolved over the past century and more.

the early photographs

ALTHOUGH THEIR CAMERAS MAY HAVE BEEN HEAVIER, their tripods bulkier, their trunks of glass-plate negatives more burdensome, photographers of the first quarter of the 20th century had one great advantage over those of subsequent generations: The world was still a bigger place, and people wore their cultural distinctiveness quite literally on their sleeves.

Street Scene

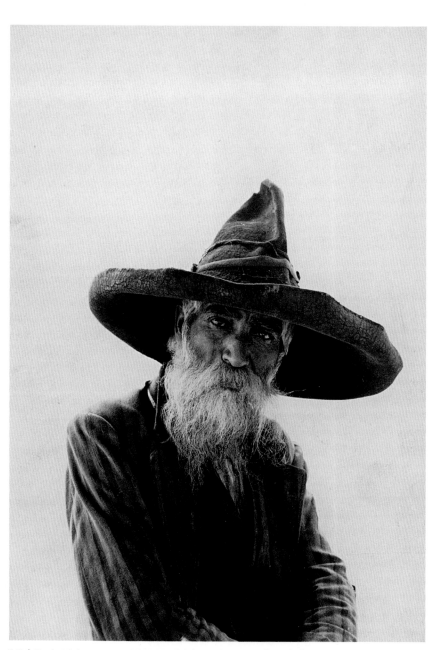

HUGO BREHME | 1916 | MEXICO *Portrait of a peasant*

COLBY M. CHESTER | DATE UNKNOWN | PALESTINE *Armenian patriarch of Jerusalem*

The Japanese tea
ceremony so impressed
Eliza Scidmore that, having
once participated in it, she
felt as if she had "slipped
out of our century, and
almost out of our planet."

ELIZA R. SCIDMORE | 1918 | JAPAN *Tea ceremony*

LEHNERT & LANDROCK | 1914 | TUNISIA *A school in the desert*

H. T. COWLING | DATE UNKNOWN | SIAM *A Siamese woman*

BARON WILHELM VON GLOEDEN | 1903 | ITALY *A Sicilian girl*

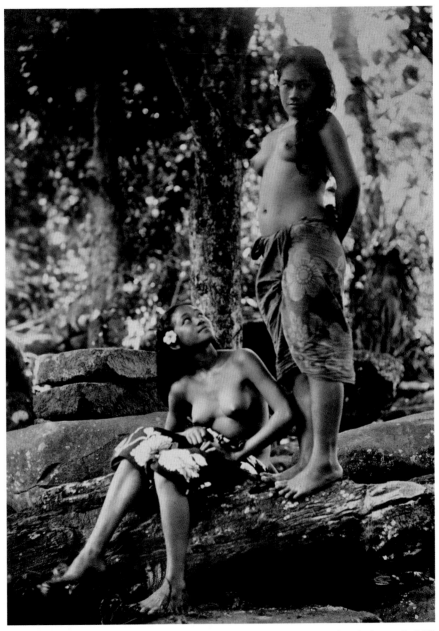

J. W. CHURCH | 1918 | FRENCH POLYNESIA *In the Marquesas Islands*

N. J. CLAIRE | DATE UNKNOWN | AUSTRALIA *Fern track in the mountains*

WILLIAM REID | 1921 | SCOTLAND *"Burning the hoof" before shoeing it*

PALACE IN THE LAKE. OODEYPOOR. 2277.

BOURNE AND SHEPHERD **|** 1877 **|** INDIA *Palace in Lake Udaipur*

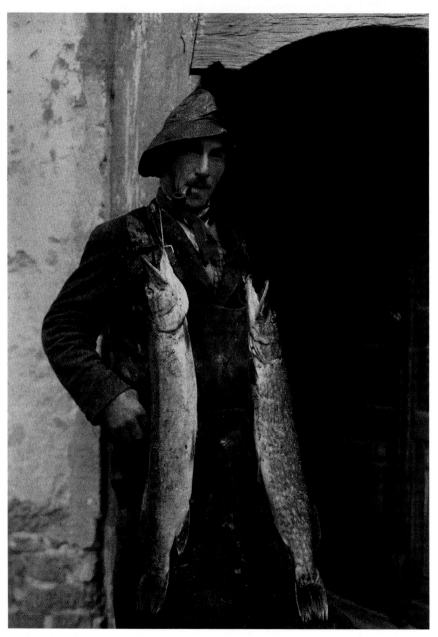

HANS HILDENBRAND | 1932 | SWITZERLAND *Fisherman and pike*

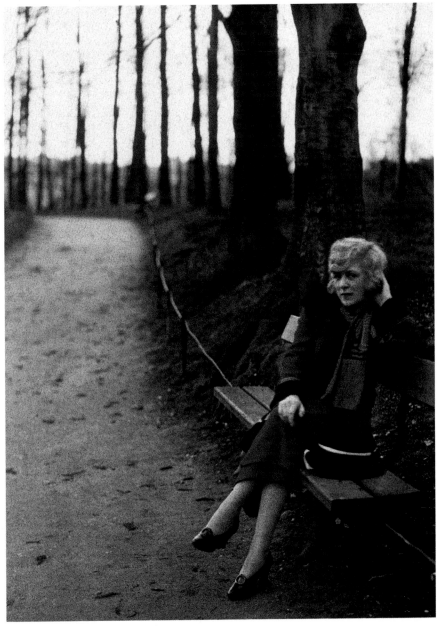

MAYNARD OWEN WILLIAMS | DATE UNKNOWN | FRANCE *Evening in Lyons*

JOSEPH F. ROCK | 1928 | CHINA *Tibetan devil dancers*

VALERIANO SALAS | 1934 | CHAD *Celebration of the Hyondo sorcerers*

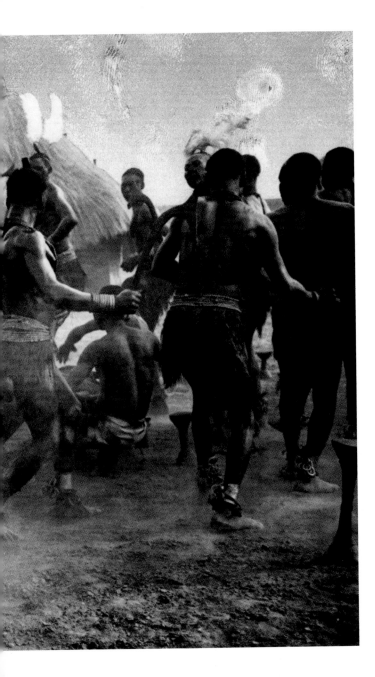

Having completed a grueling initiation in the bush, Hyondo postulants of the Sara tribe hang their shaggy garments on trees and, according to one authority, "give themselves up to hilarious rejoicings."

WILLIAM M. RITTASE | 1936 | ILLINOIS *The fall of light, Chicago*

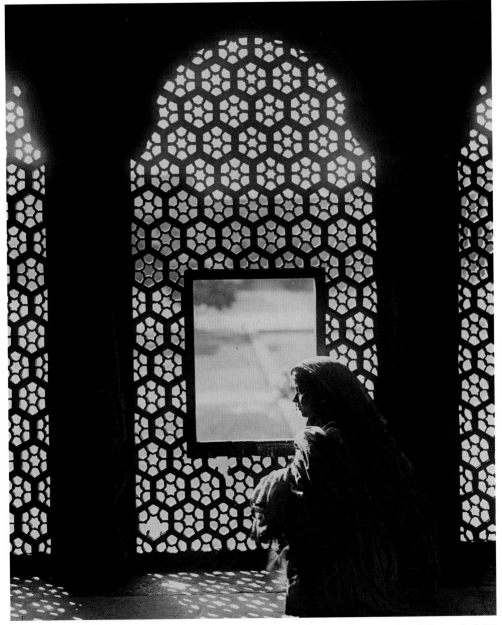

INDIAN STATE RAILWAYS | 1936 | INDIA *The fall of light, Agra*

U.S. ARMY AIR FORCES | 1945 | PACIFIC OCEAN *Final moments of a Japanese destroyer*

JOSEPH F. ROCK | 1925 | CHINA *One-twelfth of the printing blocks needed to print the Tibetan Buddhist Bible*

ESTHER BUBLEY | 1949 | U.S.A. *An interminable wait*

color & optimism

THE 35MM CAMERA CHARGED with Kodachrome film was the combination that, starting in the late 1930s, provided National Geographic its primary lens on the world—a world made sunnier thereby, somehow more innocent, the men more handsome, the women more beautiful, the smiles brighter, and the hats and sweaters and scarves rendered a deeper, more vivid red.

B. ANTHONY STEWART | 1950S | NEW YORK *Summer at Jones Beach State Park*

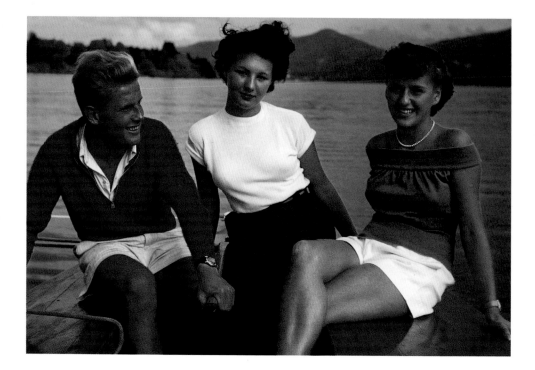

VOLKMAR WENTZEL | 1951 | AUSTRIA *On the Wörthersee*

JAMES P. BLAIR | 1963 | ARIZONA *Where even the grass is gravel*

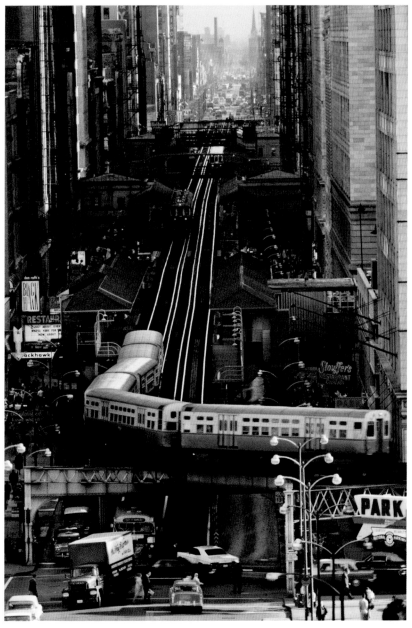

JAMES L. STANFIELD | 1967 | ILLINOIS *The Chicago Loop* Color & Optimism | 277

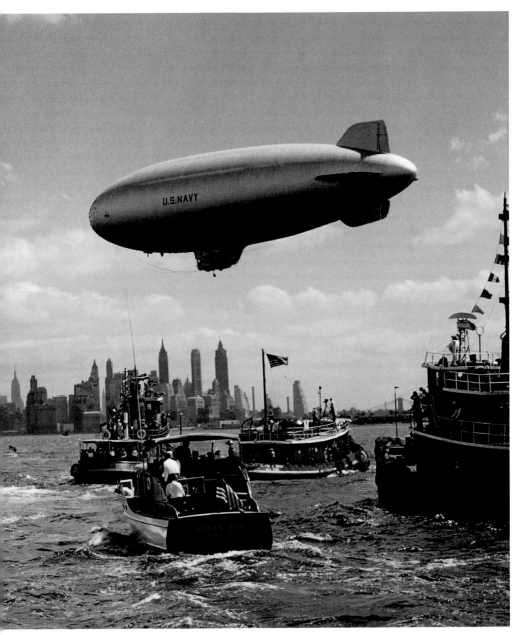

B. ANTHONY STEWART **|** 1950S **|** NEW YORK Mayflower II *entering New York Harbor*

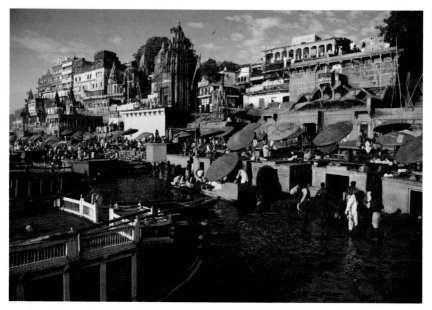

JOHN SCOFIELD | 1963 | INDIA *Mother Ganges*

JOHN SCOFIELD | 1963 | INDIA *Building a dam the old-fashioned way*

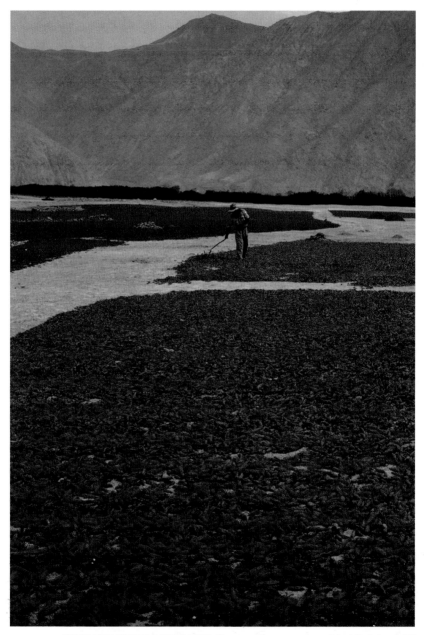

BATES LITTLEHALES | 1964 | PERU *Peppers on the cure* Color & Optimism | 281

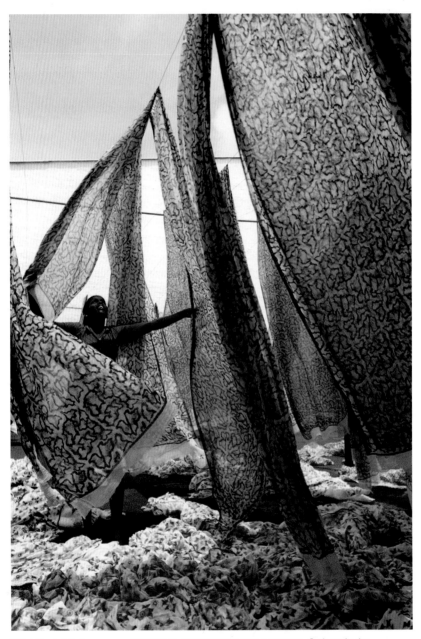

GILBERT M. GROSVENOR | 1966 | CEYLON *Saris on the dry*

WILLIAM ALBERT ALLARD | 1967 | COOK ISLANDS *Missed the band and late for church*

documentary realism

WITH THE EMERGENCE OF FULLY FLEDGED photojournalism at National Geographic, photographers returned to the streets intent on picturing the world from a different angle. Their sometimes unsparing, sometimes playful, deliberately ironic engagement with the life that people actually lived often resulted in images imbued with a gritty, unvarnished, you-are-there realism.

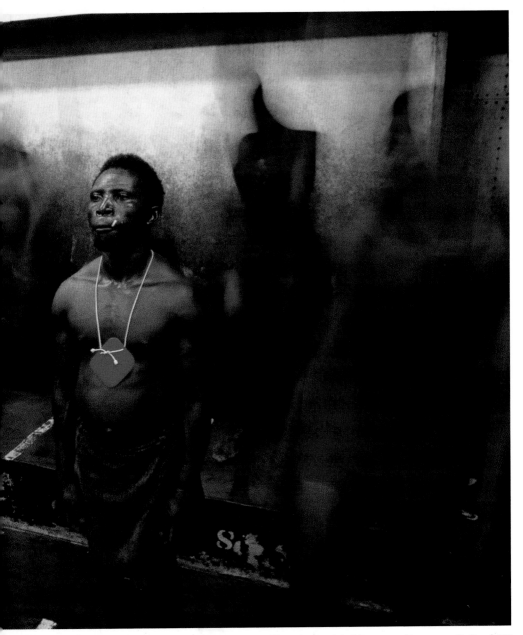

JAMES L. STANFIELD | 1974 | SOUTH AFRICA *Diamond miners in training* Documentary Realism | 289

ALBERT MOLDVAY | 1971 | HUNGARY *Shepherds and sheep*

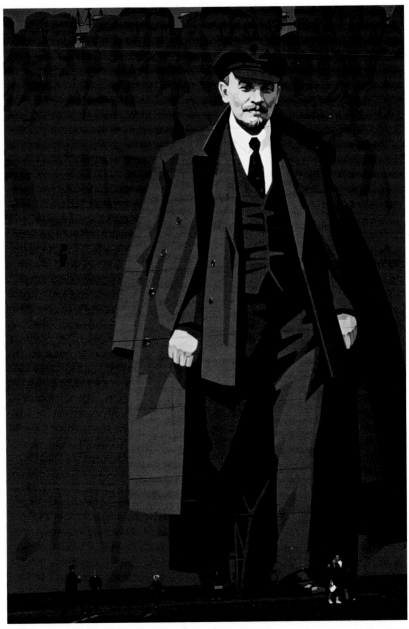

DICK DURRANCE II | 1971 | RUSSIA *Workers' paradise*

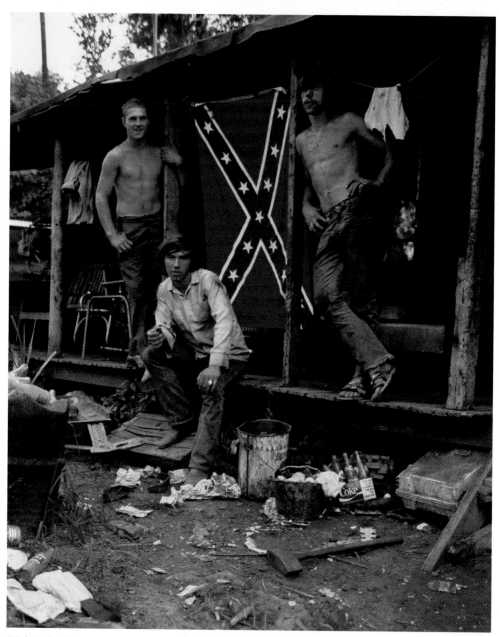

BRUCE DALE I **1973** I KENTUCKY *Mechanics taking a break*

SAM ABELL | 1974 | CANADA *Off the Newfoundland coast*

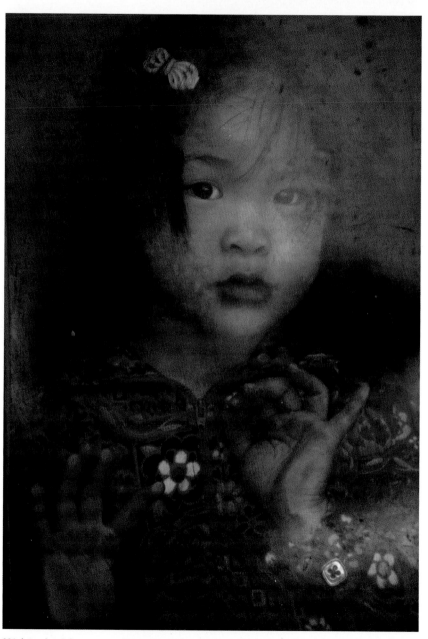

WILLIAM ALBERT ALLARD | 1975 | CALIFORNIA *Chinatown beauty*

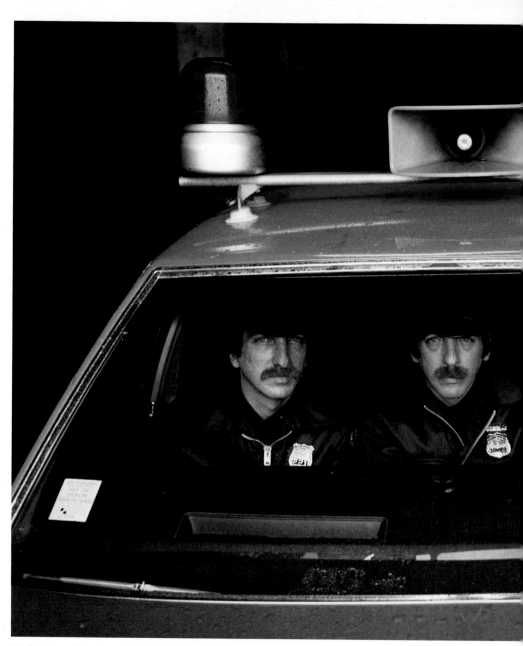

MICHAEL YAMASHITA | 1981 | NEW JERSEY *A trio of triplet policemen*

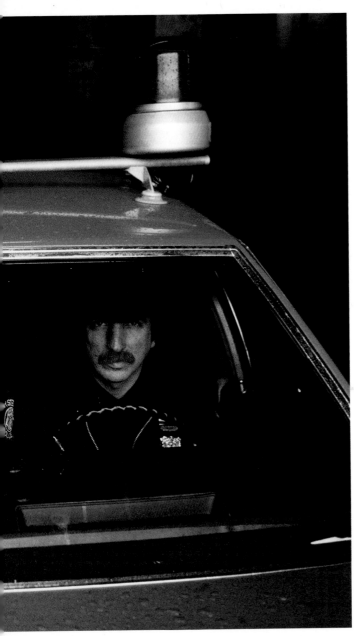

For William Carlos Williams, poet laureate of Paterson, New Jersey, "a man in himself is a city, beginning, seeking, achieving and concluding his life in ways which the various aspects of a city may embody."

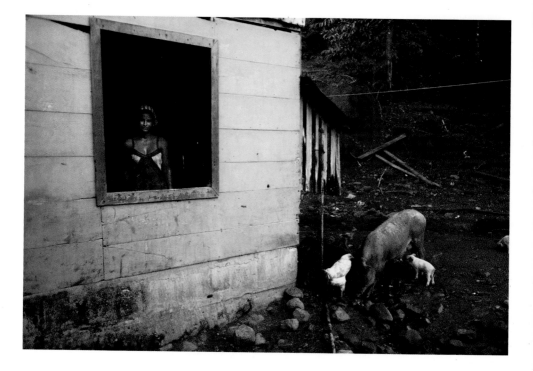

WILLIAM ALBERT ALLARD | 1981 | COSTA RICA *A hardscrabble life*

DAVID ALAN HARVEY | 1981 | CAMBODIA
Kids become killers: Pol Pot and Khmer Rouge executioners

NICHOLAS DEVORE III | 1981 | COSTA RICA *Planting potatoes*

JAMES L. STANFIELD | 1983 | ROMANIA *A mural of the fall of Constantinople*

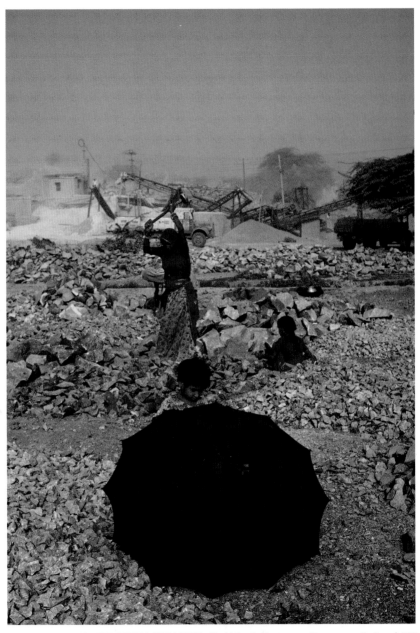

RAGHUBIR SINGH **|** 1985 **|** INDIA *The Untouchables* Documentary Realism **|** 303

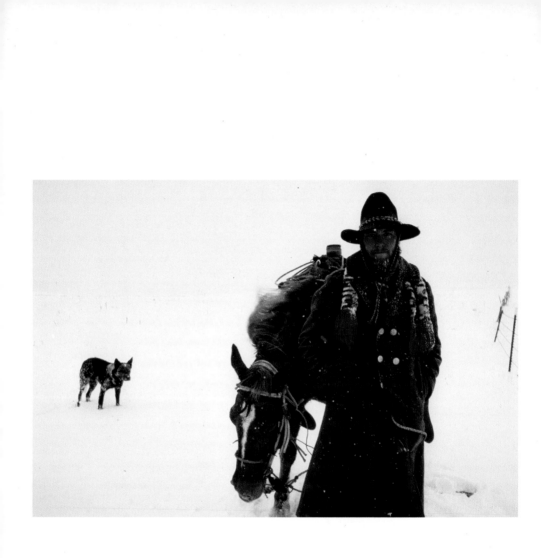

SAM ABELL | 1984 | MONTANA *Portrait of a horse wrangler*

FATHER DON DOLL | 1984 | ALASKA *Have house, will travel*

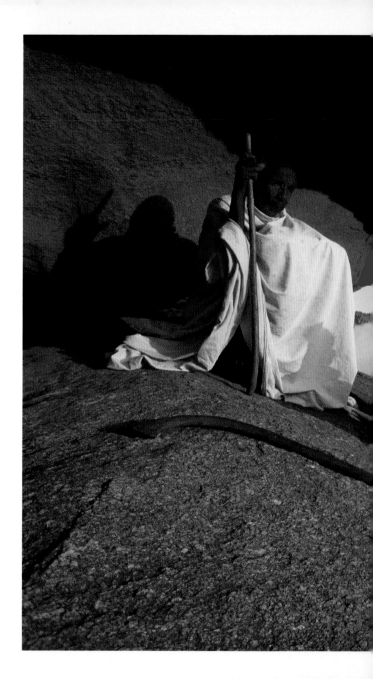

The contribution of elders to societies worldwide lies ultimately in how they practice "the art of being," according to anthropologist Colin Turnbull. "No special skill or training is needed; their age is their qualification."

ROBERT CAPUTO | 1996 | ERITREA *Village elders at sunset*

MICHAEL COYNE | 1983 | IRAN *Casualties of war*

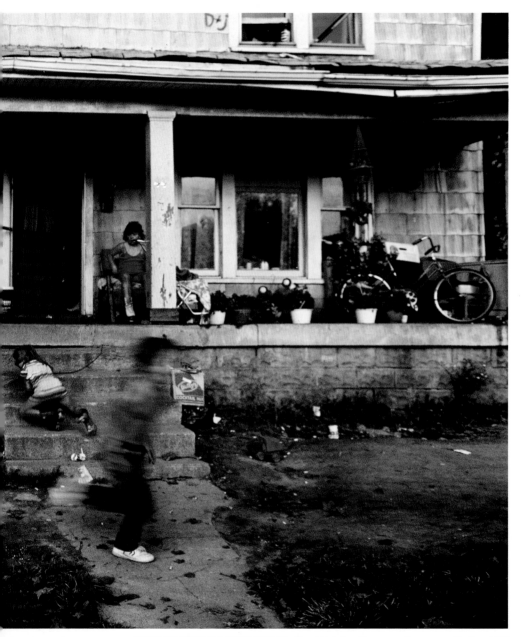

SANDY FELSENTHAL | 1987 | INDIANA *Sweet bird of youth*

MICHAEL O'BRIEN | 1988 | AUSTRALIA *Portrait of the butcher as a young man*

MICHAEL O'BRIEN | 1988 | AUSTRALIA *Lawn bowlers*

O. LOUIS MAZZATENTA | 1982 | PARAGUAY *Erecting the Itaipú Dam*

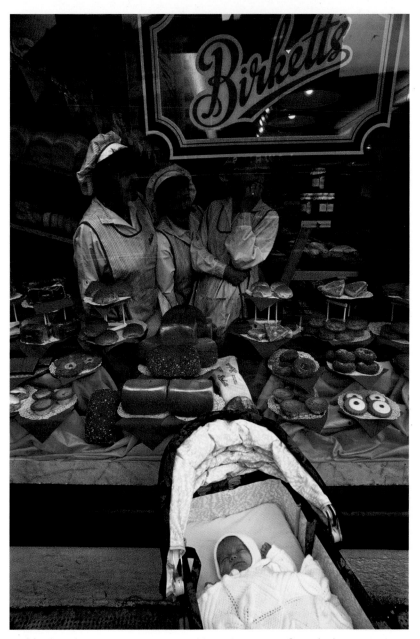

JIM RICHARDSON | 1996 | SCOTLAND *Sweets for the sweet*

GERD LUDWIG | 1996 | GERMANY *Strange bedfellows*

the digital range

WHETHER CAPTURED ON FILM OR ELECTRONIC SENSOR, the images that today's photographers are creating of people worldwide have a unique punch and vibrancy about them. That is only partially due to a technology allowing pictures to be made in a wider variety of situations than ever before. The shutter, after all, still responds primarily to the touch of a human hand.

MIKE HETTWER | 2008 | NIGER *Wodaabe men preening for the ladies*

At festivals, Wodaabe men promenade before admiring women who scrutinize their every move. According to anthropologists Carol Beckwith and Angela Fisher, "a man who can hold one eye still and roll the other is considered particularly alluring..."

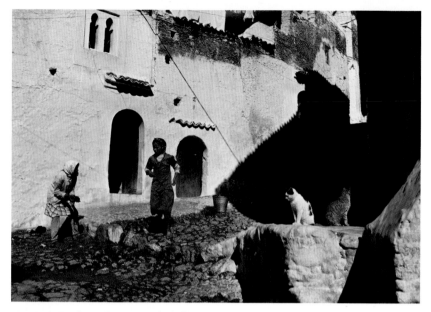

BRUNO BARBEY | 1998 | MOROCCO *In the Rif Mountains*

REZA | 1999 | KAZAKHSTAN *On the shores of the Caspian*

ROBB KENDRICK | 2007 | UTAH *A modern tintype of an old-fashioned cowboy*

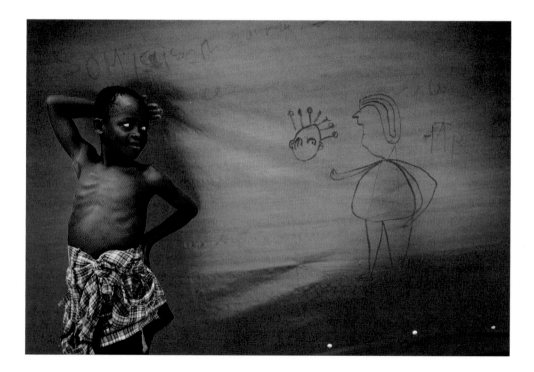

KAREN KASMAUSKI | 1998 | UNKNOWN LOCATION *Study in blue*

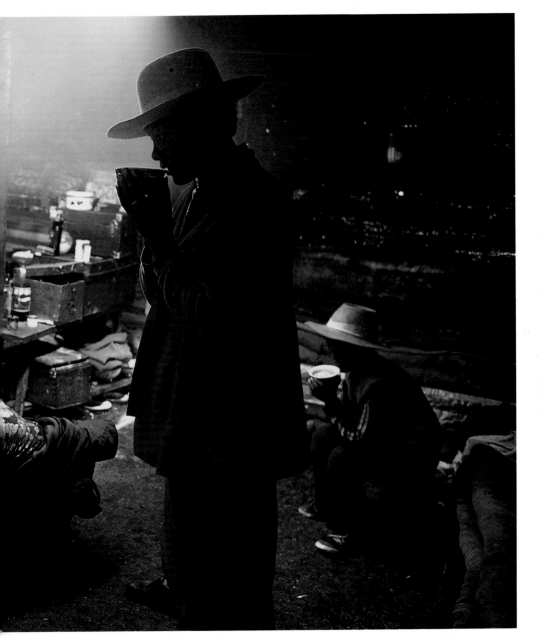

STEVE McCURRY | 2002 | TIBET *Warm soup and yak-dung fire*

SANDY FELSENTHAL | 2001 | MAINE *Home is the sailor*

TOMASZ TOMASZEWSKI | 2001 | EASTERN EUROPE
A reminiscing gypsy and his non-gypsy wife

According to Nagasaki-
born novelist Kazuo
Ishiguro, "All children
have to be deceived
if they are to grow up
without trauma."

LYNN JOHNSON | 2002 | RUSSIA *Teaching second graders how to prepare for a chemical attack*

KAREN KASMAUSKI | 2002 | JAPAN *In a Tokyo bathhouse*

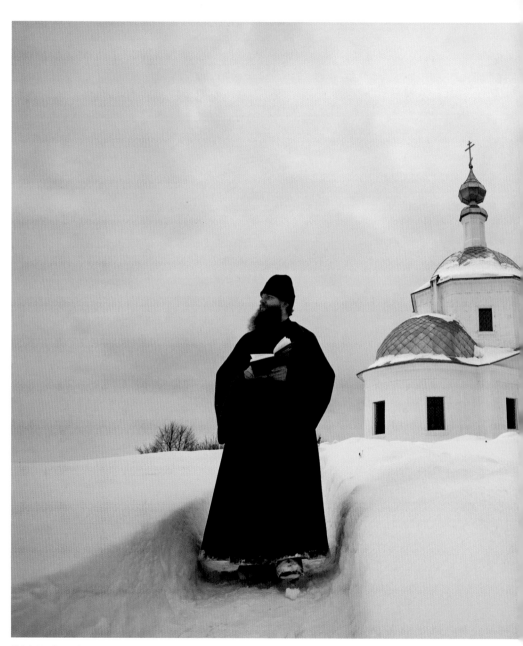

GERD LUDWIG | 2009 | RUSSIA *An Orthodox priest on a meditative stroll*

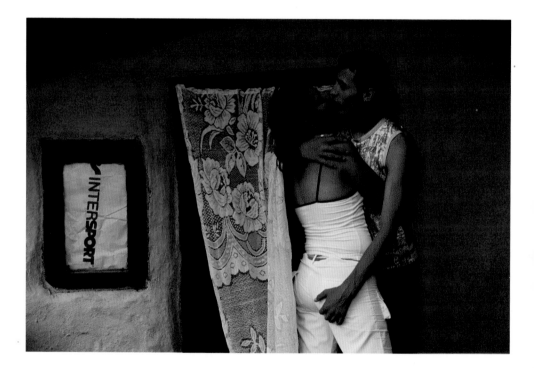

TOMASZ TOMASZEWSKI | 2005 | ROMANIA *Brief encounter*

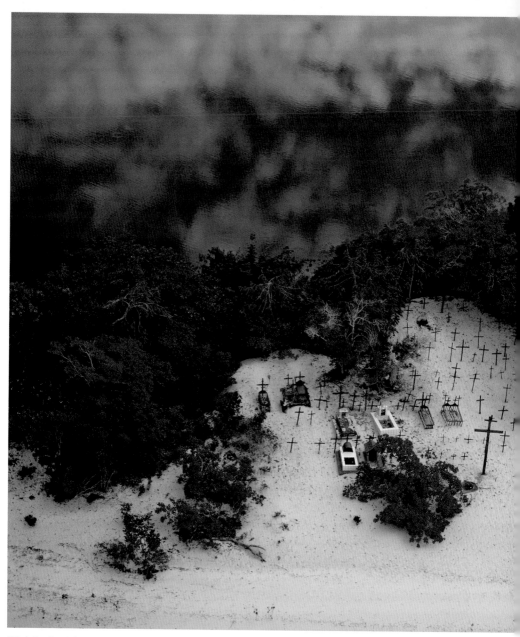

ROBERT HAAS | 2007 | BRAZIL *A beach cemetery beside the Rio Negro*

"I realized that it wasn't human history that had drawn Bobby to Latin America," observes writer Marie Arana of aerial photographer Bobby Haas. It was the wonder of the land—"its spectacle and grandeur, its too-often scarred face."

paris in black & white

WHAT IS IT ABOUT PARIS *ENTRE DEUX GUERRES*—between the wars—that makes every image of it so hauntingly evocative? Undoubtedly it has to do with that singular mélange of expatriates, writers, artists, and exiles that crowded its cafés. But just as surely it derives from the photographers who captured its nuanced black-and-white character so memorably.

KEYSTONE VIEW CO | 1929 | PARIS *Cutting a caper on Bastille Day*

MAYNARD OWEN WILLIAMS | 1930S | PARIS *At the Gingerbread Fair, Place de la Nation*

W. ROBERT MOORE AND RICHARD HANSEN | 1934 | PARIS
Passing shadows, Place de la Concorde

DREAMS AND IMAGINATION—ALEXANDER GRAHAM BELL had plenty of both, but it was imagination that compelled his son-in-law Gilbert H. Grosvenor in 1903 to photograph the inventor's picturesque aerial experiments with tetrahedral kites, and imagination that inspired the young editor, from that point on, to collect or commission for National Geographic further photographs depicting each stage in the conquest of the skies, each new use of harnessed electricity, each notable eclipse, every technological marvel that the hand of man might fabricate or a camera's lens might capture.

There was, after all, a romance about those robots and rockets springing from the dreams of madcap geniuses that could not help but entrance photographers. Many of the images resulting from their carefully contrived setups still possess a quirky, retro appeal, as if all those dials and gauges, levers and vacuum tubes—bathed in that unearthly, pulsating electronic glow—were but aspects of one colossal machine, a machine existing in some fabricated, sci-fi dimension undergirding our daily lives and divorced from the natural world. That it might fail was unimaginable, a cheering and cheerful vision epitomized by the title of one 1950s *Geographic* article: "Man's New Servant, the Friendly Atom."

Yet there had always been a dark side to technology. Those coiled cords and snaking cables might appear monstrous and alien, while men in prophylactic suits easily suggested a dystopian rather than utopian vision. Destruction, after all, rained from those machines, and the fruit of their hideous seed was the mushroom cloud. Thus subsequent generations of photographers have approached scientific or technological assignments in a more nuanced, balanced, realistic, and occasionally ironic manner. They have brought the workaday aspect of research back into their images, but above all, have retrieved the natural world, which not only exceeds in beauty and complexity the fabricated one but will surely determine its destiny. Photographs of melting glaciers or hurricane floodwaters suggest ecosystems increasingly out of balance. These photographs are persuasive witnesses to the growing extent of human-induced climate change, evidence that our technological dreams may be spawning a global nightmare.

the early photographs

THEIR CRAFT ITSELF A CHILD OF TECHNOLOGY, photographers by the turn of the last century already had a keen eye for scientific marvels and achievements. Yet for all their images of giant telescopes or flying machines, they also made pictures that captured technology's potential for destruction or exploitation—an ambiguity expressed in nuanced black and white.

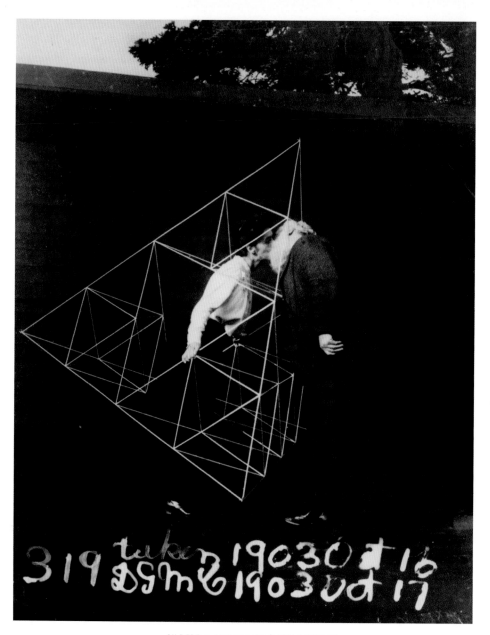

GILBERT H. GROSVENOR | 1903 | CANADA

Mabel and Alexander Graham Bell framed in a tetrahedral kite

368 | Science & Climate ChangeB. ANTHONY STEWART I 1940 I ARIZONA *Robert Goddard adjusting a steering vane*

"I would say he was probably the most conventional human being I have ever known," recalled one friend of rocket pioneer Robert Goddard, "highly conservative in everything except his wild interstellar obsession."

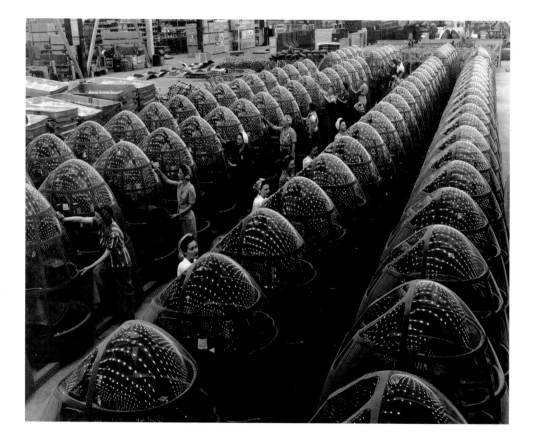

DOUGLAS AIRCRAFT COMPANY | 1942 | CALIFORNIA
Nose assemblies for Douglas A-20 attack bombers

U.S. NAVY **|** 1946 **|** BIKINI ATOLL *The second atomic bomb tested in Operation Crossroads*

WILLARD CULVER | 1946 | NEW YORK *Testing early television equipment*

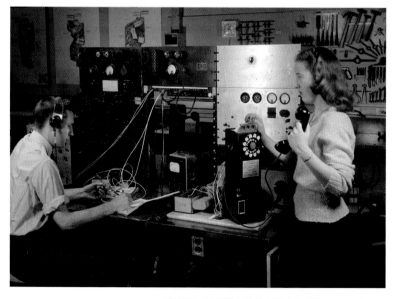

WILLARD CULVER | 1947 | NEW JERSEY
Designing a better pay phone at Bell Labs

WESTINGHOUSE ELECTRIC CORP | 1950 | NEW JERSEY
How electrical wires detour a lightning stroke harmlessly to the ground

"Even the cows are man-made," states the original caption to this picture of a tiny model farmstead built for lightning research. "Westinghouse engineers use this miniature system for tests."

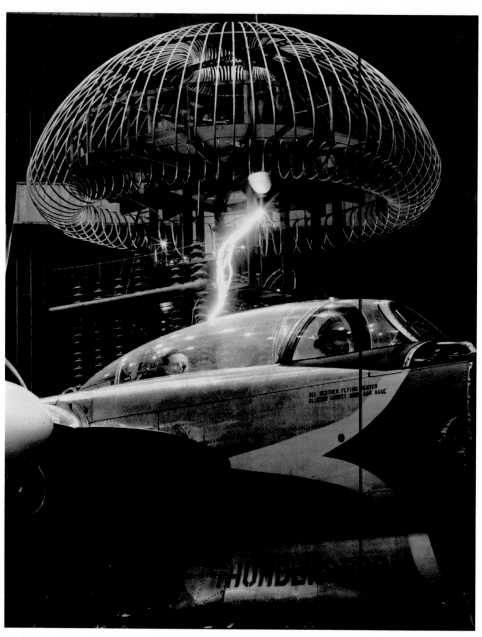

U.S. AIR FORCE | 1950 | OHIO *How metal planes shed lightning*

ERNEST J. COTTRELL | 1950 | WASHINGTON, D.C.
Demonstrating a twin-rotor helicopter to congressmen

"If the jet plane, guided missile, or rocket plane is not perfect," wrote Dr. Heinz Haber, it can be redesigned. "The same cannot be said for man. He is the most important link . . . and he cannot be redesigned."

+5065A.C.

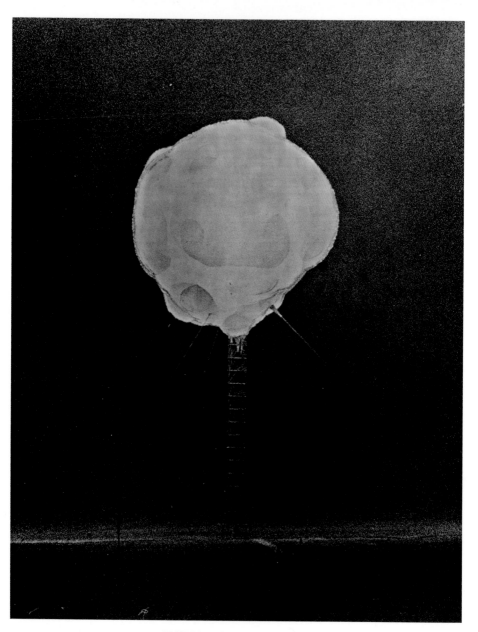

EDGERTON GERMESHAUSEN AND GRIER | 1953 | NEVADA
Fiery flower from a nuclear stem

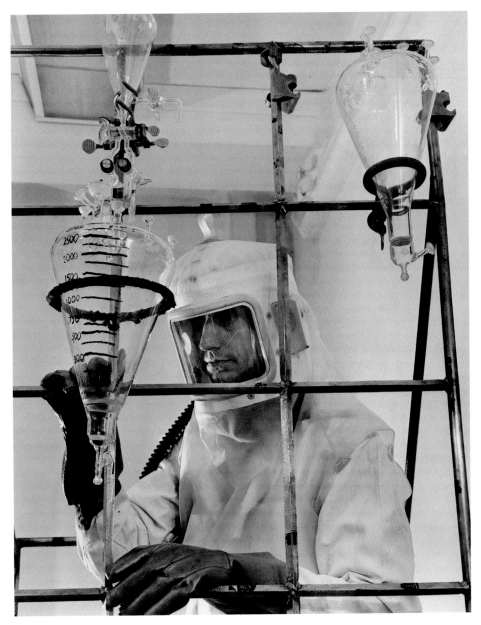

VOLKMAR WENTZEL | 1953 | NEW YORK
Better living through chemistry

color & optimism

THE COMING OF COLOR BRIGHTENED EVERYTHING, saturating images imbued with the postwar, mid-century faith in the power of applied science and technology to improve everyday life. Carefully staged setups of men and machines exuded confidence and competence. It was an uncomplicated vision, an idealization of things as they perhaps should be but probably never were.

THOMAS J. ABERCROMBIE | 1957 | ANTARCTICA
Time exposure of the sun circling the South Pole

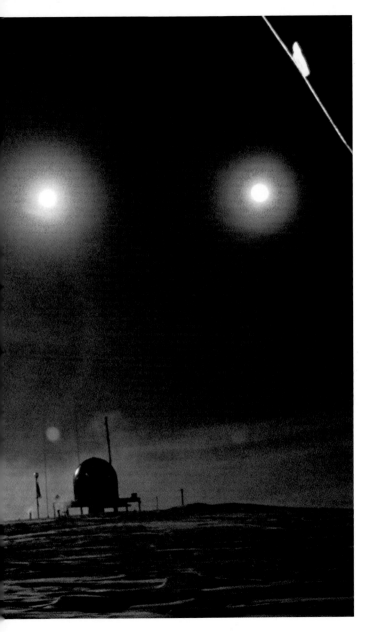

The vanishing of the sun during the Antarctic autumn deeply impressed explorer Ernest Shackleton. "The very clouds at this time were iridescent with rainbow hues. The sunsets were poems."

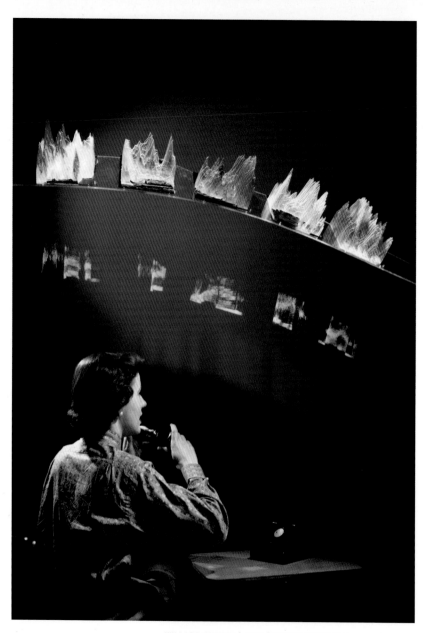

WILLARD CULVER | 1954 | WASHINGTON, D.C.
Speech made visible in plastic analogues of spoken words

WILLARD CULVER | 1954 | NEW JERSEY *Adjusting the balance on RCA Laboratories' prototype color television*

JOHN E. FLETCHER AND DONALD McBAIN | 1954 | INDIANA
Television-monitored quality control on a U.S. Steel production line

B. ANTHONY STEWART | 1958 | NEW MEXICO
High-voltage wires converging in a nuclear fusion chamber

LUIS MARDEN | 1959 | FLORIDA *Pumping liquid oxygen into the Pioneer IV booster*

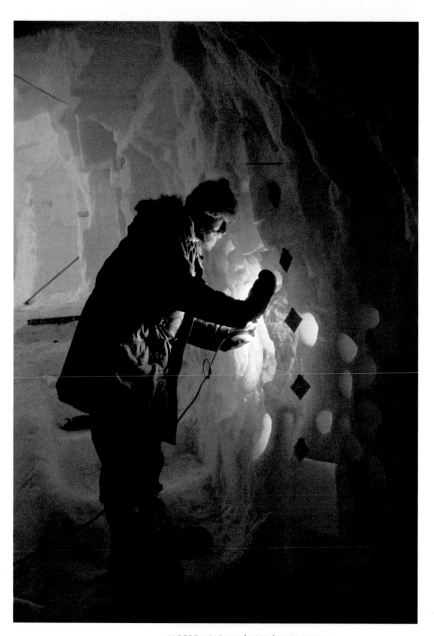

ALBERT MOLDVAY | 1963 | ANTARCTICA
Retrieving ice cores from 90 feet beneath the South Pole

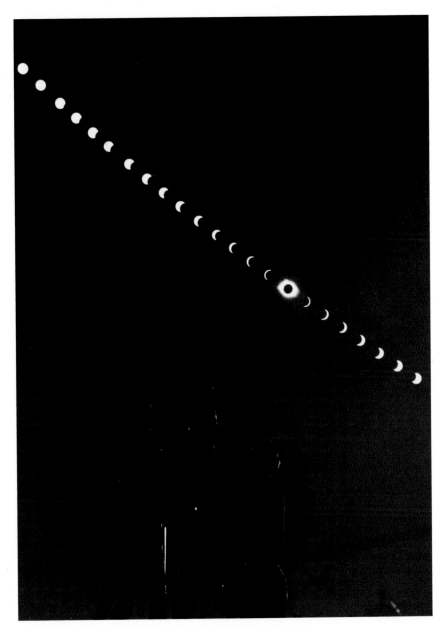

LAIRD BROWN | 1963 | CANADA
Progress of an eclipse

TREAT DAVIDSON **|** 1963 **|** MASSACHUSETTS *Freezing the stages in a frog's leap*

WINFIELD PARKS | 1963 | FLORIDA
Manipulating radioactive substances

JAMES P. BLAIR | 1968 | WASHINGTON STATE *Dwarfed by the monolithic Ross Dam*

"In the view of conservationists," wrote journalist John McPhee, "there is something special about dams, something—as conservation problems go—that is disproportionately and metaphysically sinister."

documentary realism

EVERY FASHION EVENTUALLY GIVES WAY to its opposite. Inevitably a new generation of photographers began depicting applied science in a less enchanted, more realistic vein. Their differing takes better exposed the complexities of technological subjects; this was science seen through the lens of the workaday world, inherently limited though still exciting and important.

DAVID HISER | 1982 | CANADA *A closely monitored, chronically aggressive polar bear at a Churchill dump*

WILLIAM T. DOUTHITT | 1985 | MARYLAND *Sampling the Susquehanna River for radioactive traces from nuclear power plants*

SANDY FELSENTHAL | 1982 | NEW HAMPSHIRE
Mount Washington, outpost in the clouds ·

PHILIPS ELECTRONICS COMPANY | 1982 | NETHERLANDS *Ant with microprocessor*

Writer H. G. Wells once
imagined ants having
evolved to the point
where their engineering
feats and "organized and
detailed method of record
and communication"
allow them to overwhelm
human civilization.

MARIA STENZEL | 1995 | ANTARCTICA *Gazing over the wake of an icebreaker*

DAVID MALIN, ANGLO-AUSTRALIAN OBSERVATORY | 1986 | AUSTRALIA *Halley's comet*

ANNIE GRIFFITHS BELT | 1987 | NORTH DAKOTA *In a Minuteman silo*

CHRIS JOHNS | 1987 | ALASKA *Surveying the Hubbard Glacier*

"The Hubbard Glacier
flows majestically
through a deep valley,"
wrote its discoverer,
geologist Israel Russell.
"Where the subglacial
slopes are steep, the ice
is broken into pinnacles
and towers of the
grandest description."

DANNY LEHMAN | 1987 | NEW MEXICO *The Particle Beam Fusion Accelerator II at Sandia National Laboratories*

PETER MENZEL | 1993 | MASSACHUSETTS
The 1931 Van de Graaff generator at the Boston Museum of Science

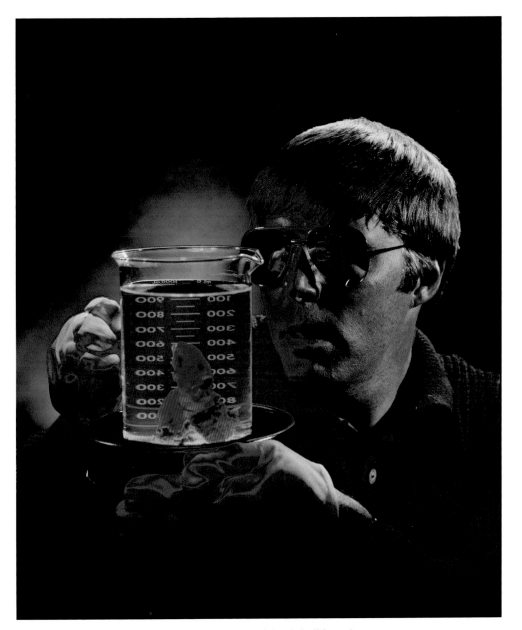

JONATHAN BLAIR | 1987 | MONTANA *Chlorophyll still fluorescing*
when primeval cyanobacteria is exposed to ultraviolet light

MARIA STENZEL | 1995 | ANTARCTICA *View from an icebreaker*

GEORGE STEINMETZ | 1997 | UTAH *A robot mirroring*
every stroke, thanks to sensors and computer relays

the digital range

AN INCREASED SCOPE FOR AN EXPANDED VISION—photographers today have the scope to depict scientific and technological subjects in complex, multilayered ways; they also have the vision to perceive just how fragile is life on this planet, and the opportunity to document the ravages that our technological hubris may be wreaking on global ecosystems.

JOE McNALLY | 2001 | CALIFORNIA *National Ignition Facility's*
target chamber for light-induced nuclear fusion

REZA | 1999 | KAZAKHSTAN *Bloody sands, the sulfurous by-product of oil extraction*

"For the first time in the history of the world," wrote Rachel Carson, "every human being is now subjected to contact with dangerous chemicals, from the moment of conception until death."

JOE McNALLY | 2001 | RUSSIA *Vitamin D-rich ultraviolet bath for light-deprived children*

MARK THIESSEN | 2006 | MARYLAND *Testing nanotech materials with a blast of ultraviolet light*

JAY DICKMAN | 2002 | TEXAS *Bat researchers trying a new approach*

VINCENT LAFORET | 2005 | LOUISIANA *Lower Ninth Ward during Hurricane Katrina*

FRITZ HOFFMANN | 2008 | CHINA *Acupuncture to alleviate Internet addiction*

GEORGE STEINMETZ | 2008 | CHINA *Wind-heaved dunes in the Kumtag Desert*

HEIDI AND HANS-JÜRGEN KOCH | 2008 | DENMARK *Patterning how a spider spins its web*

The brain, according to
Nobel Prize–winning
physiologist Sir Charles
Sherrington, is an
"enchanted loom"
ceaselessly weaving
a "dissolving pattern,
always a meaningful
pattern though never
an abiding one;
a shifting harmony
of subpatterns."

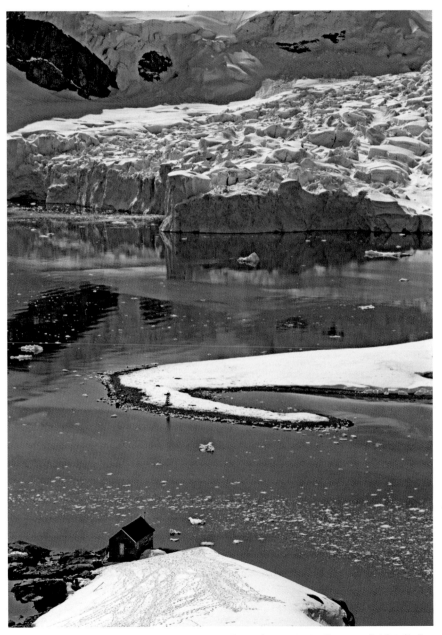

GORDON WILTSIE | 2008 | ANTARCTICA *Summer melt at Paradise Bay*

PAUL NICKLEN | 2009 | SVALBARD *Summer melt on the Austfonna Ice Cap*

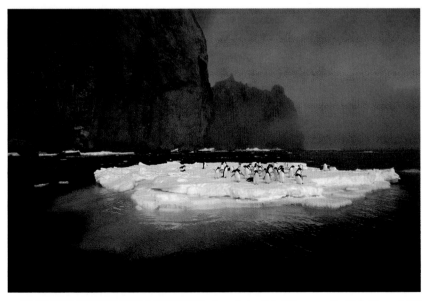

TUI DE ROY | UNKNOWN DATE | ANTARCTICA *Penguins on an ice floe* The Digital Range | 443

TYRONE TURNER | 2009 | NEW YORK *Twilight falling on the green world*

"Too late," says biologist E. O. Wilson to those who dream "in Paleolithic serenity" of restored ecosystems. "Put away your bow and arrow, forget the harvest of wild berries; the wilderness has become a threatened nature reserve."

KATHERINE FENG | 2008 | CHINA *Weighing a baby panda*

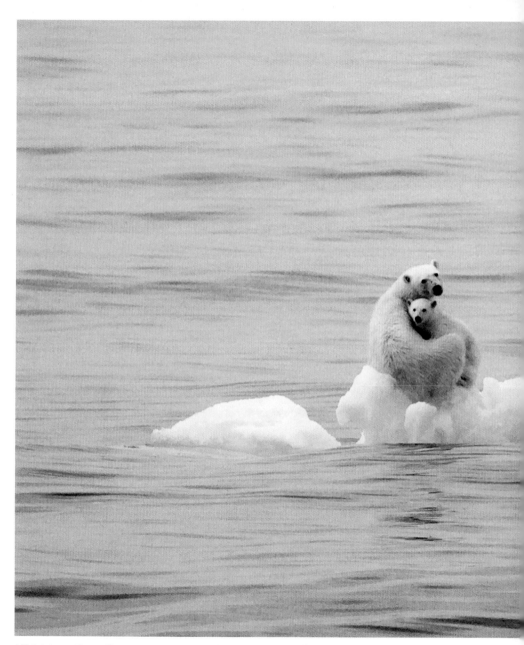

IRA MEYER | 2008 | SVALBARD *Bound to disappear*

the future of space

THE SPACEFARING DREAM—DEPICTED IN MYTH and story and art and, when we were finally on its threshold, in photographs—that dream, first and last, is what rocket pioneer Willy Ley always said it was, "the story of the idea that we possibly could, and if so should, break away from our planet and go exploring to others . . ."

NASA | 1962 | EARTH ORBIT *John Glenn orbiting the Earth*

THE COLLECT

a conversation with **Maura Mulvihill** by **Leah Bendavid-Val**

LBV: Before asking you about the Image Collection I'd like to talk about you: You've been here a long time. Where did you come from? What was your field?

MM: When I was a student I couldn't have imagined or prepared myself for a life in the Image Collection. I went to school for philosophy and rhetoric. I then decided I'd get a minor in art history. But my father was horrified. He wanted me to do something more commercial, so I decided in my last year I'd go to London to study broadcasting.

I got my first job in New York City doing audience research for Group W Broadcasting's TV advertising sales. But I had actually never liked television, and within three months I realized this was a really big mistake. I had met a law student in London, he became my husband, and he told me there were lots of jobs in Washington for art history and policy people. I saw an ad announcing that the Image Bank photo agency was hiring for a new Washington, D.C., office. They hired me and trained me in New York, and I came down to Washington and opened their D.C. branch. I started going door-to-door selling pictures. Of all the places I went, National Geographic was the nicest. The campus was beautiful. And there were such great pictures all over the walls. When I was in their offices once I asked an editor why they didn't license their pictures to other publishers. It seemed so strange that they were licensing pictures from me, but not licensing their own pictures to other publishers. I was told that that would be like selling the family jewels.

LBV: How did you actually get a job at National Geographic?

MM: The first time I walked into the building I was amazed at how big and beautiful the NGS Headquarters was. At the front desk they asked me if I had an appointment, and I didn't, but I saw the guard's book open. I looked down and the first name I saw was John Agnone with the words *picture editor*, so I said I had an appointment with John Agnone. They called

upstairs to get him, and I thought, "Oh my God." He came down, but being very polite he apologized to me for forgetting our appointment. He said, "I'm so sorry, I just didn't remember you were coming; come on upstairs and I'll introduce you to people." I fell in love with National Geographic and ended up licensing Image Bank pictures to John for *World* magazine and for books.

LBV: What amazing nerve you had! OK, so how did you land a full-time job here?

MM: Well, I worked mainly on commission for Image Bank, so it was very appealing to work somewhere where I would get not only a salary but medical and dental benefits. One day somebody in the Illustrations Library, which was what the Image Collection was called at the time, quit. I happened to be in the building and got offered the job, by Fern Dame, the illustrations librarian. I was working before she realized I had never filled out an official application!

LBV: So when was that?

MM: September of 1979.

LBV: What was the collection like then? How big was it? How would you describe it?

MM: The Illustrations Library originally belonged to the Illustrations Division of *National Geographic* magazine. When I began most of us, almost entirely women, worked in one large room. Over in the 16th Street building, the room that is now the Board Room housed all the archival records, and the downstairs room with a big fireplace was filled floor to ceiling with film boxes. We thought of ourselves as primarily clerical. We got the pictures in, we had catalogers who typed up little green cards by subject, and we made sure they were in the file. We also had a Gaithersburg, Maryland, branch within driving distance. That's where the older pictures were kept.

LBV: What went on in Gaithersburg? Did National Geographic have offices there or was it just a warehouse?

MM: There were offices in the main building there but we didn't work in the main building. The photo archive (and staff) was located in the warehouse area right next to the loading dock. Giant trucks would pull up. Products were stored on outside skids. Our member relations departments were there, too. It was called MCB, the Membership Center Building.

LBV: What did you package and mail? What do you mean by *products*?

MM: Books, back issues of the magazine, and the membership promotional mailings and renewals for our magazines. Membership did the work. The whole basement floor of the main MCB building was filled with people just mailing and shipping. In the warehouse, there was a little office where people would monitor the trucks coming and going. The picture archive was right behind that office. Initially, some of the pictures, including the glass plates, were kept outside in the warehouse. The Image Collection staff would research requests and then pull pictures and pack them for shipping for review at the DC headquarters. Our staff had to be vigilant about cleaning; we had problems with mice from time to time.

LBV: Really? Oh my gosh!

MM: A couple of heroic employees noticed that Autochromes were filed in the warehouse, open to the elements much of the time, and brought them into the picture archive. It is amazing that the Autochromes appear to have sustained little damage from this exposure. You could never have left 35mm transparencies in these conditions for 10, 15 years with so little effect. I don't know how long the plates were out there, but we filed them in the picture archive when they were

discovered. One of my early projects was to gather the Autochromes, all 12,000 of them, and bring them downtown for low-resolution scanning for videodisc. We had to pack and wrap them, and record and number them. We were producing videodiscs, silver analog discs that contained images scanned at a very low "thumbnail" resolution and cataloged by subject and photographer. Using a database and the videodiscs, we could research and review thousands of images daily without handling the delicate originals

LBV: Did the collection have a purpose?

MM: I understand that the editors didn't want to give away the pictures, but they also didn't want to keep all the film in their offices. The film boxes, "blue boxes" from past stories, were lining the hallways. Meanwhile the photographers were shooting more and more. Photographs collected by the Grosvenors were kept in one place, and pictures that various editors had collected were kept in their offices. Eventually it was decided to have a centralized place to store all the photographs and art and keep track of it, like a book library. It was in 1919 that NGS established this library for the magazine's photography and art "illustrations," managed by the illustrations editor of the magazine. That is why we were called the Illustrations Library.

LBV: So it was basically the fact that we happened to own the material, had paid for it, and had it under our jurisdiction that impelled us to somehow figure out how to manage it, was that it?

MM: And being Geographic, even if we didn't have an exact purpose for it in mind, we wanted to make sure that we were taking very good care of our collections. We weren't doing it necessarily because we recognized the tremendous historical value of the photographs and art or because we had a purpose in mind. It was because that's the kind of organization we were, we took care of our things, we took care of our buildings, we took care of our assets. I think that's why later on, in the 1960s, when NGS management began directing a culling of the collection because of file overcrowding, people didn't really object and say we have a mission to preserve these photographs for posterity. I don't think people thought of the collection that way. Editorial staff began culling—the way libraries do. They threw out material, because there had never been a verbalized purpose for retaining it.

LBV: Did the blue boxes contain both slides and prints and pretty much anything that was visual output?

MM: Well of course they're gray now, but the blue boxes were filled with 35mm transparencies. The boxes began to be accumulated as early as the late 1930s and '40s. Black-and-white prints were kept in photo folios. We had drawers and drawers of those. The culling was discontinued, but not before many important collections were discarded.

LBV: So what was the size of the collection altogether when it was all assembled downtown and the culling was stopped?

MM: Nobody actually knows for sure. We've always said it was almost 11 million pictures. And we still say that today—almost 11 million pictures. Various reports state how many we think we have but there are different ways of counting. What if there are five images on one contact sheet? Do you count it as five or as one? Do we count our duplicates? We began a massive duplicating project in the '90s before digital took over because we realized we just couldn't charge out 35mm originals anymore—too many were getting lost or damaged or not returned, or misfiled. We began only charging out dupes. Now we have probably two or three million 35mm film dupes in our film room and we don't know what to do with them. We only provide digital scans—nobody uses dupes anymore.

LBV: What do you intend to do with them?

MM: We should probably just start dumping them out. But you know—for librarians and archivists—it's hard to do that.

LBV: Actually I understand that.

MM: It took us 15 years after the computer conversion to finally dump out those little green subject cards we had, drawer after drawer of them. We kept thinking, what if something went wrong in the computer conversion and we don't have, say, the Angola series captions? We'd need the metadata! Now imagine emptying all those 35mm dupes into big, hefty bags...

LBV: Even though they're dupes they seem valuable.

MM: Imagine leaving them out for the garbageman. It's hard.

LBV: Yes.

MM: And you know that somewhere down the line we'll be missing a 35mm original, and we'd think about how we threw out the dupes.

LBV: Right.

MM: I'll leave them for the person who comes after me.

LBV: So, how did your career path go after that initial period?

MM: I worked in circulation, handling picture requests for about six months, and then I heard we were going to be automating the department. That seemed so exciting to me because I was a really bad typist and it meant we'd be getting away from typing all the little green cards, keeping track of everything with Rolodexes and card files. I worked with IBM on their study and the first automation effort. It took me away from the pictures but I was able to work at a higher operational level and I could see every part of the workflow. Everybody else thought computers would be boring but I found it all interesting. I worked on automation projects until eventually I was made director of all operations because I knew how everything worked.

LBV: How many people worked there at that time?

MM: We had about the same number of people we do now. In fact, I think we had more people then. We had 36 people in our Illustrations Library. But we didn't have a sales department, we weren't selling or marketing images, and we had no financial accounting to do. We didn't have a rights clearance service for NGS. Now about five, six people work in this area, buying pictures for the rest of the organization. But back in the early 1980s everything took much longer. Each time a transparency came in the cataloger would handwrite a legend and list all the subjects the legend should be typed under. Then it would be handed off to a typist. Someone would check the typist, and if that person made more than two typographical errors per card, it had to be retyped. Up to two mistakes could be corrected with green-out, more than that, the card had to be retyped. The typist would hand the card off to the card filer. The filer would have to file about 30 cards for each legend. We would not cut corners at all. The filer had to leave each card standing up in the file so the new filings could be seen and then somebody, the supervisor, would check to be sure it was properly filed. When you became an expert, you could become a file checker, too. It became my job to tell people we can't do our jobs like this anymore. It was painful, letting go of perfection.

LBV: How long did it take to automate the department and establish more efficient processes? It must have been an enormous undertaking.

MM: I worked on streamlining processes and automating the department from about 1980 through 1985. At the beginning

catalogers only had to catalog 50 pictures a month. Which means that you only really had to finish two pictures a day. Now we tell people we expect 200 to 400 a week. There's just no comparison.

LBV: So the change was hard for people?

MM: Yes. But it wasn't only us, this kind of change was happening in other departments, too. In 1988 we introduced the videodisc system, and that was in some ways unpopular, too. A lot of people didn't like looking at images on videodisc. Before the videodisc an editor would call and request a picture of, say, elephants. So we'd go through those little green cards, we'd write down all the candidates, then we'd go into file and pull them all. If someone was working on a book, we could easily pull 6,000, 7,000 pictures. The editor would go through them and charge out maybe a thousand. Then they'd take them to their offices, maybe not use any, and you'd get a thousand back. You had to refile all of it. Then there was talk about how costly the department was, about shutting it down and giving the collection to somebody else to manage. That's when I came forward with a proposal for Image Sales.

LBV: Just stepping back for a second: You were providing photography for secondary use for National Geographic books and other publications, right? Had that been going on for a long time?

MM: Well, our books began using a lot of our pictures probably in the 1960s and '70s. We had a Special Pubs line of books, and that series commissioned a lot of new assignments, but there were books like *National Geographic: The Photographs*. This type of collection book uses the Image Collection a lot. But the biggest use of archive pictures, at that time, was in filmstrips for schools.

LBV: So you proposed commercial use of the pictures to help keep the department financially viable?

MM: I had been suggesting it off and on every time we were called in and told how expensive the department was. I would suggest licensing our pictures. Initially the reaction was that it would be tawdry commercialism, sort of dirtying our hands by licensing our great photography for cash. And I don't think anyone in senior management at the time under-stood that all the photographers were already licensing NGS pictures that had been returned to them after the shoot. Remember, we returned all the yellow boxes—most of the unpublished pictures—to non-staff photographers who were photographing for us. They were all using agencies to license their photos that were originally commissioned by National Geographic. I used to license National Geographic photos when I worked for Image Bank. Everybody was licensing NGS photographs, why weren't we?

LBV: I thought for a long time that we owned all assignment material.

MM: In the 1970s and '80s we had a lot of staff photographers. We owned their work and kept it all. But eventually we had only a very small number of staff photographers. From an assignment shot by a freelance photographer, depending of course on the contract, we generally retained published images and a selection of unpublished images with some rights for reuse. But the vast majority of the film from the coverage—the outtakes—was returned to the freelance photographer.

LBV: Do we have a lot of outtakes that nobody has seen in the archive?

MM: There are over ten million outtakes. But they're all from that small universe of staff photographers, so there's not the variety you would expect when you hear ten million pictures. We might have 30,000 images from a single coverage. And assignments could go on for eight months, a year, two years—the photographer on assignment would still be out there shooting.

LBV: How has the fact that photographers are shooting digital changed your life?

MM: It's cheap and reusable storage for digital, so we don't really know how many pictures are being submitted annually. Quantity doesn't matter as much anymore. We don't have to store physical images; we don't have to return anything; we don't have to physically handle anything.

LBV: When you say you don't physically store them, how are they stored?

MM: The RAW files come in from photographers on assignment. Lo-res JPEGs are generated from the raw scans and the JPEG versions are used to review the pictures. Then the selected RAW files are converted to TIFFs, these are converted to CMYK, and those files are corrected for printing. Then the TIFFS are converted to high resolution JPEG for research and download. For the selected images, the TIFFs, the JPEGs at various file sizes, and the CMYKs are archived on an image server.

LBV: How do you select images for the archive and for your Image Sales clients?

MM: For Image Sales clients we select more than purely editorial pictures from editorial assignments. From every assignment we take roughly a hundred pictures. The digital files are stored here. In addition the photographer has a copy of everything, so nothing is ever really lost.

LBV: So what's the story then on your creating Image Sales?

MM: Initially we were told that we could license pictures to third parties, but only on a passive basis, meaning that we couldn't market, actually tell anybody we were licensing images. So if somebody called for a picture we could respond to the request and charge for the picture license. Before this program was approved, NGS didn't charge a licensing fee for the pictures. As you can imagine, we were swamped with requests. When we started charging it was a real shock to people. I mean we had been giving picture licenses away for free—in many cases to our publishing competitors.

LBV: Wow. So when did the payment part kick in?

MM: It started in the mid-nineties when we began licensing and charging for the artwork. Then we began licensing and charging for photographs. Our new policy was initially greeted with outrage from our past clientele that had come to expect free licenses.

LBV: Not that long ago.

MM: No, not that long ago. At first we weren't allowed to sell more than five pictures to the same person in one year, so if someone called and said they wanted to do an article, we'd have to say, well, we can give you five pictures this year, and then if you wait until March, we can give you another five. We also suddenly had a long list of embargoed editorial publications that we couldn't license images to at all because they were considered competition. It was confusing to people. We were *sooo* not commercial. But despite that, I think we earned over $100,000 in our first year, licensing images.

LBV: National Geographic photography was legendary so I guess there wasn't much need to advertise.

MM: In 1996 we produced our first catalog, our first real advertising of Image Sales. In hindsight that catalog doesn't look great. Our goal was to try to put as many pictures in it as we could, so all the pictures are tiny thumbnails. On top of that a lot of our photographers shoot in natural light so at thumbnail size the pictures looked dark. We probably invested a

quarter of a million dollars to get that catalog made. We commissioned agents to distribute our catalog and license images internationally and we made well over a million and a half dollars on it. That was a lot of money for us as a department—we had never made any money before Image Sales. So we started training researchers to be salespeople. We were told never to do that; that you cannot make researchers into salespeople. But I think you can at National Geographic. Our researchers had long tenures and they knew the collection really well. They were committed to the Society and they were the kind of people you would expect to get on the other end of the line when you call National Geographic. They were earnest, they loved the photos and National Geographic. We were being true to who we are.

LBV: Well, OK. Now that you are an agency as well as a collection, how would you compare the National Geographic Image Collection and Image Sales to other major collections? Let's start with Magnum. How would you compare us to Magnum?

MM: Well, Magnum has great cachet because of the characters and personality of the photographers behind it, the correspondents who built the cooperative. Though if you look at Magnum's web site, they've got many different types of photographers now, so it's not the old Magnum, but I think it will always focus on politics and current social issues. National Geographic feels like a kinder lens. We cover world events too, but we have always documented the things people do in day-to-day life all over the world, the normal life that goes on outside of the giant events. Our photographs show what people did on ordinary days in Africa, or Polynesia or the Midwest. These images have a unique social and cultural value. We have also documented the environment, natural history, science, and the natural world. That's our strength and our special niche.

LBV: OK, as agencies go Magnum has one personality and the Geographic has another personality. But what about the Collection side? What seems unique to me is that we seem to be a combination commercial agency and a fine photography collection. There's a history of photography in the archive here, and a lot of the material is treasured for its worth historically.

MM: Yes, and despite the fact that the iconic historical images may not be our best sellers, I think our reputation and those iconic images are our best marketing tools. I think people come to us to license sometimes very mundane pictures because of the National Geographic reputation and our legendary shooters. I always use the example of a client who asked for some lion pictures, I think by Nick Nichols or Beverly Joubert, and then called back, upset because the lion in the picture had a chipped tooth—they wanted a discount because of the chipped tooth! The client had come to National Geographic and asked for our documentary photography and were disappointed that they got it. We ended up licensing them a captive lion with beautiful dentures and they were happy. It was the legendary reputation of our photographers that brought them here, but we hope that our service and relevant imagery for their needs will make them return customers.

LBV: Does the collection as a whole have a mission?

MM: We are one of the few repositories that document the entire 20th century and the beginnings of the 21st century. We didn't focus only on war or newsworthy events like disease outbreaks or political events, but rather on social documentation of the whole world and all of its inhabitants. The only other place you'd find something comparable is in the art collections of museums, and even there you'd have to ferret out the realism from the mythic and religious symbolism to get a glimpse at how people lived and what the world was like.

LBV: Do you have a vision for the future? What do you imagine, and how would you like to build, change, or shape the future?

MM: We want more people to know about our remarkable collection of photographs, and make use of them, keeping these images circulating and accessible to people, through exhibits, books, and advertisements. This book, which showcases how we've been using images for 120 years to inspire people to care about this planet, is a great start. ∎

THE PHOTOGRAPHERS

ABELL, SAM Since first arriving as an intern in 1967, Sam Abell has lent a magic touch to National Geographic photography. Found in numerous Society books and magazine articles, Abell's pictures embrace such places as Newfoundland, Australia, Japan, and the American West and such people as Leo Tolstoy, Lewis Carroll, and Winslow Homer. His photographs are widely admired for their beauty, grace, and great contemplative power.

ABERCROMBIE, THOMAS J. A native of the Midwest who made the Middle East his beat, Thomas J. Abercrombie (1930-2006) came to National Geographic in 1956 from the *Milwaukee Journal*, where he had just been named Newspaper Photographer of the Year. He followed that up four years later with a Magazine Photographer of the Year accolade. After a colorful career on the magazine's Foreign Editorial Staff, Abercrombie, a Muslim convert, focused his reporting on the far-flung world of Islam.

ADAMS, CLIFTON R. One of the great might-have-beens in the National Geographic story, Clifton Adams (1890-1934) seemed on his way to photographic mastery when he died of a brain tumor at 44. In the 14 years he had been on the staff, he had had 30 color portfolios and hundreds of black-and-white images published in the magazine, from assignments that had taken him across the U.S., into Mexico, and abroad to Europe.

ADAMS, HARRIET CHALMERS Ranking among National Geographic's most dependable early contributors, the indefatigable Harriet Chalmers Adams (1875-1937) published 21 stories in the magazine exploring nearly every byway of Hispanic and Latin American civilization. The native Californian—who inherited her wanderlust from her footloose father—once journeyed alone from Spain through Libya to the Near East. During World War I she was the only woman correspondent allowed to visit the trenches.

ALDANA, GUILLERMO One of Mexico's most noted photographers, Guillermo Aldana

William Albert Allard

has focused on the anthropology and ethnography of his native land. He has been contributing to *National Geographic* since a 1971 story that was the first to depict the strange Holy Week rituals of the Cora Indians of the Sierra Madre. Subsequent articles have covered the eruption of El Chichón in 1982 and the disastrous Mexico City earthquake of 1985.

ALLARD, WILLIAM ALBERT Finding the best pictures on "the edges of situations," William Albert Allard has maintained his ruggedly independent take on life and the National Geographic since first arriving as an intern in 1964. Over the years, whether as a staff, freelance, or contract photographer, he has left behind him some 30 stories, a shelf of books, and a series of indelible images of people ranging from the Amish and Hutterites to India's Untouchables to the cowboys of the American West.

ALLMON, CHARLES Born in Ohio in 1921, Charles Allmon remembers the Great Depression so vividly that in the 1960s he made a midlife career change and gave up his dream job at National Geographic to become one of Wall Street's most successful and respected investors. He put behind him his happy coverages of Bermuda, Rio, and the Caribbean—nine articles altogether—so that he could afford to buy the real thing.

ALVAREZ, STEPHEN Although most noted for his cave explorations, Stephen Alvarez's first assignment from National Geographic took him high into the Peruvian Andes to photograph a 500-year-old Inca mummy. Subsequent journeys have taken him into

the caves of Borneo, Central America, Papua New Guinea, Oman, and the Caucasus. Coming up for air, the Tennessean has also covered ancient Polynesian migration, Easter Island, and conflict along the Uganda-Sudan border.

AMOS, JAMES L. Embracing photography at an early age, James L. Amos nevertheless took the roundabout way to practicing it. After graduating from the Rochester Institute of Technology, the Michigan native was for 16 years an Eastman Kodak technical representative. He was nearly 40 before he joined National Geographic—only to be named Magazine Photographer of the Year in both 1970 and '71. Before retiring in 1993 he had published over 20 stories on various technological and regional American subjects.

AURNESS, CRAIG Adopted son of actor James Arness of *Gunsmoke* fame, Craig Aurness (1946-2004) apprenticed at *Look* magazine before becoming a National Geographic freelance photographer in 1977. Over the next decade his images of the people, history, and ecology of the American West illustrated eight published stories and one Society book, and he contributed to a variety of outside publications as well. He was the principal founder of the stock photo agency West Light.

AZEL, JOSÉ Nineteen-eighty-eight was a year of living dangerously for José Azel, for during those months he was covering the cocaine trade for National Geographic. Born in Havana, Azel discovered photography while studying at Cornell. He then attended the University of Missouri School of Journalism and for three years was a *Miami Herald* staff photographer. His numerous Geographic assignments have ranged from Antarctica to Russia to the illegal wildlife trade to his native Cuba.

BAILEY, JOSEPH Joseph H. Bailey (uncertain-2001) was a NASA lab technician before joining the National Geographic staff in 1972. An all-around performer, he photographed many volumes, such as *Explore a Spooky*

Swamp, in the Society's children's book program, made pictures in Bermuda and Yosemite, and photographed many presidential Inaugurations and government officials.

BALOG, JAMES "It's a dominant theme for me and my work: the relationship of humans to nature," as photographer James Balog understates it, for his innovative depictions of animals and landscapes, often appearing in National Geographic publications, are widely seen as calling traditional representations of that relationship into question. His most recent project is the Extreme Ice Survey, a collaborative effort to bring scientists and photographers together to chart the course of climate change.

BARTLETT, DES AND JEN It was in the 1950s that Australian couple Des and Jen Bartlett began the remarkable career that soon made them among the most renowned wildlife filmmakers in the world. Along the way they contributed to some seven stories in *National Geographic*—and an Emmy award–winning film—ranging from Patagonia to Namibia.

BECKWITH, CAROL Working together for over a quarter of a century, American Carol Beckwith and Australian Angela Fisher have been documenting as many African rituals, ceremonies, and customs as possible before they are eroded by the modern world. Their resulting photographs, many of them published in National Geographic books and magazine articles, have been honored by the United Nations and many other organizations around the globe.

BELT, ANNIE GRIFFITHS A Minnesota native, Annie Griffiths Belt majored in journalism before working as a photographer for the *Minnesota Daily* and the *Worthington Daily-Globe*. By 1978 she was shooting on contract for the National Geographic Society, and over the next several decades her assignments have ranged from the Middle East—Lawrence of Arabia, Jerusalem, Petra, Galilee—to England's Lake Country and the back roads of America.

BENDIKSEN, JONAS Born in Norway, Jonas Bendiksen turned up in Magnum's London office as a 19-year-old intern before gathering up his cameras and departing for Russia to

make pictures on his own. Several years later, the results of his excursions were published in a book, and his career as a photojournalist was launched. Since then he has shot stories on Iceland, Nepal's revolution, and the slums of Mumbai for National Geographic.

BENN, NATHAN A past president of Magnum, Nathan Benn still fondly regards his freelance National Geographic career as a "twenty-year graduate course in the humanities." Starting in 1972, the native Floridian, who had received his undergraduate degree from the University of Miami, shot some 25 stories for Geographic publications on topics ranging from New En-gland to Prague to Peru to the mysteries of the ancient world.

BINGHAM, HIRAM Of the many roles that Hiram Bingham (1875-1956) played—professor, governor of Connecticut, U.S. senator—it was the one of explorer for which he is best remembered. As leader of the National Geographic–Yale University Peruvian Expeditions between 1912 and 1915, Bingham excavated the spectacular site of Machu Picchu while making photographs that stirred the imaginations of millions of people worldwide.

BLAIR, JAMES P. James P. Blair forged his photographic style through close exposure to such formative influences as Roy Stryker and Harry Callahan. For 32 years (1962-1993) a National Geographic staff photographer, Blair undertook over 40 assignments ranging from computer chips to eclipses, but his most

Annie Griffiths Belt

lasting work has been focused on social or environmental themes and photojournalism— he won the 1977 Overseas Press Club award for his striking coverage of South Africa.

BLAIR, JONATHAN It was while taking pictures of stars in Northwestern University's observatory that Jonathan Blair was first captivated by photography. Afterwards, while working as a park ranger, his pictures of Yosemite were published in *National Geographic*. That kicked off four decades of freelance assignments that have taken Blair, a versatile photographer who leans toward underwater and archaeological stories, from Hawaii to the Mediterranean to the high Himalaya mountains.

BLOCK, IRA An all-around photographer who brings the same degree of dedication to any given subject, Ira Block learned his trade while growing up in Brooklyn. By 1977 he was shooting freelance assignments for National Geographic, and in the decades since has covered everything from geography to archaeology to historical pieces to olive oil—for when on assignment, as he puts it, he is looking for "unusual things . . . not just the expected."

BOSWELL, VICTOR R., JR. In the 33 years between 1961 and 1994 that Victor Boswell was a National Geographic staff photographer, he focused his lenses not so much on people and places but rather on objects—art in particular. He shot the Sistine Chapel, the Bayeux Tapestry, and the *Last Supper* in addition to innumerable pieces in museums, galleries, and archaeological sites around the world. He also photographed Venice—as an art object in itself.

BOYER, DAVID S. When David S. Boyer (1914?-1992) joined the National Geographic staff in 1952 he was already a seasoned reporter, having been a writer/photographer for the *Salt Lake Tribune* and an instructor in photojournalism at the University of Illinois. For the next 37 years—he retired in 1989— Boyer either wrote or photographed 42 stories for the magazine. Assignments took him around the world, from London to Antarctica and dozens of places between.

BRANDENBURG, JIM Though he has shot pictures from Africa to Japan for National Geographic, Jim Brandenburg's career pivots on the prairies and woods of his native

Minnesota. In 23 magazine features and several books, the world-renowned nature photographer has depicted wilderness subjects from the white wolves of Ellesmere Island to a profile of conservationist Aldo Leopold. In 1999 he established the Brandenburg Prairie Foundation to promote awareness of that vanishing ecosystem.

BRILL, DAVID L. A native of Wisconsin, David L. Brill was working for *The Paper* in Oshkosh when he was named National College Photographer of the Year. That led, in 1970, to an internship at National Geographic. Since then he has made a specialty of archaeological and anthropological photography, depicting the ruins of Chan Chan in Peru and Aphrodisias in Turkey or the hominid fossils recovered from the eroded scarp-lands of East Africa.

BRIMBERG, SISSE Born in Denmark, Sisse Brimberg managed her own photography studio in Copenhagen before moving to the United States to shoot on contract for National Geographic. Since that time her work—whether on Vikings, Catherine the Great, the Lascaux caves, or chocolate, among many assignments—has been published in more than 30 issues of the magazine. Today she and her husband, Cotton Coulson, run Keenpress Photography in Denmark.

BROWN, NELSON Nelson Brown joined National Geographic's photographic staff in the 1960s. During Project Apollo he helped devise and install remotely triggered cameras to photograph rocket launches at Cape Canaveral. Eventually he became chief of the Society's photo equipment shop, responsible for maintaining the specially rigged, ingeniously adapted cameras, electronics, and lighting systems used by field photographers from deep in the sea to high in the sky.

CAPUTO, ROBERT Robert Caputo began his long involvement with Africa when, traveling after college, he met filmmaker Hugo van Lawick in Tanzania and learned to shoot wildlife documentaries. That led him to New York University Film School, then back to Africa, where he began freelancing for National Geographic in 1980. His articles have covered famine, war, and wildlife across the continent, while his journey up the Zaire River resulted in both a published story and a television film.

CHAPELLE, DICKEY Born Georgette Meyer in Wisconsin, Dickey Chapelle (1918-1965) gained her new last name by marriage and, after a subsequent divorce, her first by dropping Georgette and adopting Dickey. By whatever name, however, she proved herself a fine combat photographer in World War II. She continued covering conflicts worldwide and published several *National Geographic* stories on Vietnam, where she walked into the booby trap that killed her in 1965.

CHESLEY, PAUL Though he has crossed Canada by train, hiked along the Continental Divide, and explored hidden corners all over North America for National Geographic's Books Division, freelance photographer Paul Chesley has enjoyed most those assignments that have focused on Asia and the Pacific. The native Minnesotan began shooting for the Society in 1975, and he has now completed 35 Geographic projects.

CLARK, ROBERT From documenting high school football in Texas, to capturing the September 11 attack on the World Trade Center, to crossing the country making images with only his camera phone, Robert Clark is a versatile photographer. His National Geographic assignments, for instance, have largely been historical pieces—Jamestown or the Phoenicians—or penetrating essays on the evolution of dogs, whales, mammals, and Darwin's idea itself.

COBB, JODI Jodi Cobb comes by her knowledge of the Middle East naturally, for she grew up in Iran. A graduate of the University of Missouri, Cobb joined the National Geographic staff in 1977 and has since photographed over 30 stories, primarily in the Middle East and Asia. These include intimate looks at the worlds of Japanese geishas and Saudi women, groundbreaking features on love or beauty, and hard-hitting

Jodi Cobb

photojournalism on the exploitation of 21st-century slaves.

CONGER, DEAN Hailing from Wyoming, Dean Conger spent nine years as a celebrated *Denver Post* photographer before joining in 1959 the staff of National Geographic. He then spent three years on loan to NASA, making a color record of the Mercury manned space program and seeing his pictures published around the world. In the 1970s he made 29 separate trips to the Soviet Union, efforts that resulted in an unprecedented behind-the-scenes coverage of the Communist state.

COULSON, COTTON R. Cotton Coulson was only 21 when he found himself shooting for *National Geographic* magazine. Shortly afterwards, in 1977, he became a contract photographer and covered more than a dozen assignments, many on European subjects. After a stint as director of photography at the *Baltimore Sun* and *U.S. News & World Report*, Coulson is again shooting for National Geographic *Traveler*. He and his wife, Sisse Brimberg, also run Keenpress Photography in Denmark.

CRAIGHEAD, FRANK AND JOHN Twins Frank and John Craighead first appeared in the pages of *National Geographic* as teenage falconers in the 1930s. They grew up to become two of the most famous wildlife biologists in the world, and for over half a century their wildlife photographs, ranging from those made in pre-war India to those depicting their pioneering work with Yellowstone's grizzly bears and golden eagles, were published routinely in the magazine.

CULVER, WILLARD R. "Culver with his magic lens," was how one of his colleagues referred to Willard R. Culver (1898-1986), a fitting description of the National Geographic photographer who for his era—he was on staff from 1934 to 1958—was a wizard at photographing industrial, scientific, and technological subjects. Born in Delaware, Culver worked at Baltimore newspapers before joining the Society, where he became adept at synchronizing flash to light large areas.

CURTIS, EDWARD S. The celebrated photographer of the American Indian, Edward S. Curtis (1868-1952) grew enchanted with photography as a youth and set up as a fashionable portraitist in the Pacific Northwest.

By 1900 he was embarking on his life's work: a monumental, 30-year documentation of the vanishing tribes west of the Mississippi. His masterpiece, *The North American Indian*, comprises 20 volumes of text, 1,500 bound plates, and 20 gravure portfolios.

CURTSINGER, BILL A member of a U.S. Navy Photo Unit and a graduate of the Navy diving school, Bill Curtsinger was well prepared for his career as an underwater photographer. His unprecedented pictures of whales led in 1979 to his shooting on contract for National Geographic, and his stunning depictions of marine mammals, gray reef sharks, sea turtles, shipwrecks, and the life of Arctic and Antarctic seas have been gracing Society publications ever since.

CUTLER, A. W. A. W. Cutler (died 1922), of Rose Hill House in Worcester, England, began providing photographs to National Geographic in 1913. His sharp-cut, detailed scenes of Britain and Ireland were considered "superb," and he was subsequently sent by the magazine to photograph Portugal and the "scenery and peasant types" of southern Italy—where he died of malaria. He bequeathed his entire collection of negatives to the Society.

DALE, BRUCE In a National Geographic career spanning over 30 years, Bruce Dale has demonstrated an astonishing range and versatility. The Ohio native, who worked for the *Toledo Blade* before joining the Geographic's staff in 1964, shot over 40 stories for the magazine in addition to working on several books. Praised for his landscapes as well as for his portraits of gypsies and American mountain people, the technically inventive Dale also once used pulsed laser photography to make a hologram of an exploding crystal ball.

DE LOS SANTOS, PENNY Penny De Los Santos grew up in the cultural melting pot that is southern Texas and earned her journalism degree from Texas A&M. A subsequent masters in visual communication from Ohio University, where she was named 1998 College Photographer of the Year, was then balanced by hands-on experience with several small newspapers. Soon she was undertaking the seven-year project that resulted in the photographic essay on the Latino movement that was published by National Geographic in 2006.

David Doubilet

DEGHATI, REZA Born in Iran and today a French citizen, Reza Deghati—better known as just Reza—is the epitome of the journalist engagé. Having taught himself photography at 16, he went on to become the Tehran correspondent for various newsweeklies. By the 1990s he was working with UNICEF in Afghanistan and beginning to photograph for National Geographic, where he has covered stories from Libya to Pakistan and China. He has been widely honored for his humanitarian and public service activities.

DEVORE III, NICHOLAS When times were good Nicholas Devore III (1949-2003) was a charismatic, infectiously engaging photographer gifted with just that special touch. Starting in the 1970s the Paris-born, Aspen-raised Devore photographed stories for National Geographic ranging from the American West to Bali and Polynesia. But too often times were bad, and he eventually shot himself at the age of 54. "He would never settle for the boring," said a friend. "Never."

DOUBILET, DAVID Universally acknowledged to be one of the finest underwater photographers of his generation, David Doubilet has been at it since he was 12 years old. His work for National Geographic, which has stretched uninterrupted since 1971, has resulted in over 60 stories for the magazine, a number of books, and dramatic images of fish, sharks, stingrays, coral reefs, jellyfish, and other beauties of the sea.

DRY, DAN At 16, Dan Dry was a member of a team working for the rural Ohio *Athens Messenger* that narrowly missed winning a Pulitzer Prize for Public Service. At 19 he served the first of two internships at National Geographic, returning as a contract photographer after a stint of newspaper work. Over the next eight years he primarily shot pictures for regional U.S. stories, especially for the Society's *Traveler* magazine and its book division.

DURRANCE, DICK S., JR. Son of an Olympic skiing champion, Dick Durrance II was raised in Aspen, Colorado, and graduated from Dartmouth before becoming an Army photographer. In 1969 his prizewinning pictures of Vietnam led to a position on the National Geographic staff, and for the next seven years he photographed stories as diverse as Leningrad, South Africa, the North Sea, and the Appalachian Trail. He resigned in 1976 to pursue a career in advertising photography.

EASTCOTT, JOHN She came from Poland by way of New York City; he hailed from New Zealand and arrived from London. But once Yva Momatiuk and John Eastcott met in Wyoming, they forged the partnership that has made them esteemed writers and photographers on indigenous peoples and natural history subjects. In 1976 the pair began working freelance for National Geographic, covering stories from the Inuit communities of the Arctic to the high mountains of their respective homelands.

EDGERTON, HAROLD EUGENE Famous as the man whose images froze bullets in midflight, Harold "Doc" Edgerton (1903-1990), developer of the high-speed stroboscopic flash, was for many years a professor of electrical engineering at MIT. Yet he also worked closely with National Geographic, helping Jacques Cousteau improve deep-sea cameras, sonar transducers, and other imaging equipment. It was aboard the *Calypso* that he received his nickname, "Papa Flash."

EDWARDS, WALTER MEAYERS Called "Toppy" because his father was head of the Topical Press Agency in London, Walter Meayers Edwards (1908?-1994) emigrated

to the United States and joined the National Geographic staff in 1933. Over the next 40 years he served as a picture editor, layout editor, chief of the illustrations division, promoter of underwater exploration, writer, and photographer especially noted for his images of the desert Southwest.

EIGELAND, TOR Born in Norway and educated in Mexico and Canada, Tor Eigeland began his career as a freelance photojournalist in 1959. Shortly thereafter he began contributing to National Geographic publications, beginning with a natural history piece from South America for the magazine. Since then assignments have spanned a range of subjects, including Dutch tulips, the Alps, Moorish Spain, and the islands of the Caribbean.

ESSICK, PETER In over two decades of work as a National Geographic contract photographer, Peter Essick has produced more than 30 stories for the magazine. His assignments, which began with an article on model airplanes, have moved steadily toward far-ranging ecological pieces. He was the principal photographer for a special issue on water resources, and subsequent stories have embraced nuclear waste, the carbon cycle, earthquake prediction, and global warming.

FALCONER, DAVID For many years a highly regarded staff photographer for the *Portland Oregonian*, David Falconer, born in Vancouver, has supplied imagery to a variety of organizations. National Geographic has used pictures of his ranging from biology to forest fires to John Muir in its books, magazines, filmstrips, educational media, and other publications and products.

FARLOW, MELISSA A graduate of the University of Missouri School of Journalism, Melissa Farlow worked for the *Pittsburgh Press* and *Louisville Times*, where she was a member of a Pulitzer Prize–winning team of reporters. Over 15 years of freelancing for National Geographic has taken her to the swamps of Florida and New Jersey, down the Pan-American Highway, and across rangeland and forest, where she photographed pressing land use issues.

FELSENTHAL, SANDY Freelance photographer Sandy Felsenthal was hardly out of college before he was photographing

Kenneth Garrett

for National Geographic. Throughout the 1980s he shot stories on New England, Quebec's Gaspé Peninsula, the Tombigbee waterway connecting the Tennessee and Mississippi Rivers, Indianapolis, and Washington State. He then hung up his cameras and joined the family business in Arkansas.

FISHER, ANGELA Working together for over a quarter of a century, American Carol Beckwith and Australian Angela Fisher have been documenting as many African rituals, ceremonies, and customs as possible before they are eroded by the modern world. Their resulting photographs, many of them published in National Geographic books and magazine articles, have received awards from the United Nations and many other organizations around the globe.

FLEMING, KEVIN A native of Delaware, Kevin Fleming is a freelance photographer who worked for National Geographic throughout the 1980s, covering assignments as diverse as Annapolis, Maryland; war and famine in Somalia; and the history of Canada's Hudson's Bay company. In 1981, while on assignment in Cairo, Fleming witnessed the assassination of Egyptian President Anwar Sadat, and his pictures, among the few made of the event, were published around the world.

FLETCHER, JOHN E. John E. "Jack" Fletcher (1917-2003) joined the Geographic staff in 1944 and had a varied career. His assignments took him as far as the Antarctic; he devised remotely triggered cameras to photograph rocket launches, and became an expert in the electronic lighting of very large areas, his "monster flash" illuminating Piccadilly Circus, the Vienna State

Opera, the Houses of Parliament, even a joint session of Congress.

FRANKLIN, STUART A native Londoner, Stuart Franklin began his photojournalism by venturing abroad to cover fighting in Beirut, civil war in Sri Lanka, troubles in Northern Ireland, famine in Sudan, and the 1989 massacre in Tiananmen Square. He has since written and photographed over a dozen articles for National Geographic, mostly on the world's great cities, while getting a doctorate in geography at Oxford. He has also served as president of Magnum Photos.

GAHAN, GORDON As a U.S. Army photographer in Vietnam, Gordon Gahan (1945-1984) won two bronze stars and a purple heart while making the kind of images that in 1972 landed him a job on the National Geographic staff. For the next decade his varied assignments ranged from archaeology to natural history to photojournalism. In 1982 he went into advertising photography, and two years later was killed in a helicopter crash while photographing in the Virgin Islands.

GARRETT, KENNETH In 1976, armed with an anthropology degree from the University of Virginia and a genius for photography inherited from his father, former *National Geographic* editor Wilbur E. Garrett, Kenneth Garrett embarked on the freelance career that has continued unabated ever since. Specializing in historical and anthropological subjects, Garrett's images have illustrated scores of Society publications focusing on ancient Egypt, the Maya world, archaeological discoveries, and prehistoric migrations.

GARRETT, WILBUR E. Innovative and imaginative, Wilbur E. Garrett was editor of *National Geographic* between 1980 and 1990, and he helped firmly implant photojournalism at the magazine. Born in Kansas City, he was a Navy cameraman in Korea before studying at the University of Missouri. After joining the Geographic in 1954, he photographed Cold War hotspots all over Asia, his Vietnam coverage being particularly noteworthy. He has also promoted regional conservation initiatives, especially across Central America.

GAYER, JACOB Jacob Gayer (1884-1969) was an important member of the first generation of National Geographic staff photographers, which came of age in the 1920s.

Born in Ohio, he attended the University of Heidelberg in Germany before joining the Society in 1921, remaining there for the next decade. He journeyed down to South America, roamed the isles of the Caribbean, and even ventured into the Arctic to make early color pictures.

GEHMAN, RAYMOND Growing up in Virginia, Raymond Gehman was always drawn to the outdoors. So after graduating from the University of Missouri's School of Journalism and working for several newspapers, the former National Geographic photo intern began shooting for the Society's publications on a freelance basis. He has photographed features on Eastern wildlife, wetlands, fire ecology, prairie dogs, and the destruction caused by Hurricane Andrew in 1992.

GEORGIA, LOWELL The two years Lowell Georgia worked as a picture editor at National Geographic must have rekindled his photographic zeal. The Green Bay, Wisconsin, native had been an award-winning *Denver Post* cameraman before joining the Geographic in 1967. After resigning his picture editor job, he picked up his cameras again and began 20 years of freelance shooting for the Society, his assignments generally focused on the American people and their environments.

GERVAIS-COURTELLEMONT, JULES Jules Gervais-Courtellemont (1863-1931) was perhaps the most accomplished and prolific of the early Autochromists. A writer, explorer, lecturer, and publisher as well as photographer, he had a romantic passion for the Near East and eventually converted to Islam. Pictures of the Holy Land and North Africa, as well as those of countries ranging from France to India, are among his 24 photographic essays that National Geographic published in the 1920s and '30s.

GOODMAN, ROBERT B. A National Geographic staff photographer in 1961-63, Robert B. Goodman's first pictures in the magazine illustrated an article on Hawaiian volcanoes. Subsequent assignments took him under the sea for marine archaeology and over the sea to the Samoan Islands and Australia. He returned to Hawaii to depict leis, "the flowers that say 'aloha,'" and has been photographing there ever since.

GRALL, GEORGE Snakes and toads and other crawling creatures have fascinated George Grall since he was three years old, so that waiting a week in a New Guinea rain forest for one picture of a frog came to him naturally. Such patience has allowed Grall to photograph seahorses, snapping turtles, the invertebrates clustering on a Chesapeake wharf piling, and the creatures of the Chihuahuan Desert for a variety of National Geographic publications.

GREHAN, FARRELL Originally a painter and sculptor, Farrell Grehan found a new line of work when he began photographing the teeming life of New York City. That led to a stint as a *Life* magazine stringer, followed by a dozen years shooting freelance for National Geographic. His stories have ranged from biographical tributes to Thoreau, Willa Cather, and Teddy Roosevelt to the Mazatzal Wilderness in Arizona.

GROSVENOR, GILBERT H. The "master builder of the National Geographic," Gilbert Hovey Grosvenor (1875-1966) was the one man most responsible not just for making the Society and its magazine a worldwide success but also for making photography its primary language. The first and only paid employee when he arrived in 1899, Grosvenor proved to be an editor of genius, and by the time he retired in 1954 the Geographic was widely regarded as an American institution.

GROSVENOR, GILBERT M. Like his father, Melville Grosvenor, and grandfather before him, Gilbert Melville Grosvenor has served both as editor of *National Geographic* (1970-80) and president of the Society (1980-96). After joining the staff in 1954, he did spend a number of years, when not picture editing, on photographic assignments from Ceylon and Bali to Yugoslavia, the Aegean, and East Africa.

David Alan Harvey

GROSVENOR, MELVILLE BELL Son of Gilbert H. Grosvenor and a president and editor of National Geographic in his own stead, Melville Bell Grosvenor (1902-1982) joined the Society in 1924. In 1930 he made what might be the first color photographs taken from the air, using Finlay plates from a comparatively stable dirigible. His decade at the Society's helm corresponded to a period of flowering and growth in many directions, including the introduction of National Geographic television.

GUARIGLIA, JUSTIN It was while studying in China in the 1990s that Justin Guariglia grew increasingly absorbed in such Eastern religious philosophies as Taoism and Buddhism, visiting every holy mountain, temple, and shrine he could find. Over the next decade, while living in Asia, he also became a contributing photographer to National Geographic *Traveler*—which has taken him to Ireland, Mexico, or the Canary Islands as often as it has to his beloved Taiwan, Japan, and China.

HAAS, ROBERT B. Bobby Haas has achieved something many people have only dreamed of: a second career as a National Geographic photographer. A successful financier, Haas has embarked on experiments in aerial photography on continental scales. His dramatic, stirring images of African animals or South American landscapes seen from the vantage of the sky have been published by the Society as *Through the Eyes of the Gods* and *Through the Eyes of the Condor*.

HARVEY, DAVID ALAN While still relatively new to the trade, David Alan Harvey received an arts fellowship that helped steer him away from the worldview of black-and-white newspaper photography to that of color magazine photography. Yet at heart he remained a photojournalist, and over the four decades he has been shooting for National Geographic—staff, freelance, or contract—he has completed over 60 assignments. He is widely regarded as a master of his craft.

HATCHER, BILL Bill Hatcher knows that the primary requisite for being a good adventure photographer is to be both cameraman and participant at the same time. When it comes to rock climbing, skiing, kayaking, mountain biking, or any other adrenaline-soaked activity Hatcher remains closely involved. Scaling Pakistan's Trango Tower,

biking across the Alaska Range, and exploring the slot canyons of Arizona are among the adventures that he has photographed for National Geographic.

HILDENBRAND, HANS Born in Germany, Hans Hildenbrand (1870-1957) was an artistically inclined youth who took early to photography and eventually became the court photographer to King Wilhelm of Wurttemberg. In the early years of the 20th century he traveled throughout Germany, Poland, and the Balkans, making an Autochrome record of Old Europe, much of which was published in the pages of National Geographic—and much of which was also destroyed by an air raid in the Second World War.

HISER, DAVID For the better part of two decades, from the early '70s onward, Colorado-based David Hiser was a National Geographic freelance photographer with over 30 assignments to his credit. Although sometimes roaming the far-flung isles of the Pacific, he was more often photographing the remote trails and dusty byways of the West, from deep in Mexico to the mazy canyonlands of the Rockies.

HOFFMANN, FRITZ No photojournalism school gave Fritz Hoffmann a leg up on his craft—he learned photography on the job, whether that meant an Alaskan crab boat or a small-town newspaper. In 1995 he moved to Shanghai, the first foreign photographer to be accredited a resident journalist there, and traveling all over the country, has since been chronicling the rise of China to world prominence.

HEURLIN, GUSTAV A pioneer of color photography, Gustav Heurlin (1862-1939) began his camera career as an enthusiastic amateur and eventually became the Swedish court photographer. Between 1919 and 1931 National Geographic published a number of his Autochromes depicting Norwegian fjords, Danish farms, Swedish costumes, and other colorful features of Scandinavian scenery.

IMBODEN, OTIS Otis Imboden (date uncertain-2006) had hardly joined the National Geographic staff in 1961 before he was detailed to cover the space program at Cape Canaveral—an assignment that lasted the better part of a decade. A Memphis boy who had a master's degree in English literature,

Chris Johns

Imboden won the Apollo Achievement Award for his efforts and went on to photograph drowned galleons, the Everglades, ancient Maya ruins, and experimental sailplanes before retiring in 1986.

JACKSON, WILLIAM HENRY Although he showed promise as a painter, when William Henry Jackson (1843-1942) after the Civil War drifted out to Omaha, Nebraska, he opened a photographic studio. Over the next several decades he became the pioneering photographer of the American West, his images of the Grand Tetons and the Mountain of the Holy Cross destined to become icons in the American imagination, and those of Yellowstone helping to establish it as the world's first national park.

JOHNS, CHRIS Editor of *National Geographic* since 2005, Chris Johns knows firsthand the rigors that field assignments can entail. From western North America to the Kalahari Desert to the Great Rift Valley of Africa, the Oregon native has photographed eight cover stories out of the 20 magazine assignments he completed since first shooting for the Geographic as a freelancer in 1983.

JOHNSON, LYNN After 30 years as a photojournalist, Lynn Johnson feels that she is now moving from "observer to advocate." That is because, to her, "the people are more important than the photographs." Since she

commits herself so completely to the communities she encounters, this attitude has lent her pictures an especially sensitive touch—including those photographs accompanying such hard-hitting *National Geographic* stories as those on the threat of worldwide pandemics or weapons of mass destruction.

JONES, DEWITT For nearly two decades, starting in 1972, not long after his graduation from Dartmouth, DeWitt Jones was a steady freelance contributor to *National Geographic* magazine. He specialized in elegiac and evocative pieces on such topics as the wilderness vision of John Muir or the New England celebrated by Robert Frost, the majestic California Redwoods or the mysterious Anasazi people who once thrived in the desert Southwest.

JOUBERT, BEVERLY An entire world in a single image—that's what Beverly Joubert tries to instill in her wildlife photography—a single image with the power, in turn, to make us care about that world, and so to promote greater environmental awareness. Born in South Africa, she and her husband, Dereck Joubert, have spent years making spectacular and award-winning wildlife films in Botswana. Today they are both National Geographic Explorers-in-Residence.

KARNOW, CATHERINE Catherine Karnow, daughter of American journalist Stanley Karnow, was born in Hong Kong and graduated from Brown University. Becoming a full-time photographer in 1986, she has since covered subjects from Australian aborigines to Connecticut high society to the return of General Giap to the Vietnamese hideout near the battlefield of Dien Bien Phu. A durable contributor to *Traveler* magazine, she also gained access to Britain's Prince Charles for a 2006 *National Geographic* feature story.

KASHI, ED "I deeply believe in the power of still images to change people's minds," says freelance photojournalist Ed Kashi, and he has used his cameras to explore such politically and emotionally charged territory as the West Bank and Northern Ireland. His work with National Geographic, dating from 1990, began with a cover story on the embattled Kurds, and subsequent assignments have tackled such volatile issues as Syria, Zulu restiveness, and the oil-fueled violence in the Niger Delta.

KASMAUSKI, KAREN Karen Kasmauski had been an award-winning newspaper photographer when in 1984 she began shooting freelance for National Geographic. Over the years her assignments have evolved from cultural and regional pieces to increasingly wide-ranging, increasingly thought-provoking looks at aging, AIDS, obesity, radiation, and viruses—work which led to her book, *Impact: Dispatches from the Front Lines of Global Health*, which was nominated for a Pulitzer Prize.

KENDRICK, ROBB Unlike many of his peers, freelancer Robb Kendrick is not exploring the digital frontier. Instead he's returned to the old frontier, territorial as well as photographic. Kendrick has become a devotee of the kind of old-fashioned wet-plate photography that results in tintypes, each one a handmade, unique image and not a negative. His evocative tintypes of today's cowboys have been published in *National Geographic*.

KLUM, MATTIAS A face-to-face encounter with a lion in India's Gir forest is but one of the risks Mattias Klum has run in his remarkable career as a wildlife photographer. Born in Uppsala, Sweden, Klum was a full-time freelancer before he was 20. First published in *National Geographic* in 1997, he has photographed from Africa to Antarctica, but is especially focused on ecologically threatened, diminishing rain forests of Borneo.

KNOTT, FRANKLIN PRICE Perhaps the best-known American master of the Autochrome, Franklin Price Knott (1854-1930) was well past 50 years of age when that first practical method for color photography was made available. Knott, a painter of miniatures, soon steered his energies full-time in this new direction. Having had several Autochrome sequences published in *National Geographic*, in 1927 he embarked on a tour of the Orient that provided the magazine with several hundred additional unprecedented color plates.

KRASEMANN, STEPHEN J. Photographer, author, artist, Stephen J. Krasemann has had a varied career. A publicity photographer for the Rolling Stones and cinematographer for *Sesame Street*, he even worked for *Vogue* before shooting natural history assignments for the National Geographic Society. He has photographed animals in the Arctic, migrating birds in the Great Lakes, and seashore life along the southeastern coasts. He also photographed an article on the aspirations and activities of the Nature Conservancy.

KRISTOF, EMORY Emory Kristof, a pioneer in deep-sea photography, was a National Geographic staff photographer between 1964 and 1994. Using remotely controlled imaging systems, he made pioneering images of abyssal life, especially the first hydrothermal vent communities ever discovered, and photographed numerous shipwrecks lying too deep for scuba. Kristof was recognized by Kodak in 2000 as "one of four great visionaries who have taken photography to the digital frontier and beyond."

LAMAN, TIMOTHY G. Both wildlife photographer and field biologist, Tim Laman strives to make "compelling images that will convey the beauty, uniqueness, and fragility of the rain forest." Born in Japan, Laman earned a Harvard Ph.D. for his work on Borneo's strangler fig trees. Borneo remains a primary focus—he is married to orangutan researcher Cheryl Knott—though National Geographic assignments now take him increasingly around the world to document other rare animals and vanishing ecosystems.

LANTING, FRANS Born in Holland, Frans Lanting is a celebrated nature and wildlife

Bianca Lavies

photographer whose work has been frequently published in National Geographic books and magazine articles. He has photographed bonobos in tropical Africa, lemurs in Madagascar, volcanoes in Hawaii, and penguins in Antarctica. He even spent a year traveling around the world just making the pictures for a 1999 special issue on biodiversity.

LANZA, PATRICIA Pat Lanza actually began her career working in the National Geographic Image Collection before departing to become a freelance photographer. She contributed hundreds of pictures to such Society products as educational filmstrips and other media, home video, exhibit materials, and other publications and products. She has photographed all over the world, covering such subjects as the plight of the Swazi Zulu during apartheid and endangered sea turtles in the Maldives Islands.

LARSEN, LENNART Born in Denmark in 1924, Lennart Larsen worked as a staff photographer for many years at the National Museum in Copenhagen. He is best known for his studies of Tollund Man and Graubelle Man, well-preserved sacrificial bodies discovered in the 1950s in Danish peat bogs. Larsen was selected to make the official portrait of Queen Margrethe II in 1980.

LAVENBURG, JOSEPH D. Arriving at National Geographic in the early 1960s, Joseph D. Lavenburg worked for many years in the photo lab. He was often a member of the Still Photo Pool at Cape Canaveral, where he processed film of Gemini and Apollo launches for the global press. For 20 years before his 1994 retirement he was a studio photographer, making portraits of government officials and photographing objects at numerous museums and institutions.

LAVIES, BIANCA A staff photographer from 1974 to 1987, Bianca Lavies' specialty was natural history subjects, the more bizarre the better. She slithered among snakes, ventured among "killer" bees, explored the world of a compost pile, and photographed millions of monarch butterflies clustered in their Mexican winter haven. Born in Holland, she had wandered to New Zealand and South Africa before arriving in the United States after crossing the Atlantic in a 30-foot sailing boat.

LEEN, SARAH Sarah Leen, College Photographer of the Year while at the University of Missouri, was a National Geographic intern when her first story, on Uganda, was published in the magazine. That was followed by 27 years of freelance contributions, including not only geographical subjects ranging from Lake Baikal to Macedonia but also such complex assignments as urban sprawl, alternative energy, and skin (the organ). Today Leen is an illustrations editor on the magazine's staff.

LITTLEHALES, BATES An early master of 35mm underwater photography, Bates Littlehales is a Princeton graduate who was given his first diving lesson shortly after joining the Society's staff in 1952. He photographed the activities of Jacques Cousteau as well as other deep-sea pioneers and marine archaeologists. He even designed the Oceaneye, a highly praised underwater camera housing. Today Littlehales, who retired in 1989, is a highly regarded bird photographer.

LIITTSCHWAGER, DAVID David Liittschwager is a wildlife photographer with a unique provenance: He came from the world of advertising, having worked with Richard Avedon in New York City, and the techniques of portraiture he learned there he has brought to subjects as small as zooplankton. His aim is to depict even the tiniest animal as an individual, and his studies of marine microfauna and other creatures have been published in National Geographic books and articles.

LOCKE, JUSTIN A National Geographic staff photographer from 1947 to 1952, Justin Locke completed assignments ranging from Paris to the Pyrenees to Puerto Rico. Most of his attention, however, was focused on that enchanted terrain reaching from Old Mexico through the Grand Canyon and Colorado Plateau to New Mexico, where he eventually made his home. He was a painter as well as photographer.

LOUDEN, ORREN Orren Louden (1903-1974) was a writer, artist, and photographer who was on the National Geographic staff between 1925 and 1931. During these years he was mostly making color photographs around Washington, D.C., and the mid-Atlantic region. He had studied in New York City beforehand,

and afterward settled in San Diego, where he was director of the Village School of Art.

LUDWIG, GERD Born in Germany, Gerd Ludwig had been working as a freelance photojournalist when the Berlin Wall came down. He was an ideal choice to cover a *National Geographic* magazine story on German reunification, which led to a whole series of issue-driven assignments on the breakup of the Soviet Union, the lingering after-effects of Chernobyl, pollution, oil politics, and the new Berlin and new Moscow. Ludwig's images also appeared in the National Geographic book *Broken Empire*.

MADDEN, ROBERT A graduate of the University of Missouri School of Journalism, Robert W. Madden was a National Geographic photographic intern in 1967, but returned as a full-fledged staff member in 1973. For the next decade his assignments carried him across the United States, down to Antarctica, and into a newly opened China. His coverage of the 1976 Guatemalan earthquake was honored with an Overseas Press Club award.

MARDEN, LUIS A Society stalwart for half a century, Luis Marden (1913-2003) was once described as the epitome of the National Geographic field man. Beginning in 1934 and lasting long after his ostensible retirement in 1976, Marden, the prototypical "Renaissance man," introduced 35mm Kodachrome to the Society, was a pioneer in modern underwater photography, covered the early space program, and either wrote or photographed over 60 stories for the magazine.

MARTIN, CHARLES When in 1915 he became the first chief of the National Geographic photo lab, Charles Martin (1877-1977) was a department of one and used to

Gerd Ludwig

dry prints on cookie sheets in the sun. A former Army sergeant who made his name wielding a camera in the Philippines, Martin was a genius with photographic chemistry, and through his labors the first undersea color photos were made. He retired in 1942.

MAZE, STEPHANIE Born in New York City, Stephanie Maze worked for the San Francisco *Chronicle* before she started freelancing for National Geographic. She specialized in photographing the culture of the Iberian Peninsula, especially those far-flung lands in the New World that bear the stamp of Spanish and Portuguese hearths: Latin America and Brazil.

MAZZATENTA, O. LOUIS A staff member for 33 years (1963-1994), O. Louis Mazzatenta—or Ma Lao, "Old Horse Face," as he is called by Chinese friends who can't pronounce his name—has been variously a picture editor, a layout director, and a photographer. He was the first Western journalist to photograph the model army found in the tomb of Han Emperor Jin Di, and he has continued photographing the terracotta legions, oracle bones, and dinosaur fossils being discovered in China.

MCCURRY, STEVE World-famous if only for a single image, Steve McCurry has been covering war and conflict since he first donned Pashtun garb and slipped into embattled Afghanistan in 1980. Yet McCurry is more than a war photographer; he is a photojournalist primarily interested in exploring what he describes as the "broader landscape you could call the human condition." His many National Geographic assignments have given him scope to photograph the far-reaching impact of turmoil on human beings.

MCINTYRE, LOREN Loren McIntyre (1917-2003) first saw South America at 17 from the deck of a freighter. The continent so cast its spell over him that by the 1960s he was covering it as a freelance National Geographic writer-photographer. For the next 20 years, while he scaled its mountains, located the source of its greatest river, and was kidnapped by its Indians, he produced over a dozen stories ranging from the Andes to the lost world of the Amazon.

MCLEISH, DONALD A native Londoner, Donald McLeish (1879-1950), tired of taking

tourists to Switzerland and making images for cigarette cards, became in 1910 a freelance photographer. His images of Europe and the Middle East, before and after the First World War, were published not only in Britain but also in *National Geographic*. A clever chap, he built his own camera so that his 8x10 prints might render "exceptionally fine detail."

MCNALLY, JOE Joe McNally wanted to be a sports writer until he hefted his first camera. He's been hefting them ever since, deploying them in clever and technically astute ways. "If I can do something that's really cool..." McNally muses, and his celebrated and imaginatively rendered images have enlivened a number of *National Geographic* stories, including that rhyming trio: the sense of sight, the future of flight, and the power of light.

MELFORD, MICHAEL Torn between engineering and art while at Syracuse University, Michael Melford picked up a camera and his problem was resolved. As a freelance photographer who has shot prolifically for Society publications since 1990, Melford can unite his mechanical side with his creative bent. He has focused his art and craft on places of scenic grandeur such as national parks and historical sites, and increasingly on threatened wilderness areas.

MOBLEY, GEORGE F. Discharged from the Air Force, George F. Mobley decided to become a photojournalist, so he earned a degree from the University of Missouri and eventually landed a job with National Geographic in 1961. For the next 33 years assignments took him quite literally around the world; but no place in Asia, Africa, or Europe quite enchanted him as did those regions with which his work is most closely intertwined, the Arctic and Antarctica.

MODEL, BOBBY Growing up in Wyoming, photographer Bobby Model first turned to climbing and action-oriented sports as fit subjects to shoot. By the time he was shooting assignments for National Geographic *Adventure* in such places as Libya and Iran, however, he was moving toward photojournalism, toward work that might "bring new awareness, and help change situations." May he get the chance—Model received serious head injuries in a 2007 rock-throwing incident in Cape Town.

George F. Mobley

MOFFETT, MARK Originally Mark Moffett taught himself macrophotography to better document his Harvard Ph.D. thesis on Asian marauder ants. The superb artistry of his pictures, however, soon won them a spot in *National Geographic*. Ever since, Moffett has been training his lenses not just on all manner of ants but also on jumping spiders, poison dart frogs, mantids, and entire ecosystems that might clothe just one giant forest tree.

MOLDVAY, ALBERT Born in Hungary but raised in Pittsburgh, Albert Moldvay (1921-1995) had been a photographer for the Denver *Post* before joining the Society's staff in 1961. He then spent five months in Antarctica, prelude to a decade of assignments that included Spain, the Italian Riviera, New York City, and the Air Force in Vietnam. After resigning in 1972, he established an independent business and wrote a syndicated photography column.

MOMATIUK, YVA She came from Poland by way of New York City; he hailed from New Zealand and arrived from London. But once Yva Momatiuk and John Eastcott met in Wyoming, they began the partnership that have made them esteemed writers and photographers on natural history subjects and indigenous peoples. In 1976 they began working freelance for National Geographic, covering stories from the Inuit communities of the Arctic to the high mountains of their respective homelands.

MOORE, W. ROBERT "The First Million Miles," W. Robert Moore (1899-1968) was going to title his memoirs. The Michigan farmboy had worked for Detroit newspapers and taught science in Siam before his color photography landed him a job with National Geographic in 1931. Eventually serving as chief of its foreign editorial staff, Moore had a hand in nearly 90 articles, ranging from Africa to Asia and the Americas, before retiring in 1967.

MURAWSKI, DARLYNE A. With a Ph.D. in biology from the University of Texas and a master's of fine arts from the Art Institute of Chicago, Darlyne A. Murawski is well equipped for her particular kind of natural history photography. Having photographed passion vine butterflies for National Geographic in 1993, she has combed the world in search of killer caterpillars, spiders' webs, marine worms, diatoms, and other small fry that her scientific side can understand and her artist's eye can depict.

MUSI, VINCENT J. Born in Sewickley, Pennsylvania, Vincent J. Musi secured his first real newspaper job just upriver at the *Pittsburgh Press*, remaining there for nearly a decade. In 1993 he began freelancing for National Geographic, where his assignments have spanned a great range of subjects. Musi has photographed Route 66, West Indian volcanoes, the Texas Hill Country, Wales, animal thinking, and the mummy-strewn catacombs of Palermo, Sicily.

MYERS, TOM "We take pictures of what interests us," says Tom Myers, who alongside his wife and son is a freelance stock photographer. "And almost everything interests us." The images he has contributed to National Geographic over the years mirror this universality: They range over countless subjects from natural history to science and technology, and have appeared in the Society's books, magazines, filmstrips, educational media, calendars, and other products.

NACHTWEY, JAMES James Nachtwey sees his role as a photojournalist to be that of a witness, with his pictures his testimony. He has photographed nearly every war or outbreak of bloodshed since he became a freelancer in 1980. His pictures of turmoil around the world have garnered him numerous awards, while his National Geographic assignments have included moving essays on the wounded of the Iraq war and issue-driven pieces like pollution in Eastern Europe.

NEBBIA, THOMAS A combat photographer in Korea, Thomas Nebbia was working for the Columbia *State Record* in South Carolina when in 1958 he was recruited to join the National Geographic's staff. A talented

general assignment photographer, Nebbia's assignments took him to Cape Canaveral, newly walled off West Berlin, Guantánamo Bay in Castro's Cuba, and dozens of other places before he resigned in 1966. He continued shooting for the Geographic for several years thereafter on a freelance basis.

NICHOLS, MICHAEL (NICK) Michael K. Nichols has spent much of his National Geographic career slogging through Africa. Yet his photographs demonstrate the power of photojournalism to make a tangible difference: His depiction of Gabon's pristine rain forest led that nation to set much of it aside in a series of national parks, and his portrayal of the beleaguered elephants of Chad raised public awareness and, what's more, funding to help protect them.

NICKLEN, PAUL Growing up on Baffin Island in Arctic Canada, Paul Nicklen was torn between becoming a wildlife biologist or a nature photographer. Three months spent alone on the open tundra of the far north convinced him that he could better serve wildlife populations through photojournalism. His depictions of wildlife over, upon, and especially underneath the frozen surface of the Arctic Ocean have since become regular features in National Geographic publications.

NICKLIN, FLIP A San Diego native and son of an underwater photographer, Charles "Flip" Nicklin taught himself how to free dive with whales so as not to scare them with the bubbles emitted by scuba equipment. As a result he obtained unprecedented pictures of cetaceans, and has continued this for several decades, with pictures of humpback whales, blue whales, sperm whales, narwhals, orcas, belugas, and other marine mammals.

NIGGE, KLAUS Born in Germany, Klaus Nigge was for many years a wildlife biologist before turning to nature photography full-time. A painstaking craftsman, Nigge is a self-described "slow photographer," patient in approach and ingenious in the construction of his blinds. He has photographed animals ranging from bears to the rare European bison, and his pictures of white pelicans, Steller's sea eagles, and the endangered Philippine eagle have been published in *National Geographic*.

NOWITZ, RICHARD Named Travel Photographer of the Year in 1996 by the Society of American Travel Writers, Richard T. Nowitz has been contributing pictures to National Geographic books and magazines since 1992. Many of his photographs have appeared in works for children, and Nowitz has been singled out for excellence in educational publishing.

OAKES, ROBERT S. Robert S. Oakes (1922-2004), a National Geographic staff photographer from 1960 to 1985, specialized in official portraiture. He photographed U.S. Presidents, Supreme Court justices, foreign dignitaries, Queen Sophia of Spain, and Haile Selassie of Ethiopia. A Colorado native who served in the Coast Guard in World War II, Oakes even traveled to Alma Alta in the Soviet Union to photograph Russians for the U.S. Information Agency.

O'BRIEN, MICHAEL Michael O'Brien is a freelance photographer who has made portraiture his specialty. The Memphis native, who put himself through school shooting pictures for the school paper, began his professional career with the Miami *News* before entering the world of magazine photography. His work for National Geographic includes portraits of Australians for a special issue on that country's bicentennial, coal mining in Appalachia, and a profile of Austin, Texas.

O'REAR, CHUCK It was a 1978 National Geographic assignment to photograph California's Napa Valley that led Charles O'Rear to his primary vocation, the photography of wine. Before devoting himself full time to that, he worked for 25 years on freelance Geographic assignments. He shot regional and geographical profiles ranging from Canada to Indonesia, but mostly concentrated on such complex technological pieces as computer chips, lasers, holography, and advanced materials.

OLSENIUS, RICHARD Photographer, filmmaker, and musician Richard Olsenius has an abiding love for the American landscape that runs throughout his work. A former prizewinning newspaper reporter, his National Geographic assignments have ranged across the Midwest and into far northern Canada. He has photographed dogs for the magazine and joined Garrison Keillor in a quest to locate the "real" Lake Wobegon. From 1995 to 1999 he was an illustrations editor at the Geographic.

OLSON, RANDY A versatile photojournalist with a variety of assignments to his credit, Randy Olson has been shooting pictures for the National Geographic Society since 1990. One of only two people to ever win Photographer of the Year accolades in both newspaper and magazine categories, Olson's credits include stories on remote Siberia, consumerism in China, ancient Black Sea shipwrecks, depletion of global fisheries, and the conflict between park and people on the Serengeti.

PARKS, WINFIELD A native of Rhode Island and former Navy cameraman in Korea, Winfield Parks (1932-1977) was a highly touted photographer for the *Providence Journal-Bulletin* when National Geographic won the competition for his services. Joining the staff in 1961, Parks embarked on a series of assignments that for the next 15 years took him to some 40 countries. Then he died of a sudden heart attack at the age of 45.

PEARY, ROBERT EDWIN Robert Edwin Peary (1856-1920) was one of the most lionized—and controversial—figures in the history of polar exploration. Veteran of some eight expeditions to the Arctic, and the man who finally determined that Greenland was an island, Peary claimed to have reached the North Pole on April 6, 1909. That claim has been disputed but never disproved. His collection of historic photographs made during his expeditions are now in the Society's archives.

Winfield Parks

PETER, CARSTEN Going boldly where no sane person would venture, German photographer Carsten Peter has made close-ups of tornadoes, rappelled into active volcanoes, braved toxic caves and acid waterfalls, and flown his paraglider to dizzying heights. "I'm most interested in the unknown," he dryly observes. Yet he has made vivid, unprecedented images, many appearing in National Geographic publications, of natural phenomena that many people would have thought impossible to photograph—and get away with it.

PELLERANO, LUIGI An enigmatic Italian colonel who apparently lived in Rome, Luigi Pellerano (dates unknown) must have been an avid amateur photographer and Autochromist, because eight color portfolios of his pictures were published in *National Geographic* magazine in the 1920s and '30s. Many of his glass plates and black-and-white photographs now reside in the Society's archives.

PONTING, HERBERT G. As the first professional photographer in the Antarctic, and the first person to make a film there, Herbert Ponting (1870-1935) has an assured place in the pantheon of expedition photography. Inventor of the kinatome, a kind of portable projector, Ponting's photographs of the Far East were widely published in the years before he signed on with Captain Robert Falcon Scott's 1910-13 British Antarctic Expedition.

PSIHOYOS, LOUIS Complex technological subjects have always been a challenge to depict in photographs for a magazine audience, but such subjects as the nature of sleep or the sense of smell might have been thought impossible to adequately depict at all. Louis Psihoyos helped change all that with his imaginative coverages of both sleep and smell for National Geographic. A contract photographer, Psihoyos also photographed stories on trash and landfills, the information revolution, and fossil dinosaur hunting.

QUINTON, MICHAEL S. A noted wildlife photographer, Michael S. Quinton grew up in Idaho and taught himself the rudiments of cameras and lenses so that he might better indulge his interest in the natural world. He has lived near Yellowstone and in Alaska, and his photographs of great gray owls, goshawks, common loons, ravens, and even flickers have been published by National Geographic.

RAYMER, STEVE Steve Raymer not only earned a master's degree in journalism, he also studied Soviet and Russian affairs at Stanford and was a lieutenant in Vietnam. So he was well prepared when he joined National Geographic in 1972 to cover the story behind the story that was breaking news. For the next three decades Raymer's photographs illustrated articles on wars, famines, the problems of developing countries, and the challenges of the post-Cold War world.

REVIS, KATHLEEN Although not the first woman to have her pictures published in *National Geographic*, Kathleen Revis (1923-2006) was the first woman to be hired, in 1953, as a staff photographer. Growing up in India and Charlottesville, Virginia, she loved horses and hiking. For the Geographic she photographed stories on dogs as well as horses and such vacation spots as Scotland, Switzerland, Quebec, and the national parks of Canada and the U.S.

REYNARD, NICOLAS Growing up, Nicolas Reynard (1959-2004) had always dreamed of being a National Geographic photographer. The Paris-based journalist achieved that ambition shooting assignments in Myanmar and Gabon and especially in the Amazon, where he was attached to the expedition that made the first peaceful contact with the reclusive Korubo people. It was also in the Amazon, however, that he was killed in a plane crash at the age of 45.

RICHARDSON, JIM A Kansas farm boy, Jim Richardson may have traveled the world for over 25 years shooting pictures for National Geographic, but he has never left his roots behind. He has been documenting the Cuba, Kansas, community for even longer—30 years—in addition to such Geographic assignments as water issues on the Great Plains, food supply, Scotland and Cornwall, light pollution, and even an occasional volcano to scramble around in.

ROBERTS, J. BAYLOR Mild-mannered and self-effacing, Joseph Baylor Roberts (1902-1994) was nevertheless one of the most dependable National Geographic staff photographers of the mid-20th century. He photographed anything and everything anywhere in the world, contributing to nearly 60 stories between 1936 and 1967. Though nearly 60, he was selected to accompany the submarine

U.S.S. *Triton* when it made its historic first submerged voyage around the globe.

ROCK, JOSEPH F. There were few more colorful expeditions than those undertaken by Joseph Rock (1884-1962) in the 1920s to the far hinterlands of China. The eccentric, Viennese-born botanist spent 27 years in the remote Tibetan borderlands, collecting exotic plants while dodging warlords, eluding bandits, parleying with lamas, and photographing little-known peoples and ceremonies. His ten *National Geographic* articles have never lost their popularity, while his negatives and prints are an important component of the Society's archives.

ROGERS, MARTIN A North Carolina native, Martin Rogers was a full-time reporter at the Raleigh paper when he was only 16. That led to a National Geographic photo internship, and by 1972, when he was 23, he was a Geographic contract photographer. For the next 12 years Rogers' assignments ranged from Baltimore to Belgium to the catastrophic oil spill of the Amoco *Cadiz* off Brittany. Once he visited five continents covering just a story on the humble potato.

ROOT, ALAN Growing up in Kenya after World War II, Alan Root was a daredevil in quest of adventure before discovering wildlife photography. Together with his remarkable wife, the late Joan Root, he made a series of classic African wildlife films. While engaged in this undertaking, the Roots contributed several stories to the Geographic, including profiles of African flamingoes, red-billed hornbills, and the abundant wildlife found around Kenya's Mzima Springs.

ROSING, NORBERT As a young photographer, Norbert Rosing fell in love first with Scandinavia and then with the Arctic. In succeeding years he has photographed all of the creatures of the Far North: walruses, muskoxen, whales, Arctic foxes, and of course the polar bear. Many of his images have appeared in National Geographic publications. Rosing has also worked in Yellowstone, and is especially devoted to photographing the national parks of his native Germany.

ROWELL, GALEN A now-legendary mountaineer and landscape photographer, Galen Rowell (1940-2002) grew up climbing in the California Sierras and taught himself

the camera arts. Credited with many first ascents, Rowell was also a prolific writer whose contributions to National Geographic ranged as far as the Brahmaputra River, Baltistan, and the Karakorums. His final 275-mile trek over the Tibetan plateau was also memorialized in the magazine, for Rowell had been killed in a 2002 plane crash.

RUSSELL, JAMES E. A native of the Washington, D.C., area, James E. Russell began shooting pictures in high school. After briefly working for the Associated Press he was hired by the National Geographic's Photo Lab. A fun-loving young man, he proved a superb technician and his talent with the camera ensured that in 1967 he was promoted to staff photographer. Tragically, he died after abdominal surgery at the age of 29.

SARTORE, JOEL Joel Sartore became a photographer when he realized how much fun it could be. The former newspaperman, who grew up in Nebraska, began shooting on contract for National Geographic in 1992, and his numerous assignments have pivoted on complex ecological stories. Yet endangered species, endangered parks, the lost ivory-billed woodpecker, the countdown to extinction—Sartore cannot help but see in his pictures a rapidly vanishing world: "It's really the last of everything I'm photographing."

SCHERSCHEL, JOSEPH J. When Joseph J. Scherschel (1920-2004) joined National Geographic in 1963 he had already had one career on the legendary *Life* magazine staff. There he had photographed Truman and Eisenhower and Castro and desegregation. At the Geographic he photographed Louis Leakey and Macao and his ancestral homeland, Hungary. He covered Winston Churchill's funeral disguised as a dustman. When he retired in 1985 he was the assistant director of photography.

Joel Sartore

SCHNEEBERGER, JON National Geographic's superb collection of space program imagery was assembled thanks to the diligence of Illustrations Editor Jon Schneeberger (1938-2004). Joining the staff in 1966, Schneeberger soon began directing the photographic coverage of all NASA activities while securing copies of all mission photographs from Apollo through the Space Shuttle. Before retiring in 1994 he had also worked on Geographic articles profiling primitive peoples, especially those in the Amazon.

SCHREIDER, FRANK AND HELEN The five years (1964-69) that Frank and Helen Schreider were on the National Geographic staff were but one chapter in a shared life of travel. An appealing young couple, they drove amphibious jeeps—accompanied by a German shepherd—on long exotic rambles, writing and taking pictures. It was irresistible, and their wanderings across Indonesia, the Great Rift Valley, and the Near East were published by the Geographic. The Schreiders continued their vagabond ways until Frank's death in 1994.

SELLA, VITTORIO Vittorio Sella (1859-1943) was the first person to make photographs of the high Alps from the high Alps, not looking up but across. Born in Italy, Sella was 21 when he decided to combine his love of photography with that for mountaineering. The resulting prints were popular and influential, and he eventually photographed in the Caucasus, Alaska, the Himalaya, and even Africa's Ruwenzori Mountains.

SHIRAS, GEORGE III As a young man in the 1880s, George Shiras III (1859-1942) put away his gun and began "hunting with a camera." Wildlife photography was virtually nonexistent, but he pioneered methods and techniques, especially flashlight photography at night, to produce images that remain breathtaking today. Beginning in 1906 and for several decades thereafter, his pictures were seen by millions in the pages of *National Geographic.*

SHOR, FRANC Fluent in Chinese and Turki, a man who had his own wine cellar at the Paris Ritz, Franc Shor (1914-1974) was a talented journalist who served behind Japanese lines in World War II. He married Jean Bowie in Shanghai after the war, and the couple then traveled throughout Central Asia, writing

colorful stories on the Kashgai people and the Caves of a Thousand Buddhas for National Geographic. Shor eventually became associate editor of the magazine.

SHOR, JEAN BOWIE Jean Bowie Shor (1916-98), a former Red Cross worker from Texas, married Franc Shor in Shanghai and later wrote a book, *After You, Marco Polo*, describing how for a honeymoon they retraced the great explorer's route across Asia. She was on the National Geographic staff from 1955 to 1959. After the couple divorced, she married a safari guide and lived in Nairobi for many years.

SISSON, ROBERT F. Robert F. Sisson (birth date unknown-2002) joined the National Geographic staff in 1942. Over a long career he tried his hand at a span of assignments ranging from oceanography to paleontology to the Hungarian Revolution, but increasingly he favored natural history, making a specialty of photographing the small things in the round of life, such as his depiction of the changing seasons on his Virginia farm in "The World in My Apple Tree."

SKERRY, BRIAN When underwater photography was still a weekend avocation for Brian Skerry, he would usually photograph shipwrecks. But after the Massachusetts native began shooting for the Geographic in 1998, he gradually changed his focus to marine conservation. He has since photographed stories on harp seals, right whales, sharks, sea turtles, squid, dwindling coral reefs, and the decline of fisheries, all of which celebrate the sea yet also highlight its environmental problems.

SMITH, KERBY Based in California, freelance photographer Kerby Smith shot pictures on a variety of subjects—lasers, computers, ballooning, astronomy, the space shuttle—that were used in a variety of National Geographic publications and products ranging from the magazine to books and educational filmstrips.

SORIANO, TINO Born in Barcelona, Tino Soriano is a photojournalist and travel photographer who traces his inspiration to his grandfather's 35mm slides and collection of old, well-thumbed *National Geographic* magazines. After years of painstaking preparation, Soriano became a professional photographer in 1992. He has since written and illustrated

several books, and his pictures have been published in a number of Society publications, including travel guides to Madrid, Portugal, and Italy.

SPIEGEL, TED Discharged from the Army, Ted Spiegel had a camera in one hand and a fishing rod in the other. The camera only appeared to win—in 1959 he became a freelance photographer—because the focus of much of Spiegel's work has been the Hudson River Valley. That is despite—or perhaps because of—nearly two dozen National Geographic assignments that had taken him from the Arctic to such challenging subject terrain as water depletion, genetic engineering, acid rain, and air.

STANFIELD, JAMES L. Among the most celebrated of National Geographic staff photographers, James L. Stanfield was fabled even among colleagues for his dedication. A journalism graduate of the University of Wisconsin whose skills were honed at the *Milwaukee Journal*, Stanfield joined the Society's staff in 1967. For the next 28 years he worked in over a hundred countries on 65 assignments that ranged from chocolate to rats, gold to Burma, Genghis Khan to an intimate glimpse of Pope John Paul II.

STANMEYER, JOHN Expatriate photojournalist John Stanmeyer, living in Indonesia, once observed of natural disasters that "the Western press says these things are happening in remote regions. But the regions are not at all removed to the local inhabitants." Stanmeyer's coverage of the human suffering caused by Asian earthquakes, tsunamis, and volcanoes has been widely praised. Some of those arresting pictures, along with those depicting piracy in the Strait of Malacca and the scourge of malaria, have been published in the *Geographic*.

STEBER, MAGGIE "I want to tell people's stories," says photojournalist Maggie Steber. "I want to photograph what their conflicts are and what their struggles are." That's why the Texas native has spent over two decades documenting the everyday scene in Haiti. The former newspaper reporter has also, since 1991, been shooting stories for the Geographic that are equally concerned with human struggle: among them the African slave trade, the Cherokee Nation, soldiers' letters, and the loss of memory with aging.

George Steinmetz

STEINMETZ, GEORGE A Stanford graduate with a degree in geophysics, George Steinmetz left his native Beverly Hills far behind when he spent two years hitchhiking through Africa. Geophysics, however, played large in his first Geographic story, on oil exploration, and since it was published in 1989 Steinmetz has photographed dozens of pieces for the Society, including ones on the tree people of Irian Jaya, the ravages of alcoholism, and the most remote deserts as seen from the vantage of his motorized paraglider.

STENZEL, MARIA In 1980, fresh out of the University of Virginia, Maria Stenzel, unsure what to do with her life, turned up at National Geographic and accepted an entry-level job. Like many people, she quickly discovered that photojournalism was the ideal vocation. Through talent and hard work, she began publishing pictures, and two decades and over two dozen assignments later, has covered a wide range of subjects, but is especially enchanted with Antarctica.

STEVENS, ALBERT W. A pioneering aerial photographer, Albert W. Stevens (1886-1949) was chief of the Army Air Corps photography lab when he accompanied a National Geographic aerial expedition to South America. Subsequently he took the first picture to show the curvature of the Earth and the first to show the moon's shadow during an eclipse. In 1935 he rode the Geographic-sponsored *Explorer II* stratosphere balloon to a manned height record that stood for 21 years.

STEWART, B. ANTHONY Perhaps the most prolific National Geographic photographer of his era, B. Anthony Stewart (1904-1977) actually came to the Society in 1927 as the photo lab's bookkeeper. Soon enough, however, the Virginia native proved his proficiency with the camera, and before retiring in 1969 had

been long honored as the Society's chief photographer, having had many more pictures published than are even accounted for by the more than a hundred stories that carry his credit.

STEWART, RICHARD H. Tony Stewart's older brother, Richard H. Stewart (1903-2004) early established a reputation as the Society's most dependable expedition photographer. Whether in backwoods Alaska, the tropical Pacific, or the Central American jungles, Dick Stewart tackled every variety of photographic chore and often doubled as camp cook as well. It must have served him well, for the long-lived Stewart managed to hang on until the age of 101.

SUGAR, JAMES A. In 1967, James A. Sugar was a young graduate of Wesleyan University whose talent with a camera had won him a coveted spot as a National Geographic photo intern. Two years later the Baltimore native was back as a full-fledged contract photographer, and for the next 27 years he photographed a wide variety of subjects but mostly concentrated on technological pieces such as aviation or scientific ones such as the sun or, even better, the universe.

SZENTPETERI, JOZSEF L. Born in a small village in eastern Hungary, Jozsef Szentpeteri was early attracted to the natural world around him. After studying biology in school, he received a Ph.D. in plant taxonomy from the University of Pécs. But part of his childhood enthusiasm was channeled into a love of nature photography, and his talent for close observation led him to take pictures—of mayflies and dragonflies, for instance—of eye-opening quality.

TAYLOR, MEDFORD Born in rural North Carolina, Medford Taylor joined the Navy to see the world. After journalism school he saw a bit more of it while working for various newspapers and newsmagazines. In 1984, when he began two decades of freelancing for the National Geographic Society, he saw quite a lot of it, shooting assignments as varied as Newfoundland and the Everglades, Madeira and the mountains of Central Asia, Iceland and the Australian outback.

THIESSEN, MARK O. A National Geographic photographer since 1990, Mark Thiessen has shot a variety of stories, ranging from

the Baseball Hall of Fame to nanotechnology, for nearly all of the Society's publications. His particular interest, however, has been documenting the lives and activities of wildland firefighters in western North America, a project that has brought him to the wildfire front lines on numerous occasions and led him to become a certified wildland firefighter himself.

THOMPSON, WILLIAM Born on a ranch in Fresno, California, William Thompson earned a Ph.D. in anthropology, dabbled in painting, taught a little college, and ran a guide service in the Grand Tetons for 15 years before becoming, at 38, a professional photographer. He has photographed in rain forests and deserts and savannas, but for National Geographic he worked mostly in the high Himalaya, work that included the first complete aerial imagery of Mount Everest.

TOBIEN, WILHELM Wilhelm Tobien (died 1946) provided National Geographic with Autochromes and Finlay Plates in the 1920s and '30s. These early color series largely depicted scenes and villages in Austria, Sweden, and his native Germany. Yet Tobien also provided color pictures of Bulgaria, Romania, the Azores, and the Canary Islands.

TOENSING, AMY After cutting her teeth at her hometown newspaper in Hanover, New Hampshire, photojournalist Amy Toensing spent three years covering the White House and Capitol Hill for the *New York Times*. She then decided that her beat would be ordinary people. For National Geographic she has pictured the lives of ordinary people in Puerto Rico, Monhegan Island, the kingdom of Tonga, and in Australia during a severe drought.

TOMASZEWSKI, TOMASZ Born in Warsaw, Tomasz Tomaszewski began his career photographing for Polish magazines, *Solidarity Weekly*, and the underground press when *Solidarity* was outlawed. After the collapse of communism his work received favorable notice outside Poland, and by 1986 he was photographing for National Geographic. His many subsequent assignments have included not just Polish and Eastern European subjects but also stories in Central America, South Africa, and the United States.

TURNER, TYRONE Leaving hometown New Orleans, photographer Tyrone Turner went to Washington to study international relations at Georgetown University. That led to a fellowship with the Institute of Current World Affairs and two years photographing life in northeastern Brazil. Turner's National Geographic assignments have taken him back home, photographing Louisiana's troubled bayous before documenting the ravages of Hurricane Katrina and the rebuilding of New Orleans. He has also shot a cover story on energy efficiency and conservation.

TUTTLE, MERLIN The genuine "Bat Man," Merlin Tuttle is a mammalogist and founder of Bat Conservation International, established to "promote a positive image of bats and encourage their preservation." In the course of his work, Tuttle has become a leading photographer of his subjects, and his pictures of frog-eating bats in Panama, flying foxes in Africa, nectar-feeders in Mexico, and rare or threatened members of the family elsewhere have often been published in *National Geographic*.

VAN LAWICK, HUGO Known to millions in the 1960s and '70s as the Dutch husband of Jane Goodall, Baron Hugo van Lawick (1937-2002) was a wildlife photographer and filmmaker who devoted his life to documenting the spectacular animal life of the Serengeti Plain. Born in Indonesia, he was reared in England before embarking on his African odyssey, which eventually garnered him eight Emmy Awards for his films.

VON GLOEDEN, WILHELM Escaping the dank climate of his native Germany, Baron Wilhelm von Gloeden (1856-1931) settled in the sunnier one of Taormina, Sicily. Setting up as a photographer, he made portraits of the local people. Though best known for his nudes of

Hugo van Lawick

young men, they were not his only subjects, and many of his pictures were collected by connoisseurs. The National Geographic Society has a collection of his prints.

WALKER, HOWELL Refined and elegant, Howell Walker (1910-2003) was for 39 years one of the most beloved writer-photographers of National Geographic's foreign editorial staff. Fresh from Princeton when in 1933 he first turned up at the Society's door, he was gently rebuffed, but when he returned two years later having traveled around the world he was hired. His dozens of assignments took him from Ireland to the Italian Riviera to Australia, where he met his wife and where he finally retired.

WALL, STEVE Born in North Carolina, Steve Wall worked for a Chattanooga newspaper before shooting pictures all around the globe for Black Star and UPI. He started freelancing for National Geographic in 1978, concentrating mainly on social issues—the struggles of Vietnamese fishermen transplanted to Mississippi, the challenges faced by the modern Iroquois, the desecration of Indian burial grounds—as well as such environmental profiles as that of Georgia's Chattooga River.

WARD, FRED Fred Ward is a freelance photojournalist who first began working for National Geographic in 1964. A talented writer and photographer, Ward completed assignments in the 1970s and '80s on such difficult subjects as fiber optics, hazardous waste, and pesticides. He gained entry into what were then such difficult places as Tibet and Cuba (where he spent seven months). Perhaps his real specialty was articles on gems—diamonds, emeralds, and rubies.

WASHBURN, BRAD Among the most respected American mountaineers and mapmakers, Bradford Washburn (1910-2007) was contributing to National Geographic while still a Harvard undergraduate. Among many first ascents, he pioneered a new route to the top of Mt. McKinley (Denali), and his aerial photographs of the Alaska Range and Yukon Territory, made with a heavy Fairchild camera he often lugged to the mountaintops, depicted a glittering world of peaks and glaciers that he was among the first to map.

Brad Washburn

WEBB, ALEX Although his first successes were in black and white, after Alex Webb discovered color he had the ideal medium for capturing the rich palette of tropical life he finds so intriguing and beguiling. As demonstrated in numerous exhibitions as well as published work, including stories for National Geographic, Webb has portrayed places from the Amazon to Haiti to Istanbul with the eye of a street shooter married to that of an artist.

WEEMS, WILLIAM S. A graduate of Johns Hopkins' School of Advanced International Studies, William S. Weems (1943-1987) was a legislative assistant to Senator Daniel K. Inouye before beginning a career as a free-lance photographer. He soon began working for National Geographic, shooting stories on his native Atlanta, on North Carolina, and on Hungary. His career was just taking off when he was killed in a helicopter crash at the age of 44.

WENTZEL, VOLKMAR A native of Dresden, Germany, Volkmar Kurt Wentzel (1915-2006) grew up in New York State and joined the National Geographic in 1937 on the strength of his black-and-white photographs of Washington at night. Although assignments took him all over the world, he is best remembered for his two-year odyssey covering India on the eve of its independence. Before retiring in 1985, he helped protect and preserve the Society's priceless collection of Autochromes.

WILLIAMS, MAYNARD OWEN Maynard Owen Williams (1888-1963) quite simply opened the world for the National Geographic. Hired in 1919 as the Society's first field correspondent, Williams, the first chief of the foreign editorial staff, wrote and photographed some hundred stories before his 1953 retirement. Roaming Europe, the Near East, the far reaches of

Asia, even the Arctic and the Americas, he preferred cultivating "friendship, not adventure"—although he had plenty of both.

WILSON, STEVEN C. A noted landscape photographer, Steven C. Wilson began free-lancing for National Geographic in 1981 with a story on the Texas Gulf Coast, "where oil and wildlife mix." The native Iowan followed that with a profile of the Aleutian Islands before digging into a story on soil depletion and conservation.

WILTSIE, GORDON Growing up in the California Sierras, Gordon Wiltsie came by mountaineering naturally and photography through hard work. Today, however, he is widely recognized as one of the world's preeminent adventure and expedition photographers, veteran of over a hundred expeditions to such remote places as Antarctica, the Himalaya, the North Pole, and the high Andes. He has several *National Geographic* cover stories to his name.

WINTER, STEVE Jaguars, tigers, bears, snow leopards—as a boy in Indiana, Steve Winter had dreamed of being a National Geographic photographer, and when in 1991 he began shooting for the magazine he found himself having many such close encounters. He has also covered such countries as Cuba and Myanmar. He has said of this dual focus: "I am fascinated by people and culture, and have a great love for the natural world."

WISHERD, EDWIN L. Knowing nothing about photography when in 1919 he joined the Geographic as a lab assistant, Edwin L. "Bud" Wisherd (1900-1970) proved such a quick study

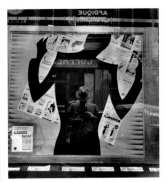

Maynard Owen Williams

that within a few years he became one the first staff photographers to process Autochrome plates in the field. In the 1930s a pioneer of 35mm Kodachrome, he then became chief of the Society's photo lab, making it one of the finest such facilities in American publishing.

WOLINSKY, CARY SOL Born in Pittsburgh, Cary Sol Wolinsky was photographing for the *Boston Globe* before even graduating from college. Shortly thereafter he began the long and prolific career, as both freelance and contract photographer, with National Geographic that has resulted in several dozen articles ranging widely from historical pieces—like Sir Joseph Banks—to photojournalism—the world's illicit diamond trade—to imaginatively conceived treatments of such uniquely interesting topics as poison.

WRIGHT, ALISON Armed with a master's degree in visual anthropology and a lifelong love of photography, Alison Wright has spent two decades documenting human rights issues and traditional cultures around the world, especially in Asia. She established the Faces of Hope Foundation to give something back to the communities in which she works because photography, she is convinced, "can bring an awareness that can help change people's lives for the better."

YAMASHITA, MICHAEL S. Though he grew up in New Jersey, Michael Yamashita caught the photography bug while working after college in Japan. He has since spent over a quarter of a century photographing Asian subjects—Vietnam, Korea, and especially China and Japan—for National Geographic, as well as undertaking coverages of "epic" proportions, following such travelers as Marco Polo and the Ming dynasty admiral Zheng He. Many books and films have been spun off from his work.

ZAHL, PAUL For many years the staff naturalist for the National Geographic Society, Dr. Paul Zahl (1910-1985) held both a masters and a doctorate in experimental biology from Harvard. The Illinois native made a specialty of natural history photography, and in 1958 he joined the National Geographic staff. His many articles and photographs for the magazine pivoted on subjects either very small—insects and sea creatures—or very large—the world's tallest tree, largest ant, or biggest flower.

THE ARTISTS

ANDERSEN, ROY Roy Andersen studied at both the Chicago Academy of Fine Art and the Art Center School of Design in Los Angeles. Some of his paintings that were used as covers for *Time* magazine are in the collection of the National Portrait Gallery; he also contributed a series of illustrations for stamps for the U.S. Postal Service.

BEAUMONT, ARTHUR A native of England, Arthur Beaumont (1891-1978) served for many years as the official artist of the U.S. Navy. He painted on-site at battles during World War II. His paintings have been exhibited at the National Gallery of Art, the White House, and naval bases throughout the U.S.

BERANN, HEINRICH A resident of Lans, Austria, Heinrich Berann (1915-1999) painted European landscapes ranging from Mount Etna to the Black Forest. In preparation for his view of the Himalaya mountains, he spent a month in India and Nepal and consulted with

cartographers and Himalayan experts before beginning the 600 hours of work at his drawing board needed to complete the illustration. His paintings of the world ocean floors, commissioned by National Geographic, had a major impact on cartography.

BIANCHI, PETER Peter Bianchi was a staff illustrator for National Geographic for more than a decade in the 1950s and 1960s. He was an expert in historical re-creations, and his work was also included in the books *Everyday Life in Bible Times, The Age of Chivalry,* and *Great Adventures: Exploring Land, Sea, and Sky.*

BITTINGER, CHARLES A native of Washington, D.C., Charles Bittinger (1879-1970) studied physics at MIT before leaving in 1901 for the École des Beaux-Arts in Paris. He enjoyed a successful career as a painter; his work was exhibited at the National Arts Club, the Art Museum of St. Louis, and the Metropolitan Museum of Art.

Else Bostelmann, The great gulper eel, *1934*

BLACKSHEAR, THOMAS II Thomas Blackshear II graduated from the American Academy of Art in Chicago and worked for both the Hallmark Card Company and Godbold/Richter Studio before becoming a freelance illustrator in 1982. He has designed many stamps for the U.S. Postal Service, including 28 portraits of famous African Americans for the 1992 Black Heritage series.

BOND, WILLIAM H. Born in London, William H. Bond began his career in art after serving in the Royal Navy during World War II. He graduated from the Twickenham School of Art. Bond joined the staff of National Geographic in 1966. The illustrator for several U.S. postage stamps, he is known for his depiction of subjects in natural history and physical sciences.

BOSTELMANN, ELSE Else Bostelmann (1882-1961) attended the University of Leipzig, Germany, and the Grand-Ducal Academy of Fine Arts in Weimar. She later moved to the U. S. and from 1929 to 1934 accompanied oceanographic expeditions to Bermuda. During these trips, she created oil paintings underwater, using a diving helmet at depths of 14 feet

BROOKS, ALLAN Born in India, Allan Brooks (1869-1946) traveled widely before and after World War I military service. While he was living in British Columbia in the 1930s, the National Geographic Society commissioned him to paint hundreds of illustrations for a series of ten articles on bird families of the United States and Canada.

Kinuko Y. Craft, Bringing news of war, *1984*

CALLE, PAUL Paul Calle was born in New York City and studied art at the Pratt Institute. He was named the official artist of the NASA Fine Arts Program; he created the illustration used for the U.S. postage stamp commemorating the Apollo lunar-landing mission.

CHAFFEE, DOUG Doug Chaffee has been illustrating space-related subjects for most of his career. A former head of IBM's art department, he has painted for NASA, the military, and for National Geographic, where he illustrated an article on Mars shortly before the Viking probes reached it.

CHANDLER, DAVID E. David E. Chandler's art for the National Geographic has ranged from illustrations of fleas, carriers of bubonic plague, to the Atacama Desert, to product development studies for such things as map place mats and geography coloring books.

CHEVERLANGE, ELIE An active marine and nature artist, Elie Cheverlange lived in Washington, D.C., and painted for the National Geographic Society during the 1930s. He later joined the staff of the Communicable Disease Center as an illustrator, and spent several years living in Tahiti.

CLEMENTS, EDITH S. Edith S. Clements (1874-1971) was born in Albany, New York, and received a Ph.D. from the University of Nebraska in 1904. She later moved to California and traveled back to the Midwest to find the floral specimens she painted for National Geographic. She also published two books of illustrations: *Flowers of Mountain and Plain* (1925) and *Flowers of Coast and Sierra* (1928).

CRAFT, KINUKO Y. Kinuko Y. Craft was born in Japan, where she attended the Kanazawa Municipal College of Fine and Industrial Arts. Craft's clients include *Time, Atlantic Monthly,* and *Sports Illustrated.* Her painting illustrating the Dallas Opera's production of *Madame Butterfly* received a gold medal from the New York Society of Illustrators.

CROWDER, WILLIAM Born in 1882, William Crowder was a writer and painter who specialized in marine life. He wrote numerous books, such as *Dwellers of the Sea and Shore,* and both wrote and painted articles for National Geographic on crabs, the aurora borealis, the moon jelly, and slime molds.

DALLISON, KEN Ken Dallison was born in England, attended the Twickenham Art College and trained as a cartographer in the army. He began specializing in vehicle illustration, especially automobiles, about 1959. He has created many U.S. postage stamps depicting such classics as the Stutz Bearcat and the Stanley Steamer.

DAVALOS, FELIPE Felipe Davalos is an illustrator and photographer who has produced a number of children's and young adults' books. For National Geographic he has illustrated articles on the Aztec, Tenochtitlan, and the Pueblo culture.

DAWSON, JOHN D. John D. Dawson studied at the Art Center College of Design in Pasadena. His illustrations have been published in *Audubon* and *Ranger Rick* magazines, and in the *World Book Encyclopedia;* other clients include the National Park Service and the American Museum of Natural History. He is co-author of the book *Grand Canyon: An Artist's View.*

DAWSON, MONTAGUE Montague Dawson (1895-1973) was one of Britain's premier maritime artists. To the manor born, he grew up in a yachting world and specialized in painting 18th- and 19th- century sailing ships bending beneath clouds of canvas.

Louis Agassiz Fuertes, A hit on grouse, *1920*

Jean-Leon Huens, Galileo—first to see the heavens, *1974*

DI FATE, VINCENT Vincent Di Fate has produced more than 3,000 illustrations. His work is included in many museum collections, including those of the Smithsonian Institution's National Air and Space Museum. His awards include both the Hugo and the Frank R. Paul Awards. Di Fate is the author of the 1997 book *Infinite Worlds: The Fantastic Visions of Science Fiction Art,* a history of the field.

DURENÇEAU, ANDRE Andre Durençeau (1904-1985) trained at the École des Beaux-Arts and the Germain Pilion in Paris before moving to the United States. As an illustrator, his clients included hotels, ocean liners, and the 1939 World's Fair in New York. He also worked as a muralist for prominent families such as those of Cornelius Vanderbilt Whitney.

DZANIKBEKOV, VLADIMIR Vladimir Dzanikbekov became a Soviet cosmonaut in 1970 and made five flights into space, for which he was twice decorated as a Hero of the Soviet Union. Unsurprisingly, when he retired from the cosmonaut program and took up painting as a hobby, he turned to space themes. He has a minor planet named after him.

EATON, MARY E. Born in Gloucestershire, England, Mary E. Eaton (1873-1961) studied art at several schools, including the Royal College of Art. After moving to the United States, she created illustrations for the New York Botanical Gardens for 21 years. Eaton made 672 paintings for the National Geographic Society; some 200 were published in the magazine and in the Society's 1924 *Book of Wildflowers.*

ELLIS, RICHARD A graduate of the University of Pennsylvania, Richard Ellis is known for his marine natural history illustrations. Among his many publications are *A Book of Whales* (1985), *A Book of Sharks* (1989), and, with John E. McCosker and Al Giddings, *Great White Shark* (1995). He has also contributed more than 80 articles to magazines such as *Audubon* and *Geo.* Ellis has led cruises for the American Museum of Natural History to Alaska and Antarctica.

EMERSON, GILBERT Gilbert Emerson was an artist on the National Geographic staff during the 1950s and '60s. He painted subjects as varied as Hannibal crossing the Alps, atomic energy, space satellites, underwater archaeology, the Dead Sea Scrolls, and notable trees.

ESTILL, ELLA A painter of botanicals, Ella Estill was born in Ohio but painted mostly the flora of the desert Southwest. A watercolorist, her depictions of cactuses and other plants were often painted for the Smithsonian Institution.

EUBANKS, TONY Tony Eubanks is a painter of the American West. Born in Texas, he studied at the Art Center in Los Angeles before returning home and taking up his craft. He has painted cowboys, landscapes, and Pueblo Indians, among a wide range of subjects.

FJELD, PAUL Paul Fjeld is a writer and illustrator whose paintings of Apollo, Skylab, and the space shuttle were used by NASA, CBS News, and a number of publications, including *National Geographic.* He was also an adviser to the HBO series *From the Earth to the Moon.*

FOSS, CHRIS A native of Devon, England, Chris Foss has become known for his dramatic illustrations of airplanes, ships, and

Alexandre Iacovleff, Racing to the goal, *1936*

space vehicles. His sketches for an early but unrealized film version of the Frank Herbert novel *Dune* led to a career depicting futuristic and fantasy subject matter.

FOSTER, LARRY Larry Foster is one of the world's most respected painters of whales and other marine mammals. His work has illustrated many books and has appeared in a number of National Geographic publications.

FOUNDS, GEORGE George Founds is a graphic designer and illustrator who contributed to a number of National Geographic publications, ranging from *Our Threatened Inheritance* and *The Appalachian Trail* to children's books, maps, and magazine articles.

FUERTES, LOUIS AGASSIZ Louis Agassiz Fuertes (1874-1927) was born in Ithaca, New York, and graduated from Cornell University; he illustrated more than 35 books. His works are in the collections of the American Museum of Natural History and the Academy of Natural Sciences in Philadelphia.

GESKE, ERICH J. Erich J. Geske, a botanist affiliated with the College of Medicine of the University of Cincinnati, wrote and illustrated two articles for *National Geographic* magazine. His detailed water-colors in "Beauties of Our Common Grasses," published in June 1921, and "Marvels of Fern Life," from May 1925, showed their subjects as a microscope would reveal them.

GLANZMAN, LOUIS S. Not trained formally in art, Louis S. Glanzman taught himself to draw by studying classic texts on anatomy, reading *Art Instruction* magazine, and taking a correspondence course. Following military service, he sold his first paintings to *True* magazine in 1948; his work was also seen in *Collier's*, *Saturday Evening Post*, and *Cosmopolitan*. His painting of Robert F. Kennedy appeared on the cover of *Time* magazine on June 14, 1968.

GURCHE, JOHN John Gurche combines his skills as a sculptor and illustrator with degrees in paleontology and anthropology to create his images of prehistoric subjects. His illustrations have appeared in *Discover*, *Natural History*, and *Smithsonian*. His paintings and sculptures are a part of exhibits at the Denver Museum of Natural History, the Smithsonian Institution, and the American Museum of Natural History.

Tom Lovell, Saved by a kick, *1963*

GURNEY, JAMES M. James M. Gurney studied anthropology at U.C. Berkeley, and art at the Art Center College of Design in Pasadena. He is best known for his illustrated book series, *Dinotopia*, but has provided cover illustrations for numerous books. He created illustrations for Ace Paperbacks, backgrounds for animated films, and stamps for the U.S. Postal Service.

GUSTAFSON, DALE Dale Gustafson contributed to a number of National Geographic stories on such technical subjects as lasers, computer developments, the space shuttle, and astronomical advances. He was also versatile enough to provide illustrations on shipwrecks and the humble potato as well.

HALL, H. TOM H. Tom Hall studied art at the Tyler School of Fine Art and the Philadelphia College of Art. He illustrated children's books for 12 years before turning to adult book and magazine illustrations. His book covers have graced publications by Bantam, Fawcett, Ballantine, and Avon books.

HALL, RICK Rick Hall contributed illustrations to National Geographic throughout the 1960s. The topics included underwater

research, space satellites, naval vessels, and the Himalaya.

HALLETT, MARK An artist, naturalist, and teacher, Mark Hallett has painted murals for natural history museums in both Los Angeles and San Diego, and his illustrations have appeared in several books on dinosaurs.

HARLIN, GREG Greg Harlin is widely recognized for his watercolors of scientific and historical scenes. His illustrations have appeared in *Smithsonian* and *Kid's Discover* magazines and have won awards from the New York Society of Illustrators, *Communication Arts*, and *American Illustration*.

HARTMANN, DR. WILLIAM K. Dr. William K. Hartmann is a noted painter of space topics and astronomical scenes. An expert on the origin and evolution of planetary surfaces, his illustrations have appeared in a number of National Geographic Society publications. He is a member of the imaging team for the Mars Global Surveyor.

HAVLICEK, KAREL Karel Havlicek was born in Prague and attended art school there before emigrating to the U.S. in 1980. He has created illustrations for such institutions as

Sea World in San Diego and the American Museum of Natural History in New York; his clients have included Delta Airlines and Coca-Cola. He received a Clio award in 1991.

HERGET, HERBERT MICHAEL Herbert Michael Herget (1885–1950) was born in St. Louis and studied art at the Washington University School of Fine Arts there. An early interest in the native peoples of the Americas led to his creation of more than 150 paintings on early peoples of the western world for the National Geographic Society.

HSIEN-MIN, YANG A native of Shangdong, China, Yang Hsien-Min moved to the United States in 1975. For his paintings on historical subjects, Hsien-Min uses traditional materials such as rice paper and bamboo, but has developed a unique personal style. His work has been exhibited in museums throughout the country, as well as at the White House.

HUENS, JEAN-LEON Born in Melsbroeck, Belgium, Jean-Leon Huens (1921-1982) studied art at La Cambre Academy. His career as an illustrator began in 1943. Huens produced 600 paintings on commission from a tea company that illustrated centuries of Belgian history.

HYNES, ROBERT A native of Washington, D.C., Robert Hynes attended the Corcoran School of Art and the University of Maryland. Among the many awards he has received is the 1986 Outstanding Children's Book Award from the Children's Book Council, given for the National Geographic Society book *Secret World of Animals*. He has painted 13 murals for the National Museum of Natural History.

IACOVLEFF, ALEXANDRE Born in St. Petersburg, Alexandre Iacovleff (1887-1938) was educated at the Imperial Academy of Fine Arts. He left Russia in 1917 to travel and practice his art. Iacovleff served as official artist for two motorized vehicle treks sponsored by the Citroën Motor Company, one across the Sahara desert in 1924-1925 and the other from Beyrouth (now in Lebanon) to Peking, in 1931-1932.

KIHN, W. LANGDON Born in Brooklyn, W. Langdon Kihn (1898-1957) studied at the Art Students League in New York City. On a trip through the western United States,

Davis Meltzer, Shrinking the space station, *1991*

he began a lifelong series of illustrations depicting Native American cultures. Selections were included in the 1983 book *Portraits of Native Americans by W. Langdon Kihn, 1920–1937.*

KLEIN, CHRISTOPHER A. Christopher A. Klein studied art at the University of Maryland and at Cooper Union in New York City. He became a staff artist at National Geographic in 1981. Klein's paintings have been included in a number of exhibitions produced by the New York Society of Illustrators.

KNIGHT, CHARLES R. An interest in depicting wild animals led Charles R. Knight (1874–1953) to his long association with the American Museum of Natural History. Knight was the first artist to reconstruct the appearance of extinct animals. The murals he painted between 1911 and 1930 were installed as a part of the museum's renovated Lila Acheson Wallace Wing of Mammals and Their Extinct Relatives.

KRASYK, FRANCIS J. Francis J. Krasyk first contributed illustrations to National Geographic in the 1960s, when he was working for the Goddard Space Flight Center. His paintings of space subjects appeared in Society books as well as the *National Geographic* magazine article on the Apollo 11 moon landing. His later paintings ranged from black holes to sea turtles.

KUNSTLER, MORT Mort Kunstler has been specializing in American Civil War art since the 1980s. He learned his trade, and gained his reputation for accuracy, during the years he worked for National Geographic, painting historical subjects and working with historians and researchers. He has been described as the "foremost Civil War artist of our time."

LIDOV, ARTHUR Arthur Lidov (1917-1990) painted historical, scientific, and medical illustrations for magazines such as *Fortune, Collier's, Saturday Evening Post, Good Housekeeping,* and *Sports Illustrated.* Lidov's paintings have been exhibited at the Museum of Modern Art in New York, the Art Institute of Chicago, and the National Gallery of Art.

LOUGHEED, ROBERT ELMER Robert Elmer Lougheed (1901-1982) was a painter of Western subjects. His illustrations graced numerous books and such magazines as *Reader's Digest* as well as *National Geographic.* Born in Canada, he came to love the scenery and landscapes of New Mexico.

LOVELL, TOM Tom Lovell (1909-1997) was born in New York City and studied art at Syracuse University. Known for his illustrations of American history and the Old West, he was elected to the Society of Illustrators Hall of Fame in 1974. He received awards from the National Academy of Western Art and the National Cowboy Hall of Fame.

MAK, KAM A native of Hong Kong whose family moved to New York in 1971, Kam Mak studied at the School of Visual Arts. His work has appeared in publications such as the *New York Times Magazine* and *Rolling Stone.* The Laurence Yep book *The Dragon Prince,* which Mak illustrated, received the Oppenheim Platinum Award as the best children's picture book of 1997.

MANCHESS, GREGORY Gregory Manchess graduated from the Minneapolis College of Art and Design in 1977. Among the clients for his illustrations are Walt Disney Pictures, and Polo/Ralph Lauren. His work has been reproduced in magazines such as *Scholastic* and *Atlantic Monthly.* He received a "best of show" award at the 1996 Society of Illustrators Los Angeles annual exhibition.

MATTELSON, MARVIN Marvin Mattelson was an award-winning illustrator who

painted over 20 *Time* magazine covers. He worked for the National Geographic Society as well as for Scientific American and the U.S. Postal Service before becoming a full-time portrait painter.

MATTERNES, JAY H. Born in the Philippines, Jay H. Matternes studied painting and design at Carnegie Mellon University in Pittsburgh. He has become expert at depicting early human evolution based on reconstructions of fossil remains. His 1993 mural on primate evolution was installed in the new Hall of Human Biology and Evolution at the American Museum of Natural History, and he has painted murals or designed dioramas for a number of museums since.

MEAD, SYDNEY Sydney Mead graduated from Art Center College in Los Angeles. He established his own company, Syd Mead Inc., in 1970, and has contributed designs to many major motion picture and automotive companies. Among the films to feature his work are *Tron, Star Trek: The Motion Picture,* and *Blade Runner.*

MELTZER, DAVIS Davis Meltzer painted illustrations for National Geographic for 25 years. He has created a number of stamp designs for the U.S. Postal Service, including a portrait of Eddie Rickenbacker, a ballooning aerogramme, and the 15 illustrations that made up the "Celebrate the Century 1920–1929" stamp series.

MELTZOFF, STANLEY Stanley Meltzoff (1917-2006) created more than 60 cover illustrations for *Scientific American.* His work also appeared in *Life* and *Saturday Evening Post.* Meltzoff began painting underwater subjects in 1969; he had portfolios of paintings in *Sports Illustrated* and *Field and Stream.*

MINER, EDWARD HERBERT Edward Herbert Miner (1882-1941) was an American wildlife artist who painted subjects, ranging from dogs to horses and cattle, for *National Geographic* magazine in the 1920s and '30s. His work appeared in numerous publications.

MION, PIERRE Pierre Mion studied at George Washington University and the Corcoran School of Art. His illustrations have appeared in *Air and Space Magazine, Smithsonian,* and *Reader's Digest.* Mion is known for his rendering of a tsunami that he painted from eyewitness accounts of the tidal wave on Prince William Sound in March 1964.

MURAYAMA, HASHIME Hashime Murayama (1878-1955) joined the staff of National Geographic at a time before reproducing color photography was common. Dedicated to pictorial precision, he was known to have counted the scales of a fish to ensure the accuracy of his paintings. His watercolors appeared regularly until his retirement in 1940.

Thornton Oakley, Battleship *Alabama, 1942*

OAKLEY, THORNTON A native of Pittsburgh, Thornton Oakley (1881-1953) studied architecture at the University of Pennsylvania before training as an illustrator under Howard Pyle. Oakley wrote and illustrated for many magazines, including *Century, Collier's, Scribner's,* and *Harper's Monthly.*

OTNES, FRED Fred Otnes studied at the American Academy and the School of the Art Institute of Chicago. His work has been included in publications such as *Saturday Evening Post, Fortune,* and *Reader's Digest;* among his clients for commissioned work are NASA, Exxon, and the National Academy of Sciences.

PESEK, LUDEK Ludek Pesek (1919-1999) was born in Czechoslovakia and attended the Academy of Fine Arts in Prague. Noted for his astronomical paintings, he created illustrations for books and magazines in Europe and the United States. In the early 1980s, he produced a series of 35 paintings on the planet Mars. Pesek wrote several science-fiction novels, which he also illustrated.

PETERSON, ROGER TORY The naturalist Roger Tory Peterson (1908–1996) was best known for his 50-volume Peterson Field Guide Series; the first, *A Field Guide to the Birds,* was originally published in 1934.

Ned M. Seidler, Teeming life of a pond, *1970*

Peterson established the Roger Tory Peterson Institute in Jamestown, Virginia, in 1984 to provide nature education to teachers.

PINKNEY, JERRY Jerry Pinkney is widely known for his illustrations for children's books, for which he has received five Caldecott Honor Medals. He has also received numerous medals from the Society of Illustrators. His work has been exhibited in more than 20 solo exhibitions and 100 group shows in the United States, Japan, Russia, Italy, Taiwan, and Jamaica.

RIDDIFORD, CHARLES E. Charles E. Riddiford (1887-1968) was for many years a cartographer with the National Geographic Society. He is best known for designing the distinctive typeface that was used on Geographic maps for the better part of the 20th century. He also drew elaborately decorated borders for certain maps in the 1930s.

RILEY, KEN Ken Riley was raised in Colorado and studied art at the University of Colorado in Boulder, graduating in 1992. Executing all of his work with pen and ink,

he has been influenced by varied artistic traditions, including Japanese.

SANO, KAZUHIKO A native of Japan, Kazuhiko Sano studied painting in Tokyo before moving to San Francisco to study at the Academy of Art College in 1975. Fifteen of his illustrations are reproduced on the U.S. Postal Service's "Celebrate the Century 1970–1979" series. Sano's work has been shown at the Central Museum, Tokyo, and the Museum of American Illustration, New York City.

SANTORE, CHARLES A native of Philadelphia, Charles Santore's work has appeared in all the major illustration markets. In the mid-1980s, he began illustrating classic children's stories such as Aesop's Fables and the *Wizard of Oz*. Santore has received many awards, including the prestigious Hamilton King Award from the New York Society of Illustrators.

SCHALLER, ADOLF Adolf Schaller is a painter of space-related subjects who once worked closely with the late Carl Sagan. A writer and composer as well as a painter,

Schaller has worked in media ranging from magazines to movies. He has won numerous awards for his creative work.

SCHLECHT, RICHARD Richard Schlecht began his career as a graphic artist while stationed in Washington, D.C., in the Army. His work has been published by Time-Life Books, the National Park Service, and Colonial Williamsburg. He has designed more than 24 stamps for the U.S. Postal Service, including the series commemorating Christopher Columbus' first voyage.

SEIDLER, MARK A former member of the National Geographic staff, Mark Seidler has been a frequent contributor to Society publications as a freelance artist, providing illustrations on topics ranging from archaeology to earthquakes, from elephants to El Niño.

SEIDLER, NED M. Born in New York and educated at Pratt College and the Art Students League, Ned M. Seidler worked as a freelance illustrator for 21 years before becoming a staff artist for National Geographic in 1967. Since his retirement from the magazine in 1985, Seidler has created designs for a

Richard Schlecht, Pre-Columbian Makah Indians hunting whales, *1991*

Herb Tauss, Pizarro, conqueror of the Inca, *1992*

number of stamps for the U.S. Postal Service. His work has been shown at the New York Society of Illustrators and at the Brandywine Museum in Pennsylvania.

SIBBICK, JOHN Born in Guildford, England, John Sibbick began a career as a freelance artist after being commissioned to illustrate a children's encyclopedia in 1972. His work appeared in the 1981 book *The Illustrated Encyclopedia of Dinosaurs* as well as in the BBC television series *Lost Worlds, Vanished Lives.*

SILVERMAN, BURTON A native of Brooklyn, Burton Silverman studied art at the Pratt Institute, Columbia University, and the Art Students League. He has had solo exhibitions in New York, Boston, Philadelphia, and Washington, D.C., and his paintings are in the collections of museums such as the National Museum of American Art and the National Portrait Gallery. Silverman was named to the New York Society of Illustrators Hall of Fame in 1996.

STOREY, BARRON Barron Storey's paintings have appeared in such publications as *Smithsonian* and *Scientific American;* he contributed 14 cover illustrations to *Time* magazine between 1974 and 1984. Among his corporate clients are Paramount Pictures and McDonald's. His mural of the South American rain forest is permanently installed at the American Museum of Natural History in New York.

TAUSS, HERB Herb Tauss's only training in art was at the High School of Industrial

Arts in his native New York. He provided illustrations for magazines such as *Saturday Evening Post, Redbook,* and *Good Housekeeping.* His recent work has concentrated on subjects of social significance such as the Holocaust and the Trail of Tears. He was named to the Hall of Fame of the Society of Illustrators in 1996.

UNRUH, JACK Jack Unruh studied at the University of Kansas and Washington University, St. Louis. His work has appeared in *Rolling Stone, Audubon,* and *Sports Illustrated* and he has received commissions from commercial clients such as IBM, American Airlines, and Neiman Marcus. Unruh received

the Hamilton King Award from the New York Society of Illustrators in 1998.

WEBER, WALTER A. Walter A. Weber (1906-1979) served as a staff illustrator for National Geographic for 22 years. Trained both as a biologist and an artist, his first position was with the Field Museum of Natural History. His painting of snowy egrets was reproduced on a 1947 U.S. postage stamp issued upon the creation of the Everglades National Park and was reissued on a special postal card commemorating the 50th anniversary of the park.

WYETH, ANDREW Andrew Wyeth's (1917-2009) long career as an artist was recognized by both the Presidential Medal of Freedom, in 1963, and the congressional Gold Medal, in 1990. His work has been exhibited worldwide. The Center for the Wyeth Family, which opened in Maine in 1998, houses a collection of nearly 4,500 artworks by Andrew Wyeth.

WYETH, NEWELL CONVERS (N.C.) Newell Convers (N.C.) Wyeth (1882-1945) was born in Needham, Massachusetts. His first commercial sale, in 1903, was a cover illustration for *Saturday Evening Post,* for which he received $60. Between 1911 and 1939 he created widely acclaimed illustrations for more than 25 classic children's books published by Charles Scribner's and Sons. In the 1920s, the National Geographic Society commissioned Wyeth to paint five large murals for its headquarters in Washington, D.C.

N. C. Wyeth, The caravels of Columbus, *1928*

THE AUTOCHROMES

EACH GLASS PLATE, and there are nearly 15,000 of them, is a survivor, having traveled perhaps thousands of miles, enduring falls, careless handling, and slipshod packing before reaching this final destination. Each is tucked into an identical brown paper sleeve. Remove the sleeve, however, and each plate is unique, not an infinitely reproducible negative but rather a positive image, luminous, with a delicacy of color that still remains tantalizingly elusive, like the color of a memory. That is the magic of Autochromes, the first practical method of color photography, and the Image Collection houses one of the finest assemblages of Autochromes in the world, because in the 1920s *National Geographic* was its chief American purveyor.

The quest for color photography was almost as old as the medium itself. By the end of the 19th century some promising inroads had been made, but they were so time-consuming and cumbersome that most

Jules Gervais-Courtellemont, 1930s, Algeria

colored photographs were hand-tinted prints. These could be exquisite, such as those of the Far East that Editor Gilbert H. Grosvenor published in the November 1910 *Geographic*. This experiment was so successful with the Society's members that color had come to stay. It was only a matter of time before hand-tinted pictures gave way to Autochromes.

Invented by the French brothers Auguste and Louis Lumière, the original Autochrome, made widely available in 1907, was a standard 5x7 glass plate evenly coated on one side with a fine mixture of minute starch grains, dyed subtle variations of the primary colors red, green, and blue. A standard panchromatic emulsion was applied to the other side, and the whole was covered by a protective plate. Slotted into a camera, the starched side faced the lens, the emulsion the cameraman. The image-bearing light would strike the starched side first, filtering through its colored mosaic before striking the emulsion.

The result, after development, was a positive image that reflected all the colors, though softened and muted, present in the original scene. As exposure times were slow, too slow to capture action or movement, Autochromes were used for landscapes and still lifes and posed portraits, all of which, however, were lent a beguiling tranquility, a painterly calm which, with that whisper of color, could be quietly enchanting.

The first Autochrome to appear in *National Geographic* was published in the July 1914 issue. "A Ghent Flower Garden," by Paul Guillumette, was a riot of bloom included for no other reason than to prove that real color, "color in the camera," could be engraved and printed in the magazine's pages.

Two years later several series of color plates, made by a former miniaturist painter named Franklin Price Knott and depicting American scenes, were published, heralding the opening of the Geographic's romance with the Autochrome.

When Gilbert Grosvenor, in 1920, installed the first color lab in American publishing, he was inaugurating the golden decade when Autochromes—over 1,800 of them—ruled the pages of the magazine.

Jacob Gayer, 1936, Ohio

No more than 15 photographers were involved, roving all over the world with their cameras and tripods and magical glass plates that, sent in trunks and crates to Washington, might have been as close as they ever got to Society headquarters.

Helen Messinger Murdoch started the parade when eight of her Autochromes of India and Ceylon were published in the March 1921 issue. But soon Grosvenor had enlisted a corps of largely European "Autochromists" to fill his needs.

There was the Frenchman Jules Gervais-Courtellemont, a swashbuckling Orientalist traveler, lecturer, and author as well as photographer who had cut a romantic figure by the turn of the century. Gervais-Courtellemont provided the Geographic with hundreds of Autochromes of the French countryside, dreamy Spain, sun-splashed North Africa, and exotic scenes from as far afield as India and Cambodia—enough to make up 24 color series.

Hans Hildenbrand, a former court photographer for the King of Wurttemberg and the only German cameraman to record World War I in color, had over 150 Autochromes of Germany, Central Europe, the Balkans, and Italy published. There are more than 700 of his Autochromes still remaining in the Image Collection; they are perhaps the only ones still extant, for the rest were destroyed during a 1944 air raid on Stuttgart.

His fellow countryman Wilhelm Tobien supplied plates enough for 15 color

Franklin Price Knott, Unknown, Egypt

series, depicting not only European scenes but those in Madeira, the Canaries, and the Azores as well.

Gustav Heurlin supplied four color series portraying Scandinavia, while Luigi Pellerano, who had written a popular manual of Autochrome photography, had 41 photographs of Sicily, Rome, and Libya published.

There were Americans contributing Autochromes as well. Fred Payne Clatworthy, who owned a photographic studio in Colorado, supplied images of the peaks and scenic marvels of western North America. And in 1927, at age 73, Franklin Price Knott embarked on a 40,000-mile tour of the Orient, making hundreds of Autochromes from India to Bali and Japan expressly for the Geographic.

When it came to the exotic, however, there was no one quite like Joseph Rock. The Viennese-born plant hunter spent most of the 1920s and '30s, when not dodging bandits, combing the steep hills of southwestern China, collecting rare and useful species for science and making thousands of photographs—including 888 color plates—of wild tribes, otherworldly lamas, and picturesque Tibetan ceremonies.

By the 1920s, furthermore, Grosvenor was assembling his own photographic staff. It included the legendary Maynard Owen Williams, who actually lived abroad and sent back such a volume of material—pictures of Europe, the Mediterranean, the Near East, the Holy Land, and India—that at times it threatened to overwhelm the office. Jacob Gayer joined Williams in making Autochromes in the Arctic, supplying in addition colorful scenes of Latin America and the Caribbean.

The talented Clifton Adams set up his tripods all over the United States as well as in the British Isles, Mexico, and Haiti. And Edwin L. "Bud" Wisherd, making pictures from Louisiana to the desert Southwest, was among the first staff men to actually process Autochromes in the field.

The world was simply wide open for anyone with a camera, tripod, and trunkful of plates to record. In many places he was simply the first of his breed to arrive.

When W. Robert Moore surfaced in Ethiopia to photograph the spectacular coronation of Haile Selassie—he had the emperor hold still for nearly ten seconds, the time needed to expose his portrait—he was the only color photographer on the scene.

And in an era of "firsts," proudly proclaimed at every opportunity in the magazine—the first "natural color" pictures to be made underground, in Carlsbad Caverns, or in Arctic Greenland, where even in daylight flash powder was needed under those leaden skies—there is one series of plates representing a genuine achievement.

In 1926, in the Dry Tortuga Islands off Florida, scientist William Longley and the

the air, they were exposed on Finlay plates, not on Autochromes. Finlays, which used a grainier emulsion and a dot pattern screen, was marginally faster, fast enough to be used on the relatively stable platform of a dirigible. Soon thereafter the Finlays began displacing the Autochromes, to be superseded in turn by film-based Dufaycolor before Kodachrome swept the field, opening a new era altogether.

By then the Autochrome had sunk into obscurity at the Geographic, the last one being printed in the 1940s. Altogether over 2,300 of them had been published in the quarter century of their reign.

Today, however, the Finlay plates have all fallen out of register, leaving only the black-and-white image behind. But tucked into their paper sleeves the Autochromes, which first brought the world in "natural colors" to millions of people, have proved remarkably resilient. Nearly 15,000 of them are in the Image Collection, and many still hold their magical color, the perfect color for portraying a vanished world; a world seen without war, without turmoil; a world soft, quiet, autumnal, and serene.

Wilhelm Tobien, 1930, Yugoslavia

Franklin Price Knott, Unknown date and location

Geographic's Lab Chief, Charles Martin, pushed the exposure time of the Autochrome plate by coating it with a special emulsion, making it just fast enough that, when one-quarter pound of magnesium flash powder was detonated on a surface raft, the resulting explosion was so bright it even lit up the underwater gloom, enough to capture swimming fish on the plates. Published in 1927, these were the first color photographs ever made beneath the sea.

Yet a few years later, in 1930, when the first color pictures were made from

THE BLACK & WHITE PRINTS

Edward S. Curtis, Unknown, Montana

LOOMING 14 FEET TALL and running seemingly into infinity, the shelves holding the Society's black-and-white print collection are completely filled with brown accordion files. Arranged geographically, beginning with Africa, they are filed not so much by the names of today's countries and continents but more often by those of yesterday. For to plunge into the black-and-white collection is to vanish into the past—it might be for a very long time, for nearly 500,000 prints are there, only a fraction of which have ever been published.

Reach anywhere into that past world—Abyssinia, for instance—and the prints found there will be mounted on boards, with captions, dates, credits, and relevant indexing information written on the back, alongside the occasional cryptic, and endlessly intriguing, comment. Such prints represent a time when pictures were assiduously collected from any and every source, a time rooted in the early years of the 20th century and the editorial genius of Gilbert Hovey Grosvenor.

Once Grosvenor and his endlessly inquisitive father-in-law, Alexander Graham Bell, had steered the *National Geographic* magazine on a photographic course, the young editor determined to build a stockpile of pictures. It would be a collection to draw from when needed, a repository containing more pictures, perhaps many more, than would ever likely be published. He bought collections seen and unseen; he picked up pictures on his travels; he tapped the endless supply of U.S. government plates and prints; but mostly he depended on a polyglot group of travelers, soldiers, diplomats, journalists, scientists, explorers, and the occasional rogue to provide him with photographs from the far parts of the world. The stockpile became the kernel of what, as the years and decades rolled past, became the black-and-white collection.

Yet not every print is snug in its brown accordion folder. There are collections within the collection, portfolios and albums containing enough related pictures to warrant a separate status. Many were simply picked up somewhere along the way. There are, for instance, the five large

Luis Marden, 1936, Guatemala

albums containing some of William Henry Jackson's original albumen prints. Widely regarded as *the* pioneering photographer of the American West, Jackson photographed in Nebraska, Wyoming, and Colorado in the 1870s while accompanying one of the great Western surveys that eventually coalesced in the U.S. Geological Survey. (The prints, in fact, are mounted on pages displaying the U.S.G.S. emblem.) There is also, in the Society's Rare Book Room, a rare complete set (number 276 of 300 printed) of Edward Curtis' monumental *The North American Indian*, all 20 volumes of it, which with the 20 additional portfolios of gravure prints make over 2,000 portraits of the 80 Indian tribes still found west of the Mississippi in Curtis' day.

Alexander Graham Bell originally obtained the first volume of this Curtis set; the great inventor is himself honored in the Bell Collection, 1,600 prints of tetrahedral kites and other fantastic flying machines, or the Aerial Experimental Association, or family life in and around the Bell summer estate in Nova Scotia.

In the late 1870s a Harvard graduate named Charles Harris Phelps embarked on a two-year round the world honeymoon. The marriage might not have lasted, but the pictures have, 26 portfolios of them—views, landmarks, cities, countryside, ruins, ceremonies—pictures from Java to Japan, India to Italy, the Balkans to the Baltic. Decades later, the enigmatic A. W. Cutler, of "Rose Hill House, Worcester, England," made some splendid pictures of Britain and Ireland for Grosvenor, who then sent him to Portugal and Italy for more, only the gentleman died of malaria in Calabria. Nevertheless, Cutler bequeathed his entire collection to the Geographic, and Grosvenor treasured those negatives for years.

Sometimes the collecting zeal ran to extremes. There are in the archive 200 prints made by Baron Wilhelm von Gloeden, the turn-of-the-century German expatriate whose portraits of young Sicilian men, garbed in classical wreaths and little else, long appealed to certain of the cognoscenti. These prints were obtained by Admiral Chester Colby, a veteran member of the Society's board, probably more out of ardor than aesthetics. Most of them, understandably, have never been published in the magazine. But after Mussolini's thugs destroyed so many of von Gloeden's negatives, such collections of his prints have assumed increasing importance.

The black-and-white collection not only affords a trip around a vanished world; it also provides a journey through the early years of the National Geographic itself. There are, for instance, the pictures of Lhasa, still in the box in which they arrived, that when published in the January 1905 issue did so much to spur popular interest in the magazine. Then there are George Shiras' original glass-plate negatives, some of the most important images in the history of wildlife photography. First published in the magazine in 1906, the nocturnal images of startled deer captured by flashlight launched the magazine in a direction from which it has never looked back.

Herbert G. Ponting, 1922, Antarctica

Then again, the whole romantic story of the Society's early voyages and expeditions is also found among those tall shelves. Long before the explorer Anthony Fiala accompanied Theodore Roosevelt to the River of Doubt he led several abortive expeditions to the Arctic. The Ziegler Polar Expeditions of 1901-02 and 1903-05 came nowhere near the goal of reaching the North Pole, but you wouldn't know it from Fiala's lantern slides, glass plates, and negatives, which hold some classic images of dog-sledding excursions made at the height of the "heroic age" of polar exploration. So do the 7,000 prints that constitute the voluminous Robert E. Peary Collection, which ranges from some curious "ethnographic" studies of Intuit physical types to the much scrutinized, much debated images taken (or not) at the North Pole itself.

After Grosvenor, in 1911, listened to Hiram Bingham describing the site of Machu Picchu high in the Peruvian Andes, the National Geographic joined Yale in sponsoring several seasons of excavation there. The perennial appeal of Machu Picchu is due in no small part to the 9,000 prints in the Bingham Collection, which not only painstakingly document each stage in the labor, each wall cleared, each bit of masonry unearthed, each granite staircase tumbling sheer down the breathtaking slope, they also capture the excitement of exploration the old-fashioned way in a spectacular part of the world.

The Valley of Ten Thousand Smokes is the evocative name given the strange volcanic wonderland that Robert F. Griggs discovered in Alaska after Mount Katmai's tremendous 1912 eruption. A broad valley of steaming fumaroles, it offered a sublime vista to which no camera could do justice, although the 7,000 prints in the Image Collection represent the attempt to do just that. Publication of only a fraction of these pictures led President Woodrow Wilson to declare the Valley of Ten Thousand Smokes a national monument.

Dig a little deeper, and there are the 22 albums of prints illustrating the launches of the National Geographic-U.S. Army stratosphere balloons *Explorer I* and *Explorer II*, which latter attained a manned height record, towering nearly 11 miles in the sky, which stood for 21 years. They depict the launching site, the "Strato-Bowl," in South Dakota, the great tent city, the balloons as

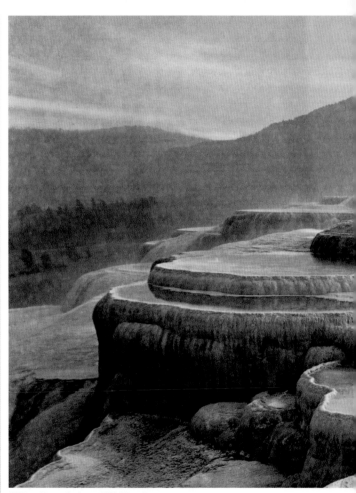

William Henry Jackson, 1871, Wyoming

tall as a ten-story building, the daredevil aeronauts wearing leather football helmets—every aspect of those now-largely forgotten events that gave birth to the space program.

And on to the other side of the world, where more than 500 prints are marked "Byrd Antarctic Expedition." The Society helped sponsor Admiral Richard E. Byrd's highly mechanized assaults (1928-1930 and

1933-35) on the great white continent. The small armies of men and machines seen going about their duties marked the effective end of the heroic age of exploration. Nevertheless, at this same time, Grosvenor obtained not just one but two sets of Herbert Ponting prints depicting Captain Robert Falcon Scott's classic 1910-1912 Antarctic expedition. There was no editorial use for them, he admitted, but he wanted the more than 1,000 prints for their

historical value alone; they were something the Geographic should have.

There are a further nine albums of prints made by Bradford Washburn on his 1936 expedition to the Yukon, a world of majestic, glittering peaks and glaciers only just beginning to be mapped. And although ten of his abundantly illustrated articles were printed by the magazine in the 1920s and '30s, there still remain 2,500 of Joseph Rock's pictures of "the land that time forgot" in far southwestern China that have never yet been published.

Black-and-white photography at the Geographic rolled on, decade after decade, until the end of the 1950s. The gem-cut, large-format negatives staff photographers made with their Linhofs; the square-cut, medium-format ones they took with their Rolleiflexes, still offer abundant evidence of black-and-white's enduring appeal. It might have been the preferred medium for art photographers and photojournalists alike, but at the magazine, where color was king, black-and-white came to play a workmanlike role. Though it had carried the burden of National Geographic photography for so many years, when the magazine finally went all color in 1962, it retired from those pages altogether.

THE COLOR TRANSPARENCIES

Maria Stenzel, 1996, Antarctica

IN OUTWARD APPEARANCE identical clones, distinguished only by the occasional notes and comments scribbled over some of their mounts, the slides line up by the million in long metal drawers, in filing cabinets, in cold dark storage. Each individual, mount included, is approximately two inches square; each has a single rectangular eye, set in a 3:2 aspect ratio, 24x36 mm, which, it has been observed, is very close to the proportions of the golden rectangle, supposedly the most pleasing of geometrical forms, found in the facade of the Parthenon as well as the whorl of the chambered nautilus.

That is certainly what it has been for the National Geographic Society, for, the accidental resemblance between the golden rectangle and the yellow rectangle

Steve McCurry, 1985, Afghanistan

that is the Society's logo aside, the 35mm transparency has played a central role in the evolution of National Geographic photography. And though the emulsion residing within those golden dimensions may differ—it may be Ektachrome or Ansochrome, for instance—by far and away the vast majority of those 35mm legions are Kodachrome. Surely one of the most repeated phrases in the history of the magazine must be that which appeared beneath innumerable pictures: *"Kodachromes by _____"*

In 1925, when the E. Leitz Company of Wetzlar, Germany, first introduced the Leica (*Leitz camera*), few people could have foreseen the revolutionary effect a 35mm camera would have on photography. After all, the "miniature camera," as

it was tagged, used tiny bits of old movie film, each frame no bigger than a postage stamp, which meant that it would have to be considerably enlarged before it could be of any use. Too much enlargement usually entailed some degradation in quality. Shortly thereafter, the first Leica appeared at the National Geographic, but significantly enough, it was purchased not by a photographer but rather by a writer.

The illustrations hierarchy at the Geographic was too wedded to the large-format cameras that produced the tack-sharp negatives, easily engraved for optimum magazine reproduction, to give the toy "miniature camera" anything but a scornful look. Yet the Leica was making inroads on professionals elsewhere, who saw in its portability and proverbially quiet shutter an unobtrusiveness that allowed for a more natural, spontaneous kind of photography. When Luis Marden showed up at the Geographic for his first day of work in 1934, he had a Leica hanging from his neck. Despite having written a book on color photography with the "miniature camera" he had little opportunity of using it until, two years later, he tested some rolls of Eastman Kodak's new film, Kodachrome. Instantly he saw in the virtually grainless, (somewhat) fast film the royal road to a brighter future for the color-obsessed National Geographic. Thus he was the first to champion the 35mm-Kodachrome combination that would become the magazine's most durable signature.

Although initially skeptical, even the hierarchy could see the rich color that Kodachrome promised, and once the technical challenge of engraving from the postage stamp–size negative was solved, it embraced the new format wholeheartedly. It was a tremendously exciting time, as Marden and such colleagues as W. Robert Moore, B. Anthony Stewart, and Volkmar Wentzel felt liberated from the tyranny of the tripod. The first Kodachromes were published in 1938; only two years later, of the 393 color photos published in the magazine, 350 were 35mm Kodachromes.

By World War II National Geographic was leading the magazine world in the editorial use of 35mm color. In the traveling kit of its staff photographers the large-format Linhofs and Graflexes and medium-format Rolleiflexes were ceding priority to the now-privileged Leica, which was solely reserved for color work. That led to an

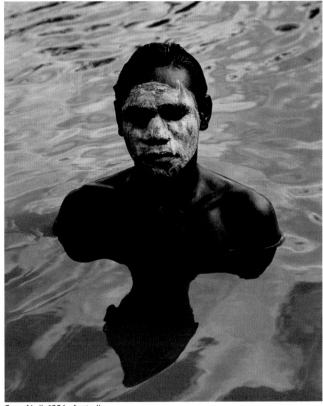

Sam Abell, 1996, Australia

occasional irony: Kodachrome, with an ASA rating of 8, was still not fast enough to capture dramatic action except in broad daylight, so the portable Leica was often on the tyrannous tripod while the Rolleiflex, charged with black-and-white film, was kept in the hand.

Field photographers in the 1940s and '50s, however, were more hobbled by the realities of National Geographic publishing at that time. Editors still demanded the scenic color that characterized the "humanized geography" that was obtained before the war. The advantages of 35mm were often wasted on contrived setups using models decked out in red scarves or sweaters, also part of the photographers'

traveling kit because red was said to make Kodachrome "pop."

It remained for a new generation of staff photographers to overturn the old editorial order and get the most out of the versatile 35mm format. In 1957, Melville Bell Grosvenor, son of the pioneering editor who had been for so long the Society's guiding spirit, took the helm for a decade. He recruited young photographers trained by the rigors of daily newspaper work or at the University of Missouri School of Journalism: Bill Garrett, Tom Abercrombie, Dean Conger, Win Parks, George Mobley, Jim Blair, Bruce Dale, and Jim Stanfield among them. And "at the heart of his system," remembered Garrett of

Michael Nichols, 1990, Republic of the Congo

James L. Stanfield, 1996, Uzbekistan

Grosvenor, "like the core of a nuclear reactor—he enshrined the magical little 1x1½-inch color slide."

Everything was bent to its service. New printing presses provided capacity for an all-color magazine. New films were tested—including Kodachrome II and High-Speed Ektachrome—to fill its magic proportions. New single-lens reflex cameras were adopted in preference to the old Leica range finders. By the early 1960s, staff photographers armed with SLRs were shooting about 20 percent less film on any given assignment. And that was important because the tide of 35mm transparencies was starting to flood: In 1961, for instance, more than 3,600 36-exposure rolls of Kodachrome alone were logged in, not to mention rolls of Ektachrome and other formats. Those numbers would only swell.

The staff photographer's kit, by the 1960s, had also changed in response. Gone were the larger-format cameras that had once carried the burden of black-and-white. With occasional exceptions for specialized needs, and the Polaroids for making friends and checking exposure, it was all 35mm: one to three Nikon Fs, perhaps, with a full complement of lenses from 21mm to 400mm, and some Leicas for good measure.

The resulting images bloomed in the magazine and overran the staid old oak-and-laurel cover. The Kodachrome-infused articles were a heady mixture of travelogue, Vietnam, archaeology, and such photogenic

characters as Louis Leakey, Jane Goodall, and Jacques Cousteau. Portable 35mm cameras could be carried to the summits of the highest mountains. Together with faster films they promoted a flowering of wildlife photography; images of birds on the wing and animals on the move were made with greater accuracy and artistry. Luis Marden and Bates Littlehales pushed the frontiers of modern underwater photography using 35mm; they passed the torch, or rather the Oceaneye 35mm underwater housing Littlehales helped devise, to their acolyte, David Doubilet, now widely recognized as one of the great masters of the art. And a host of Geographic photographers snapped pictures of every aspect of the manned space program from Projects Mercury to Apollo. (Two large cabinets house what is called the Space Collection, a treasury comprising some 80,000 images—35mm transparencies, medium-format cut film negatives, black-and-white prints, and more, assembled by Illustrations Editor Jon Schneeberger. It includes images of rocket launches as well as pictures documenting astronaut training and aerospace work all over the country. It also holds spectacular images made by the astronauts themselves, because Schneeberger ensured that National Geographic received from NASA a master copy of all mission photography from Apollo through the space shuttle.)

By the 1970s and '80s, under the leadership of Editors Gilbert M. Grosvenor, third of his family to serve, and Bill Garrett, the

William Albert Allard, 1994, Italy

tide of 35mm documentary photography at the magazine only continued to advance. National Geographic photographers garnered a stupefying number of national awards and accolades. Legendary Director of Photography Robert E. Gilka harnessed a pool of talented staff as well as contract and freelance photographers, including Sam Abell, Bill Allard, Jodi Cobb, and Dave Harvey, many of whom developed distinct individual styles that sometimes complemented and sometimes diverged from traditional Geographic norms. All were equipped with 35mm.

Increasingly sophisticated cameras, equipped with battery-powered motor drives, autoexposure, and autofocus, coupled with advanced electronic flash, allowed for greater flexibility in illustrating scientific and technological stories. An already versatile system, 35mm was given even broader latitude by ingenious tinkering in the Society's lab and custom equipment shops. There was hardly a subject, it seemed, that given enough flair and imagination, a photographer could not cover using the format.

Above all, however, a fully fledged photojournalism was at last liberated. The images accompanying articles on South Africa, Haiti, or Harlem turned the old pattern on its head: Here poverty and despair and injustice coexisted with smiling faces or scenic grandeur. An increasingly ecological turn led to in-depth coverages of pollution, pesticides, energy challenges, water resources, deforestation, and the decline of biodiversity. It was all captured on those magical little slides.

Though the magazine did not cover breaking news, save for the occasional natural disaster, it did publish articles on the geographical context giving rise to the headlines. Articles on the Middle East might depict a war-torn Beirut, while those on the Soviet invasion of Afghanistan portray that conflict's toll on human beings. What many people have come to see as the "iconic" National Geographic image—Steve McCurry's 1985 portrait of Sharbat Gula, the "Afghan Girl," was made on 35mm Kodachrome.

That was when 35mm was at full flood. Day in and day out, the shipments would roll in—36 rolls to a shipment—thousands of transparencies flowing in from every point of the compass and depicting a bewildering variety of subjects. Once processed, they entered the bloodstream of the Society; were arranged and spread out across light tables, where their fate was summarily meted out—discards, file selects, seconds, firsts—even images of exceptional quality might not make the final cut. The chosen few that did were then pumped into the Society's books, magazines, filmstrips, and educational products. Once published, the images went out to the world, educating, illuminating, and inspiring millions of people, while the slide joined the hosts of

Emory Kristof, 1991, Atlantic Ocean

Jim Brandenburg, 1987, Canada

its fellows, taking up its appointed place in one of those long metal file drawers.

Now that, too, has passed. Inevitably, the usurper has been in turn usurped. It had a long reign, spanning some six decades, and though today the tide of transparencies is on the ebb, giving place faster and faster to the onrush of electronic images, its rival and successor has adopted many of its features. Digital cameras are often styled like 35mm ones, and those equipped with a full-frame sensor have inherited the golden rectangle.

Before the digital shadow fell across those banks of slides, Luis Marden, who had played such a pivotal role in ushering in the Kodachrome era, looked about him and saw the triumph of 35mm color in everything from family snapshots to scientific applications to the gallery wall. A photographer, he once mused, could only be thankful to have lived through "the greatest revolution in photography since the invention of film."

Chris Johns, 1995, South Africa

DIGITAL

WHEN IN THE 1970s Emory Kristof embarked on his career-long photographic exploration of the deep sea, he rigged up 35mm cameras and lowered them into the deep. He has ever since been tethering or mounting ingeniously devised imaging systems to longlines, submersibles, or remotely operated underwater robots. With these he has made pioneering images of shipwrecks and sea creatures in the dark abyss. In 1997, having lowered a computer-controlled digital video camera a mile into the ocean off New Zealand, he filmed a sequence of a squid attacking a shark. When frames from that video were published in the June 1998 *National Geographic*, they were probably the first digital images ever printed in the magazine.

They would not be the last. But at least four years passed, while the Geographic kept a weather eye on the new technology, before the illustrations for a major magazine article on the future of flight, published in December 2003, were planned as being all digital from the get-go. Photographer Joe McNally had proved himself a wizard depicting technological subjects with 35mm. Cutting-edge digital seemed somehow appropriate for photographing dazzling new supersonic aircraft, but it also offered other advantages photographers were discovering: wider amplitude in the kinds of images possible, and greater freedom in the making of them.

Underwater photographers like Brian Skerry and Paul Nicklen, for instance, are not limited to shooting a 36-frame roll at a fixed ISO before having to surface to change film. They can now shoot hundreds of pictures on a single dive, and as light conditions change, raise or lower the camera's ISO correspondingly. They can move back and forth from portraits of sea creatures to depictions of entire ecosystems with comparative ease.

Ken Geiger, 2008, England

So can wildlife photographers like Beverly Joubert, photographing leopards in the dappled sun and shade of the wooded savanna. No more great shots missed because she was changing rolls. No more fumbling for a different speed film when the quarry moves deeper into the gloom. The ability to run up and down the ISO scale allows her to shift her focus from sunlight to shadow instantly while maintaining the proper exposure. The result is more and better pictures and a better understanding of such intriguing animals.

What George Shiras, stringing his clumsy trip wires back in 1900, might have given for the camera traps Nick Nichols devised to photograph elephants is anyone's guess. The pioneering wildlife photographer of a century ago had only one shot at any animal that happened to trip the wire at night—flash, bang, develop the single plate the next morning, and hope for the best. Digital camera traps today can take hundreds of pictures under a great range of lighting

David Liittschwager, 2007

Jim Richardson, 2008, Arizona

conditions, providing a more comprehensive portrait of elephant habits and activities. As a result, Nichols is getting not just stunning pictures but is adding to our knowledge of these majestic beings as well.

In 1971, naturalist George Schaller had made the first photographs of rare snow leopards in the wild, glimpsed through a telephoto lens and a screen of swirling snow. Steve Winter, using a digital camera trap, has obtained a breathtaking up-close image of this most beautiful but elusive of creatures.

Even photojournalists and street shooters are acknowledging the advantages of digital photography. And it's not merely the ability to slip indoors or outside without having to change film or worry about the effects of flash. Photographers in the field once worked blind. They depended on periodic reports from headquarters informing them about the quality of their exposures. Today they have the luxury of checking those exposures with their own eyes—instantly. It's comforting to know that never again, dozens of rolls into an assignment, will they be cabled that their camera seems to be malfunctioning, that all their hard-won pictures are, say, light-struck. Those photographers working for weeks on end in remote places are also freed of one of 35mm's most onerous burdens: the slew of film-crammed Halliburton cases they had to drag from airport to back of beyond and then protect against heat, humidity, and rain. Today the kit is stripped down almost to cameras, memory cards, lenses, and laptop.

There are photographers who still feel that film has a look and feel about it that digital, despite its many advantages, can't always emulate. Yet even they are subject to the digital nature of today's workflow, for sooner or later their transparencies must be scanned as part of the print production process. For the most part, however, the flood of film that once streamed into headquarters has ebbed. Today it is about hard drives, and digital images are stored on computer servers.

So with each new published image and each new digital file select cataloged, a new chapter is being added to the story of the Image Collection. The digital archive is comparatively small but growing rapidly—and it has this advantage over the small stockpile of pictures that originally gave rise to the Collection: it is being daily swelled by newly scanned images pulled from that Collection's broad and deep repository, legacy of a century and more of National Geographic photography.

Brian Skerry, 2007, New Zealand

NATIONAL GEOGRAPHIC
IMAGE COLLECTION

Published by the National Geographic Society
John M. Fahey, Jr., *President and Chief Executive Officer*
Gilbert M. Grosvenor, *Chairman of the Board*
Tim T. Kelly, *President, Global Media Group*
John Q. Griffin, *Executive Vice President; President, Publishing*
Nina D. Hoffman, *Executive Vice President;*
 President, Book Publishing Group
Maura Mulvihill, *Vice President, Image Collection and Image Sales*

Prepared by the Book Division
Barbara Brownell Grogan, *Vice President and Editor in Chief*
Leah Bendavid-Val, *Director of Photography Publishing*
 and Illustrations
Marianne R. Koszorus, *Director of Design*
Carl Mehler, *Director of Maps*
R. Gary Colbert, *Production Director*
Jennifer A. Thornton, *Managing Editor*
Meredith C. Wilcox, *Administrative Director, Illustrations*

Staff for This Book
Leah Bendavid-Val, *Editor*
Adrian Coakley, *Illustrations Editor*
William Bonner, Steve St. John, *Contributing Illustrations Editors*
Melissa Farris, *Art Director*
Rebecca Lescaze, *Text Editor*
Mark Collins Jenkins, *Contributing Writer*
Mike Horenstein, *Production Project Manager*
Marshall Kiker, *Illustrations Specialist*
Al Morrow, *Design Assistant*
Michael J. Walsh, *Contributing Designer*

Manufacturing and Quality Management
Christopher A. Liedel, *Chief Financial Officer*
Phillip L. Schlosser, *Vice President*
Chris Brown, *Technical Director*
Nicole Elliott, *Manager*
Rachel Faulise, *Manager*

The National Geographic Society is one of the world's largest non-profit scientific and educational organizations. Founded in 1888 to "increase and diffuse geographic knowledge," the Society works to inspire people to care about the planet. It reaches more than 325 million people worldwide each month through its official journal, *National Geographic*, and other magazines; National Geographic Channel; television documentaries; music; radio; films; books; DVDs; maps; exhibitions; school publishing programs; interactive media; and merchandise. National Geographic has funded more than 9,000 scientific research, conservation and exploration projects and supports an education program combating geographic illiteracy. For more information, visit nationalgeographic.com.

For more information, please call 1-800-NGS LINE (647-5463) or write to the following address:

National Geographic Society
1145 17th Street N.W.
Washington, D.C. 20036-4688 U.S.A.

Visit us online at www.nationalgeographic.com

For information about special discounts for bulk purchases, please contact National Geographic Books Special Sales: ngspecsales@ngs.org

For rights or permissions inquiries, please contact National Geographic Books Subsidiary Rights: ngbookrights@ngs.org

For professionals interested in licensing images,
visit www.nationalgeographicstock.com

ISBN 978-1-4262-0968-0

Illustrations credits for "The Photographers": 471, William Allen; 475, Wilbur E. Garrett; 479, Winfield I. Parks. Jr.; 480, James E. Russell; 484, Kenneth Love.

The Library of Congress has cataloged the 2009 edition as follows:
National Geographic Image Collection.
 p. cm.
ISBN 978-1-4262-0503-3 (alk. paper)
 1. National Geographic Society (U.S.)—Photograph collections. 2. Travel photography. 3. Nature photography. 4. Documentary photography. I. National Geographic Society (U.S.)
 TR 790 .N36 2009
 779—dc22

 2009012387

Printed in China
12/PPS/1